Divine Images, Human Visions

THE MAX TANENBAUM COLLECTION OF
SOUTH ASIAN AND HIMALAYAN ART
in the
NATIONAL GALLERY OF CANADA

PRATAPADITYA PAL

NATIONAL GALLERY OF CANADA

BAYEUX ARTS

1997

DIVINE IMAGES, HUMAN VISIONS
The Max Tanenbaum Collection of South Asian and Himalayan Art
in the National Gallery of Canada
Pratapaditya Pal

Copyright © 1997 National Gallery of Canada, Ottawa,
and Bayeux Arts Incorporated, Calgary

Design by George Allen and Christine Spindler, Carbon Media, Calgary
Divine Images, Human Visions has been typeset in Galliard and Univers Condensed.
Film and printing by Sundog Printing Ltd., Calgary
Printed on Luna Matte 100lb text paper

Produced by the Publications Division of the
National Gallery of Canada, Ottawa:
Serge Thériault, Chief
Lynda Muir and Myriam Afriat, Editors
Colleen Evans, Picture Editor
in collaboration with Bayeux Arts Incorporated, Calgary.

PRINTED IN CANADA

Available through your local bookseller or from:
The Bookstore, National Gallery of Canada,
380 Sussex Drive, Box 427, Station A, Ottawa K1N 9N4

Canadian Cataloguing in Publication Data

Pal, Pratapaditya
Divine Images, Human Visions.
The Max Tanenbaum Collection of South Asian and Himalayan Art
in the National Gallery of Canada

ISBN 1-896209-05-X
1. Asian Art. 2. Art Museum Religion. I. National Gallery of Canada.
II. Title: Divine Images, Human Visions. III. Max Tanenbaum Collection.
IV. National Gallery of Canada.
I. Art and Religion II. Nature in Indo-Tibetan Art
III. Religious Sculpture IV. Indian Painting V. Tibetan Painting
VI. Portraiture in Indo-Tibetan Art
N910 07 T73 1997

Cover: *Radha and Krishna*, India, Himachal Pradesh, Kangra, c. 1875 (23637)
Back cover: *Rahula*, Central Tibet, 15th century (26720)
Frontispiece: *Crowned Amitabha Buddha*, Nepal, 15th century (26687)

CONTENTS

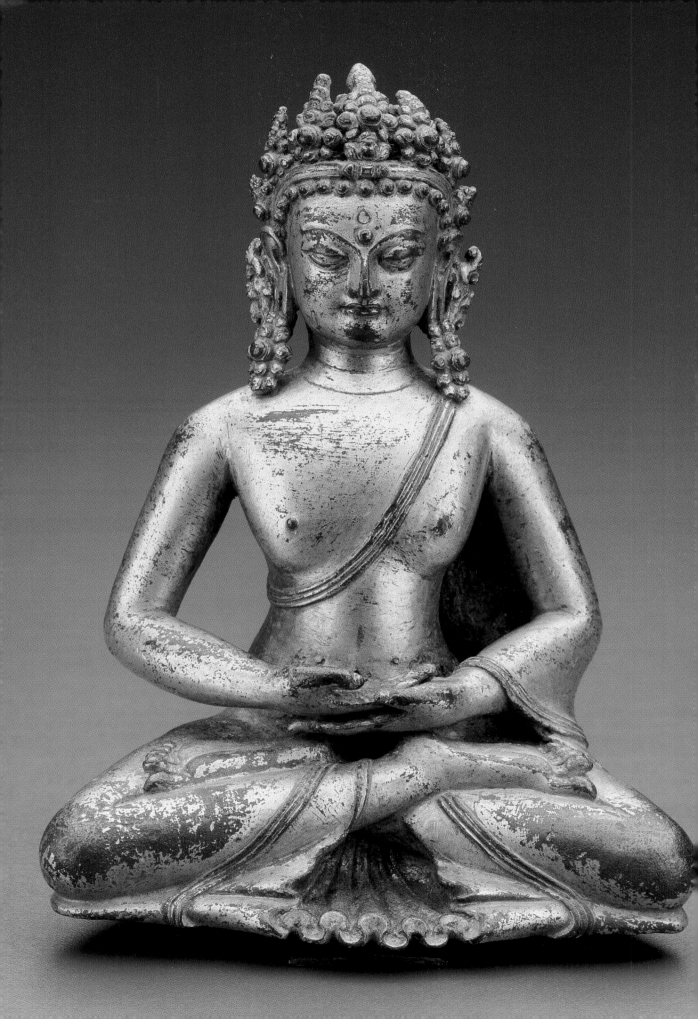

FOREWORD

This book commemorates one of the most sumptuous gifts in the history of the National Gallery of Canada, timed to coincide with its centenary in 1980. At that time, Dr. Hsio-Yen Shih, my predecessor, in a successful effort to expand the collection beyond the confines of the arts of Canada, Europe, and North America, attracted this remarkable donation. It was Dr. Shih who recognized that the dispersal in the late 1970s of the Heeramaneck collection of Asian art, the finest and most extensive in private hands, presented an ideal opportunity for Canada.

It may be recalled, that for almost half a century, Nasli M. Heeramaneck (1902–1971) was one of the leading figures in Indian and Himalayan art. A dealer in New York, his erudition and expertise were formidable. His wife, the painter Alice Arvine, had joined him in a passion for collecting which easily overshadowed his activity as a dealer. Following his death, it was her task to oversee the fate of a vast numbers of objects of almost unparalleled variety. Several groups of works were purchased for the Los Angeles County Museum of Art, and further works went to the Museum of Art in Richmond, Virginia. At that time, Dr. Shih, who was familiar with the material, undertook negotiations on behalf of Ottawa. It remained to find a patron with humanist ideals and a sense of vision prepared to support the project and the National Gallery of Canada.

An enlightened benefactor appeared in the person of Max Tanenbaum (1909–1983), the construction magnate and President of York Steel Construction Ltd., who, with typical enthusiasm, at once endorsed the proposal. His wife, Anne Tanenbaum, a philanthropist of the first order in her own right, vigorously supported the idea.

Max Tanenbaum had come to Canada from Poland with his family when he was six months old. He left school early, joined his father's firm, and went on to build his fortune in the steel business. One of the most influential figures on the Canadian scene, his generosity was legendary, as many a charitable organization can attest. However, he was extremely discreet and not apt to discuss his benefactions in public. When the news of the gift of the collection that took his name captured the imagination of the public, he gave one of his rare interviews. With characteristic modesty he simply said: "Canada gave my father, myself, and my children opportunities far beyond what we could ever have expected when he landed as an immigrant at the beginning of the century. It is only right that we should try to pay back to Canada something of what it has so richly given to us." It is gratifying to be able to thank the Tanenbaum family and Dr. Pratapaditya Pal for having made possible this admiring tribute to one of our great patrons.

Dr. Shirley L. Thomson
Director
National Gallery of Canada

ACKNOWLEDGEMENTS

When the Tanenbaum collection arrived at the National Gallery, the accession process was assigned to Sylvia Giroux who, under the direction of Hsio-Yen Shih, Director, and Myron Laskin, Jr., Curator, oversaw with diligence the housing of the material, and set up curatorial files. At that time, the opinion of scholars was widely sought, and credit must be given in particular to Milo Cleveland Beach, John C. and Susan L. Huntington, John M. Rosenfield, and the indomitable Stella Kramrish for their illuminating remarks on iconography, style, and dating.

Happily, from 1979 on, a checklist of the collection was published in the Gallery's *Annual Bulletin*, thus making available the complete extent of the Tanenbaum gift. In the years that followed, other scholars have generously commented on the works, notably Ralph and Catherine Benkaim, and Dr. Neelima Vashistha from the University of Rajasthan, Jaipur. In 1989, on the occasion of the Tibetan exhibition at the Art Gallery of Greater Victoria, Barry Till, Paula Swart, and a team of specialists contributed new insights into a number of works. For the last two years, Pratapaditya Pal's stimulating collaboration added immeasurably to our knowledge of an extremely diversified collection.

As always with important new acquisitions, exhibitions were organized almost immediately, allowing the works to be seen across Canada. Dr. Shih and Dr. Elizabeth Merklinger prepared first *Brahma and Buddha*, which opened at the National Gallery in 1979 and travelled to Halifax, Edmonton, Saskatoon, London, and Kitchener. In 1980, *Paintings of Imperial and Princely India* opened in Ottawa and was seen in Vancouver, Hamilton, and Guelph. Previous to the move to the new building, the late Dr. David Ditner took charge of the collection with characteristic passion and flair. Since 1988, most of the sculpture has been permanently on view, while paintings and the remaining smaller bronzes have been shown, by rotation, in thematic displays.

It is with pleasure that we record the unfaltering support of the conservators who took daily care of the collection. The paintings received expert attention from Karen Graham and particularly from Anne Maheux, while Doris Couture-Rigert assumed responsibility for sculpture, with the invariably friendly and informed cooperation of the Canadian Conservation Institute. Charles Hett and Judy Logan deserve special thanks for their work on the bronzes. More members of staff than there is place to mention have been involved with the objects. One must single out, however, Michael Gribbon, responsible for making the paintings available for study, Magda Le Donné, Curatorial Assistant, and Laurier Marion and his resourceful team in Technical Services who have contributed greatly not only to the handsome new installations but to making possible new photography for this book. In this context, we are deeply indebted to the photographers, Clive Cretney, Robert Fillion, and most of all, Richard Garner.

Michael Pantazzi
Associate Curator of European Art

PREFACE

A little over two years ago I received a call from Michael Pantazzi of the National Gallery of Canada inquiring if I would be interested in writing a book about the Gallery's Indian and Himalayan collections. I was happy to accept the invitation, as almost twenty years ago I had initiated the negotiations that led to the acquisition of the collection from Mrs. Alice Heeramaneck. However, upon familiarizing myself with the collection, I realized that writing an introduction to the arts of the Indian subcontinent, Nepal, and Tibet – the three regions represented in the collection – would not be an easy task. No single collection in any institution is complete enough to cover the entire history of art created in these areas. I have, therefore, organized the book in a manner intended to provide readers, especially those with little familiarity with the arts of the region, with sufficient background information to immerse themselves further in the extensive literature on the subject. To make it easier for the general reader, diacritical marks for Sanskrit words have been avoided in the text and Tibetan names have been spelled phonetically. The index, however, spells all such words in the proper academic mode.

The book was written during the first four months of 1996, when I was a Getty scholar. Indeed, I could not have written it within that time frame if I did not have the facilities (including afternoon teas) and congenial atmosphere of the Getty Institute for Research in the History of Art and Humanities in Santa Monica, California. I deeply appreciate the cooperation of the staff of the Institute in general, and in particular of Jennifer Pascaran, Elizabeth Garrett, and Janice Schmitz, who helped me in putting the manuscript into the computer, a world with which I remain stubbornly unfamiliar.

For help in preparing the catalogue I remain indebted to the many scholars who have seen the collection since its acquisition and have offered comments, as well as to Andrew Topsfield of the Ashmolean Museum. Much of the fresh information, however, is derived from the generous reading and translation of inscriptions by Dr. Z.A. Desai, the eminent Indian epigraphist for Persian and Arabic, and by the distinguished Tibetan scholar and author Lobsang Lhalungpa of Santa Fe, New Mexico.

I have also benefited enormously from Michael Pantazzi's unfailing cooperation and familiarity with the collection. For someone whose field is European Art, Michael's devotion to and knowledge of the collection are remarkable. Working closely with him and with Colleen Evans, the National Gallery's perspicacious and always obliging picture editor, has been a great pleasure and privilege.

Finally, I would like to thank Lynda Muir, the editor of the text, and Myriam Afriat, the editor of the French-language version, for their professional and diplomatic skills, which made the transformation of manuscript into book a pleasure.

Pratapaditya Pal

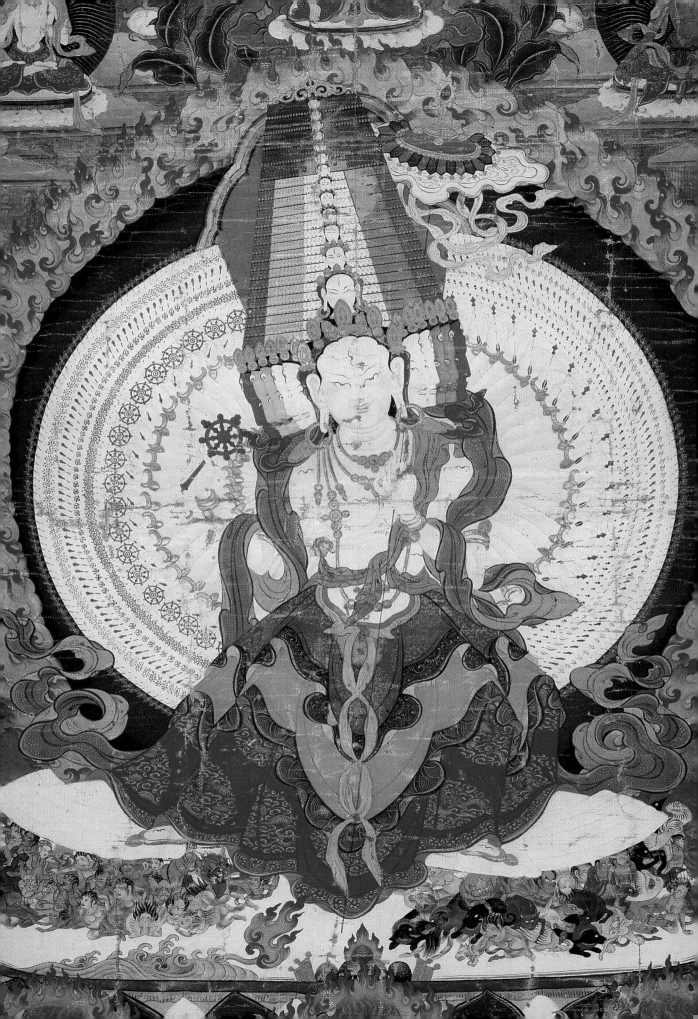

❶ Art and Religion

Most art, whether produced in India, Nepal, or Tibet, was closely associated with religion, except for Indian paintings of the Mughal and Rajput schools belonging to the last three centuries. The three religions whose divinities and mythology provided the subject matter for the sculptors are Hinduism, Jainism, and Buddhism. And, as we shall see later, religious themes also played a major role in paintings, especially those meant for Hindu patrons.

The predominant religion in India today is Hinduism, whose roots go back to the distant past. The oldest sacred writings of the Hindus are known as the *Veda* and were composed by ancient seers in an early form of the Sanskrit language. Because Sanskrit is related to Persian as well as several European languages including Greek, it was postulated that they all belong to a single Indo-European family of languages. Nineteenth-century philologists applied the expression "Aryan" to denote the people who composed the Vedic hymns, the earliest of which they believed date to about 1200 B.C. Neither theory is universally accepted today, and parts of the Vedic literature may have been composed earlier.

Archaeological evidence indicates that a highly developed urban civilization, known as the Indus Valley Civilization, once spread from Punjab in today's Pakistan to Gujarat and western Uttar Pradesh in India and flourished between 3500 and 1500 B.C. During the same period, both in the south and in the east, there were distinctive Neolithic cultures. While the relationships among the creators of the Indus Valley Civilization, the people responsible for the Neolithic cultures, and the composers of the Vedic literature remain unclear, all three have contributed to the later development of Hinduism. What is clear is that most northern Indian languages today are derived from Sanskrit, whereas in the south the predominant languages – Kannada, Malayalam, Tamil, and Telegu – belong to a different language group called Dravidian.

Both these major groups of languages as well as others spoken by various tribes have interacted over the millennia, just as the diverse beliefs of the different communities have contributed to the religious mosaic known as Hinduism. Since the Vedas could not be modified, most of these beliefs, cults, and rituals were collected and codified in texts known as *purana* (ancient lore), *agama*, and *tantra* (see p. 29). Along with two epics, the

Mahabharata and the *Ramayana*, they serve as the source of Hinduism's social and religious customs and practices. These texts also provide the forms and myths that were assiduously transformed into sculpture and painting by mostly unknown artists over the last two millennia or so. By and large, religious art in India has been produced by artists who remained anonymous, for the purpose of art was not self-expression but to exalt divine glory.

The other two major religions originating in India are known as Jainism and Buddhism. Orthodox Hindus regard both as heterodox religious systems, for neither believes in the existence of a Supreme Being, called Brahman (and hence Brahmanical) by the Hindus. Both emphasize the ascetic or mendicant (*sramana*) traditions, and hence are often referred to as Sramanical, as opposed to Brahmanical. Unlike Hinduism, which does not owe its origins to a single individual, both Jainism and Buddhism originated from the teachings of enlightened mortals. Jainism believes in twenty-four eminent teachers, the last one, Mahavira (c. 599–527 B.C.), being the most important. Buddhism began with Buddha Shakyamuni (560–480 B.C.), who, like Mahavira, also lived and preached in Bihar.

Although both these religions were established as alternatives to the ritual-dominated Hinduism, in the course of time both became ritual-oriented. While some of the Buddhist rituals have become as elaborate as those of the Hindus, the Jain rituals are simpler. Jains also often employ Hindu priests to perform some of their rituals. Both Buddhism and Jainism began by denying the existence of God, but over the centuries both developed elaborate pantheons peopled with deified teachers and saints and countless divinities. At an intellectual level these deities do not exist but their representations in material form, whether in sculpture or painting, are important for elementary religious praxis. For the Jains they help the devotee attain both material and spiritual well-being, while for the Buddhists they are like *aide memoires* in their search for enlightenment. To the Hindus an image of a deity indicates divine presence, and even a glimpse or sighting (*darsan*) of one, not to mention veneration (*puja*), brings spiritual merit.

While Jainism remained confined to the subcontinent, both Hinduism and Buddhism spread beyond India. Both religions flourished in Nepal, where mingling with local traditions, as well as absorbing influences from Tibet, they developed a characteristically Nepali flavour, with devotional nuances and iconographic forms that are unknown in India. Hinduism did not penetrate into Tibet but Buddhism did in a marked degree. After a checkered history for four centuries following its introduction in the seventh century, it became the dominant force in the religious, cultural, and political life of the Tibetans in a unique way.

Whatever their doctrinaire differences, in practice all three religions encourage the use of images of deities and deified enlightened beings both for worship and didactic purposes. Although the human form constitutes the principal referent for divine imagery, its imperfections and blemishes were overcome in imaginative ways. Unlike the Greeks, who used the perfect athlete's body as an ideal for their gods, for the Indians the meditating Yogi's body served as the ideal for enlightened teachers (fig. 16–17, 20) and some gods (fig. 8). Other deities were given regal attributes (fig. 4, 59). Ideal shapes and forms were also borrowed from both the plant and the animal worlds to constitute the divine forms (see chapter 2). Admiration for the superior strength of animals resulted in grafting their heads to human bodies (fig. 3, 62), which were further provided with additional limbs to emphasize the cosmic nature and omnipotence of the deities. This is such a conspicuous trait of

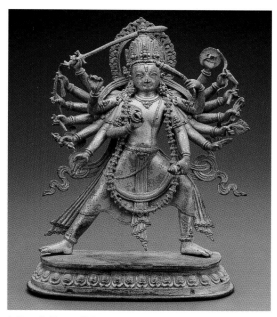

1. **Cosmic Form of Vishnu** Nepal; 16th century (26689)

2. **Ushnishasitatapatra, the Cosmic Goddess**
Central Tibet; 18th century (26843)

Indian iconography that a few words of explanation are necessary.

Generally, the deities are given two additional arms to represent the four directions and to emphasize their pervasiveness. Four heads also serve the same purpose; a fifth head usually represents the centre. The number of arms and heads, however, can be increased according to iconographic needs to further demonstrate the deity's cosmic form and functions. And so, in a rare gilt bronze from Nepal (fig. 1) the Hindu god Vishnu is represented as a militant, regal figure, equipped with sixteen arms exhibiting various weapons and emblems. In a still greater display of omnipotence and omniscience, the Buddhist goddess Ushnishasitatapatra in a Tibetan painting (fig. 2) has a thousand heads, twice as many arms and legs, and at least three thousand eyes. What is admirable is that in both instances the multiple limbs are so deftly integrated to the body that they seem to be organic rather than artificial.

Hindu Deities

A vast number of deities of both sexes dominate the Hindu religion, but only a few are represented in the collection. All Hindu worship begins with the invocation of the elephant-headed deity called Ganesha (literally "lord of the people"). As the lord of beginnings and because of his appealing "teddy-bearish" form, he has remained a popular god and is adored by Buddhists and Jains also, in India as

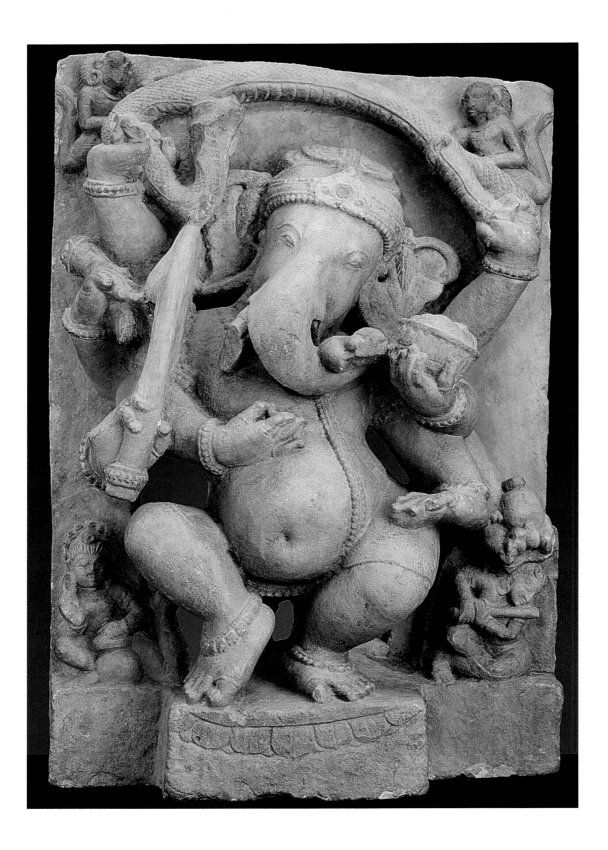

well as abroad. In a live sandstone stele of about the tenth century (fig. 3) he dances with his plump legs bent and displaying his prominent belly. Imitating his father, Shiva, he holds a cobra above his head like a canopy or a victory garland. His trunk is busy spooning sweetmeats from a bowl into his mouth. Two musicians provide him with musical accompaniment below, while two celestials hover above to watch his antics.

The two most important male deities of the Hindu pantheon are Vishnu and Shiva. They constitute two members of the Hindu Trinity, the third being Brahma, who did not become the focus of devotion as Vishnu and Shiva did. Although each has a defined role – Brahma is the creator, Vishnu the preserver, and Shiva the destroyer of the universe – to their sectarian devotees each performs all three functions.

Vishnu travels the universe on his mount, the sun-bird Garuda, as shown in a small bronze in the collection, weathered by constant rubbing of unguents during worship (fig. 4). Garuda here is almost completely human. Vishnu's spouse Lakshmi, the goddess of wealth, is perched on his left thigh. Distinguished by the tall crown, Vishnu's attributes are the conch shell, the wheel, and the club. The last two are also represented in their anthropomorphic forms as sentinels on either side.

His role as the preserver makes Vishnu a saviour god who is said to descend (*avatirna*) on earth from time to time to deliver mankind from evil. Such incarnations are known as *avatara* (avatar in English). While he has descended on

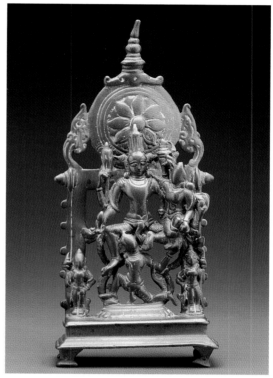

4. **Lakshmi and Vishnu**
India, Uttar or Himachal Pradesh; 13th century (26651)

3. **Dancing Ganesha**
India, Madhya Pradesh; late 9th–10th century (23244)

numerous occasions, ten of the avatars are regarded as the most important. In the first four of these he assumed animal forms, but the others are human. Buddha Shakyamuni is the ninth avatar, and the tenth is yet to come. These incarnations of the deity have remained popular and are often represented in sculpture on Vaishnava (follower of Vishnu/Krishna) temples and in paintings.

A beautifully decorated nineteenth-century palm-leaf manuscript from Orissa (fig. 5A, B) gives us a less common group of twelve avatars, including Krishna. The Fish, the Tortoise, the Boar, and the Man-Lion avatars are shown as composite figures, their divinity emphasized by their multiple arms and their hieratic postures. Only in the Man-Lion and the Dwarf avatars is the narrative aspect of the myths emphasized. In the former (third from the top in fig. 5A) Narasimha has placed the titan Hiranyakasipu across his lap and has torn open his belly; in the latter (fourth from the top in fig. 5B) the Dwarf receives alms from the titan king Bali. The other avatars are all depicted essentially as human, with Kalki, the future avatar, as the apocalyptic horseman brandishing a spear. In sculpture the group is frequently included in subsidiary icons of Vishnu (fig. 52), or in images of individual avatars such as the Varaha in the collection (fig. 62). The representation always is cryptic and synoptic rather than narrative.

While Vishnu remains the major figure among the Vaishnavas in the deep south, across much of the continent the principal focus of Vaishnava devotion is the dark-skinned pastoral god Krishna. Sometimes regarded as an avatar of Vishnu, he is said to have lived in the Mathura region about three millennia ago. In fact, the present Krishna is probably a conflation of at least three heroic personalities: a pastoral and heroic Don Juan, a Machiavellian counsellor to kings, and a supreme teacher of yoga.

5A, B. **Manuscript with Avatars of Vishnu** (see also fig. 66)
India, Orissa; 19th century (23641)

16

In his classic and most familiar image Krishna is portrayed as a cowherd standing with his legs crossed at the ankles and playing the flute. He may be accompanied by his beloved Radha and his animals, as can be seen in a delicately rendered early nineteenth-century picture in the popular Kangra style (fig. 6). In an earlier, exquisitely crafted South Indian dagger (fig. 7) Krishna's identification with Vishnu is articulated by the two additional arms holding the wheel and the conch, and the kneeling Garuda below. Krishna is a pervasive figure in Indian culture, and his legendary life stories provided Indian artists with their richest source for poetry and painting, and music as well as dance.

Shiva

In his benign form, Shiva is represented often as an ithyphallic yogi, with or without his spouse, who is known as Parvati or Uma (fig. 8). Although most

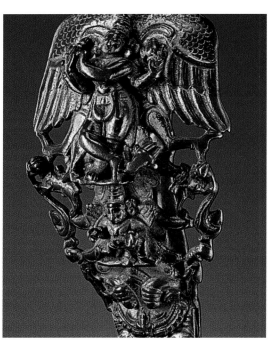

7. **Ceremonial Dagger with Fluting Krishna** (detail of fig. 33)
India, Tamil Nadu; 16th century (26678)

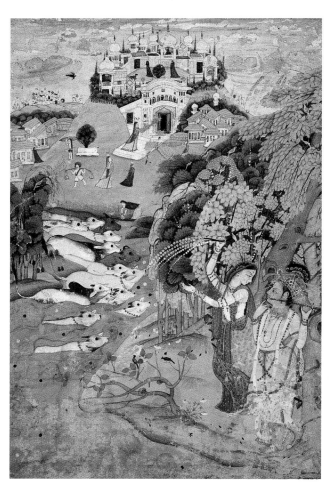

6. **Radha and Krishna in a Landscape**
India, Himachal Pradesh, Mandi, ascribed to Sajnu; c. 1810 (23631)

of his traits, such as matted hair, the rosary, or the erect penis symbolizing yogic self-control, are those of an ascetic, he also has a wife with whom he lives on the sacred Mount Kailash in the Himalayas. Later Indian artists, especially of the Pahari (Hill) tradition, were very fond of showing the couple, along with their two sons, Ganesha and Kumara (the general of the gods), engaged in various leisurely activities in their mountain abode (fig. 9).

Apart from his membrum virile and his matted

hair, the most distinctive mark of Shiva is the vertical third eye on his forehead. This is his principal weapon of destruction, for when he is angry it emits laserlike rays that burn up the target. While Shiva is usually portrayed with four arms to further emphasize his divinity, his spouse has no such divine trappings. Typically, when they are depicted together in the north (fig. 8), she sits demurely on his left thigh like a shy bride. His bull mount is included in the picture but not in the sculpture.

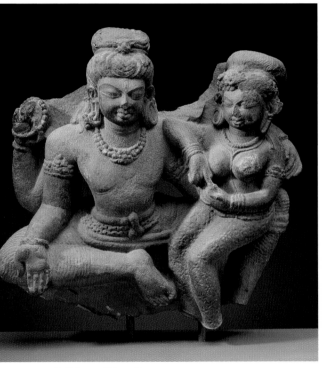

8. **Shiva and Parvati**
India, Madhya Pradesh; 6th century (23235)

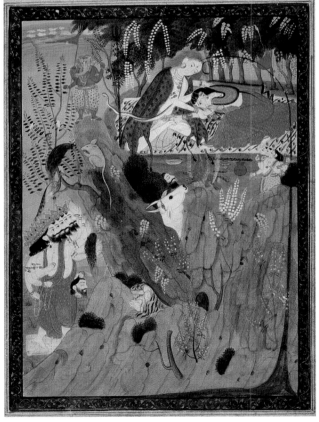

9. **Shiva and Parvati on Mount Kailash**
India, Uttar Pradesh, Garhwal; c. 1825 (23632)

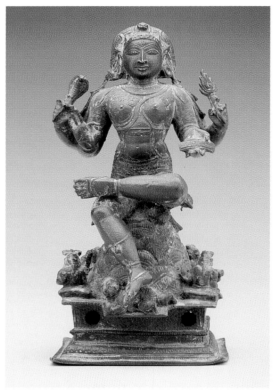

10. Shiva as the Graceful Teacher
India, Tamil Nadu; 16th century (26674)

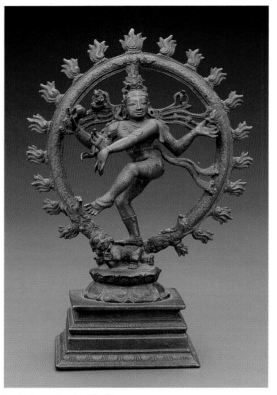

11. Shiva as Lord of the Dance
India, Tamil Nadu; 17th century (26682)

In two of his well-known benign forms, typical of Tamil civilization in the south, the god is shown as the supreme teacher (fig. 10) and the lord of the dance (fig. 11). The former iconic type is known as *Dakshinamurti*, meaning both the south-facing image and image of grace. Seated on the pinecone-like, cosmic Mount Meru, and watched by his devout bull, Shiva dispenses wisdom to a group of mortal ascetics. His role as the teacher is further indicated by the teaching gesture and the book displayed by the normal hands. The others hold the purificatory fire and the serpent symbolizing regeneration.

The two last attributes are also included in the lord of the dance form known in Sanskrit as *Nataraja*. In addition, he holds a small kettledrum to provide the rhythm for his cosmic dance, while the two normal hands exhibit the gestures of reassurance and blessing. The crouching dwarf (*apasmara purusha*) below his right foot symbolizes ignorance, and the circle of flames circumscribes the phenomenal world.

Rich in multivalent symbolism, the Nataraja has become emblematic of Hindu civilization. Not only does it quintessentially express the basic cosmogonic concept of the Hindus, who believe in the cyclical nature of the cosmic process, but visually it is a compelling image, at once dynamic and reposeful. Even though the dance is characterized as *tandava*, meaning frenzied, in point of fact, the sense of movement is both restrained and elegant.

In his destructive mood Shiva assumes a terri-

fying form variously known as Rudra, Bhairava, and Mahakala. Bhairava is the more popular name for the specific iconographic form that is seen in artistic representations in Hindu temples. The Tanenbaum Collection includes two northern Indian images of Bhairava (fig. 12, 58), one of which is only partially preserved. The name Mahakala is more familiar in later Buddhist art (fig. 13), for this emanation of Shiva became an important deity in the Vajrayana pantheon. Known in Tibet as mGon-po, he is a popular protective deity, and most monasteries include a special shrine for him called the *mgon-khang*. He is frequently included in religious paintings known as *thanka* (fig. 50–51).

Appropriately, Bhairava is given a number of awesome features, which in Indian sculpture are confined mostly to his face. Often bearded and fanged, the face has a menacing expression. The Tanenbaum Bhairava head (fig. 12) is indeed an impressive piece of sculpture that once must have belonged to a colossal statue. The beard and mustache, the open mouth with gnashing teeth (scarcely visible now), large circular eyeballs that seem to shoot out of their sockets like bullets, and flaring nostrils make the face highly expressive of demonic anger. Originally such figures would have been polychromed, and seen in flickering lamplight the effect on the viewer would have been awesome. An additional Shaiva trait, the crescent moon on the matted hair, is clearly visible in this powerful head.

We will never know what sort of body was attached to the Bhairava head, but a highly expressive Tibetan painting of Mahakala (fig. 13) not only demonstrates the iconographic difference but gives us an idea of the rich imagination of the Tibetan artists. Here the six-armed deity of black complexion (the epithet Mahakala means both Great Time and the Great Black One), wearing a flayed tiger

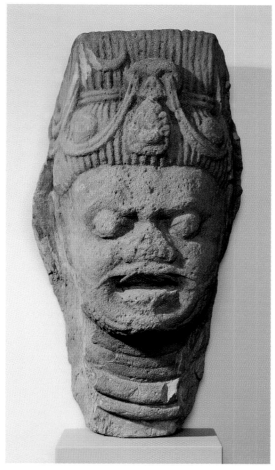

12. **Head of Shiva Bhairava**
India, Madhya Pradesh; 9th century (23246)

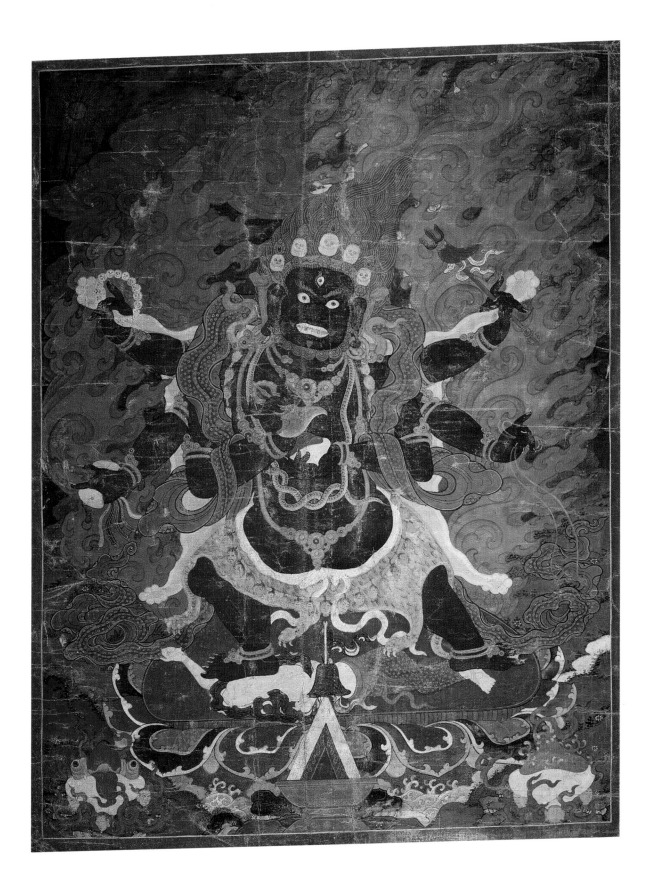

skin, strikes a militant posture as he tramples an elephant-headed being who does not symbolize the Hindu Ganesha but represents evil, which Mahakala destroys. His principal attributes held against his chest are the chopper and the skullcup, others are a rosary of human skulls and a kettle-drum on the right, and a trident and rope or lasso on the left. He is bearded, has the third eye, and wears a tiara of skulls. Apart from his apparel, hair and arms flying in all directions, the dancing tongues of flame add to the drama and power of the composition.

Like the male deities, the goddesses have both benign and angry forms. Parvati is gentle and docile only when she is with her husband. As is the case with Lakshmi, the goddess of wealth, and Sarasvati, the presiding goddess of learning and the arts, Parvati too has an independent career and like her husband assumes an active role in destroying evil. In one popular form known as Durga she is shown in a classic tableau killing a titan disguised as a buffalo, hence the epithet *Mahishasuramardini* or the Destroyer of the Titan Buffalo. It is in this form that she is worshipped annually in the autumn for ten continuous days (*dusserah*) in many parts of India, but especially in the east.

The collection has a small but ornate bronze from the Kulu Valley in Himachal Pradesh, in a lively folkish style (fig. 14). Here her divinity is in no doubt, for she is provided with eight arms equipped with various weapons. The most prominent is the trident or spear with which she has pinned the buffalo to the ground. A scrawny, dog-like animal representing her lion attacks the hind-part of the buffalo, while a male stands on the goddess's left with hands joined in reverence. This is very likely the titan who has emerged from the

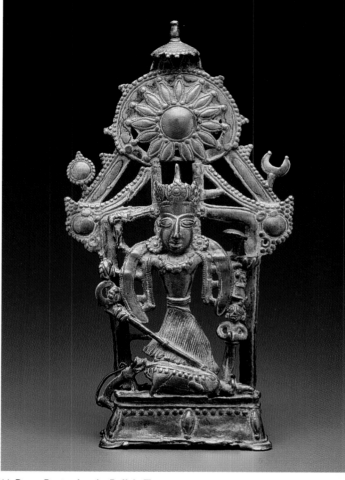

14. **Durga Destroying the Buffalo Titan**
India, Himachal Pradesh, Kulu Valley; before 15th century (26653)

13. **Mahakala**
Central Tibet; 18th century (26845)

23

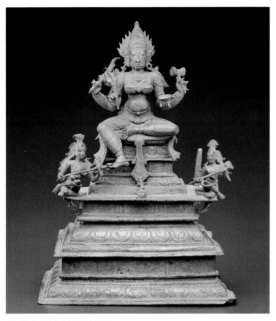

15. Kali with Musicians
India, Tamil Nadu; 15th century (26681)

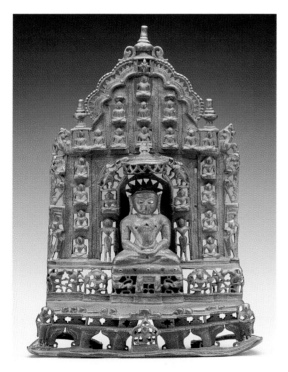

16. Altarpiece with Shitalanatha and Twenty-three Jinas
India, Karnataka; 1474 A.D. (26661)

buffalo's severed neck and given up the struggle, although in the texts he is killed by her and thereby liberated. The bronze is a fine example of abstract modelling combined with compositional balance and ornamental flair.

A diminutive but interesting bronze from Tamil Nadu (fig. 15) represents the goddess's ferocious form known as Kali or the Black One. As is customary in South India, Kali is a perfectly proportioned figure conforming to the Indian ideal of feminine beauty and is seated gracefully with the right leg pendant. Only the prominent fangs protruding from her mouth and the flame-like hair make her a menacing figure. Her attributes, the kettledrum, the skullcup filled with blood, the trident and the sword, also announce her belligerence.

What is unusual about this well-crafted and exquisitely detailed bronze is the addition of the bull and the two lively musicians on the pedestal. Rarely is the bull associated with Kali, although it is given to Maheshvari, the mother goddess, who is the embodiment of Maheshvara's or Shiva's energy. The presence of the musicians is more difficult to explain, unless they represent permanent offerings of music, which is essential in the worship of the goddess.

Jainism

The term Jainism is derived from the Sanskrit word *jina*, meaning the conqueror or victor. Those who have conquered all their passions and desires and have attained liberation from the chain of rebirth are entitled Jina. Of the twenty-four such beings represented collectively in a small ex-voto shrine (fig. 16), the most eminent are Mahavira and Parshvanatha, who may have lived in the eighth century B.C. Because they no longer exist, theoretically the Jinas should not be represented in art. But here they are shown as ascetic figures, either

completely naked (*digambara*, also the name of a sect), or clothed in one piece of unstitched white cloth (*shvetambara*), and only in two postures. Either they are seated in the meditating posture with hands placed in the lap in the meditation gesture (*dhyanamudra*), or they stand firm and erect with the arms extended along the body without touching it. This characteristically Jain gesture is called *kayotsarga* (body abandonment). All Jinas have short curly hair covering their heads, as does the Buddha, with two exceptions: Parshvanatha, who is distinguished by a multihooded snake canopy above his head, and Rishabhanatha, the first Jina, who has long matted hair falling down his shoulders (fig. 17). The only means of recognizing the other Jinas is by the emblem on the bases of the representations, and the attendant deities who carry different attributes.

According to Jain belief, these attendant deities also need to be liberated. Until they are, however, they look after the welfare of the lay devotees who cannot interact directly with the Jinas. The function of a deity is made clear by an illumination from a *Kalpasutra* (the most sacred book of the Jains) manuscript (fig. 18). In the picture, Indra or Shakra, the king of the gods in Vedic literature and a prominent figure in Buddhist or Jain mythology as well, dispatches his messenger Harinaigamesha to transplant the embryo from a brahmin lady to one of the warrior (*kshatriya*) caste in the birth legend of Mahavira. The goat-headed (cf. Ganesha, fig. 3) Harinaigamesha is a fertility deity of unknown origins, venerated universally by women and having his own shrine. Other deities of well-being worshipped by the Jains include Lakshmi, Ambika, Chakreshvari, Balarama, and Krishna.

Although the Jain religion is less ritual-oriented than both Hinduism and Buddhism, the zeal for pilgrimage is no less intense. Visits to the

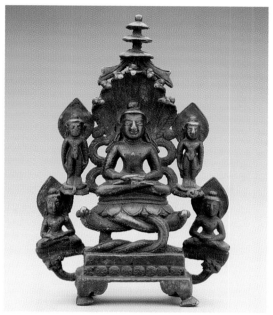

17. **Altarpiece with Parshvanatha and Four Jinas**
India; 10th century (26659)

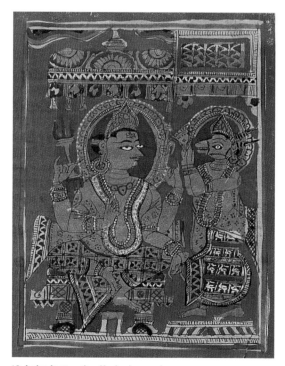

18. **Indra Instructing Harinaigamesha**
from a *Kalpasutra* and *Kalakacharyakatha* manuscript
India, Gujarat; 16th century (23582.1)

19. Shvetambara Pilgrims Performing Prostrations in front of Jain Temple
India, Rajasthan, Marwar(?); late 18th century (23583)

various holy sites, usually placed on mountaintops, such as Girnar and Satrunjaya in Gujarat, are almost mandatory for Shvetambara Jains, while the well-known site of Sravanabelgola (Karnataka) with its colossal statue of Bahubali, is among the popular Digambara pilgrimage sites. In a simple Rajput picture of the late eighteenth century (fig. 19) a group of Shvetambara pilgrims are on their way to the hilltop shrine of a Jina. Clad in a simple white garment (the women have their heads covered), they proceed by prostrating themselves all along the path. This is also done by Tibetan Buddhists, especially as they approach such holy shrines as the Jokhang in Lhasa. Each Jain pilgrim, however, covers his or her mouth with a piece of cloth in order not to swallow any insects, and carries a small brush to sweep the ground ahead to avoid killing any crawling creatures. The picture therefore not only demonstrates the religious fervour of the Jains but also the great significance they attach to the principle of non-violence or *ahimsa*, which is a central tenet of their faith. It is needless to emphasize that vegetarianism is obligatory for all Jains.

Buddhism

Buddha Shakyamuni has remained the most important figure in the Buddhist pantheon and art, despite the proliferation of deities in the later forms of the religion known as Mahayana and Vajrayana. The most classic icon (fig. 20), associated only with Shakyamuni, is that in which he is shown as a meditating monk seated on a royal throne below the Bodhi tree with his right hand extended. The image thus epitomizes the historical occasion when he was enlightened (*bodhi*) while meditating below the peepul tree at Gaya and is also symbolic of his transcendental nature. Apart from the tree, the historical occasion is marked further by the gesture of the right hand, which signifies his calling upon the earth to witness his victory over Mara, the god of desire, who had come to tempt him, as Christ was tempted by Satan. Buddha's transcendental and divine nature is symbolized by the elaborate lion throne, emphasizing spiritual kingship, and the flaming halo behind the head. It should also be noted that the Buddha is fundamentally no different from the Jina, except for the upper garment

draping his torso and the prominent bump above his head signifying wisdom, a further indication of his transcendence.

The image of the Buddha did not appear in Indian art much before the beginning of the Common Era. Until then, the *stupa* or the *chaitya*, a solid hemispherical and tumulus-like structure, was the principal focus of Buddhist veneration. Originally, it was purely a royal funerary monument, and before his death the Buddha himself suggested that stupas be raised over his mortal remains. Subsequently, it became the most visible symbol of the new faith before which devotees meditated and chanted; it also symbolizes an *axis mundi* which they circumambulate. This function

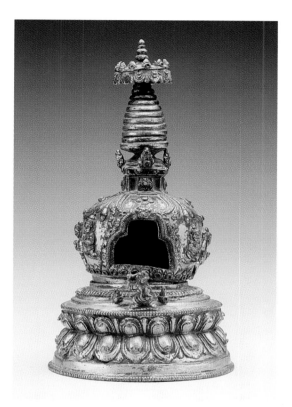

21. **Reliquary (Chöten)**
Central Tibet; 17th century (26712.1–2)

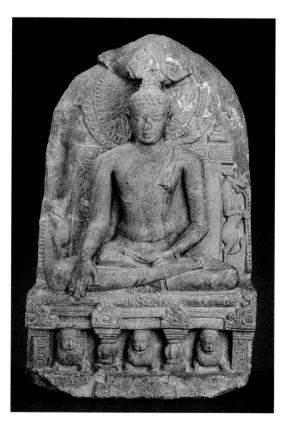

20. **Enlightenment of Buddha Shakyamuni**
India, Bihar, Gaya district; 10th century (23260)

was appropriated by the image of the Buddha in most countries to which Buddhism travelled, except Sri Lanka, where the stupa still plays an important role.

Both the funerary and votive characters of the stupa are maintained in Nepal and Tibet. The remains of the Dalai Lamas (the title of the principal spiritual and temporal leader of the Tibetans) are enshrined in large indoor stupas (called a *chöten* in Tibetan), while commemorative stupas, both large and small, crowd the courtyards of monasteries in Kathmandu and Patan, and other Buddhist settlements in Nepal. A small portable gilt stupa from Tibet (fig. 21) once served as a votive shrine with an arched aperture to house an image, probably of the goddess Ushnishavijaya. This dome is

known as *anda* (egg) or *garbha*, meaning womb. An alternative name for a stupa is *garbhadhatu*, or essence containing womb. Appropriate to a shrine, images of protector deities are represented on the body of the dome on the cardinal sides. The thirteen-tiered conical finial above the rectangular entablature and the wide-brimmed parasol are characteristic of both Nepali and Tibetan stupas.

Among the doctrinal changes that profoundly influenced Buddhism was the belief in the concept of the *bodhisattva* or potential Buddha. Both mortal and divine, a bodhisattva embodies the

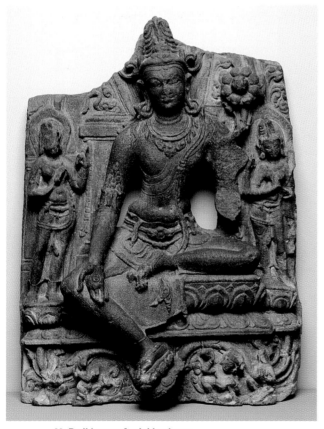

22. **Bodhisattva Avalokiteshvara**
India, Bihar, Gaya or Patna district; c. 1000 A.D. (23261)

virtue of compassion and helps the less fortunate towards the path of enlightenment rather than achieve the goal himself. Because of their role as saviours, bodhisattvas became popular with the common people, and their images came to be set up and worshipped not only for spiritual salvation but also material benefits.

As the texts say, there are as many bodhisattvas as there are grains of sand on the banks of the river Ganges, but only a few are prominent. They are Avalokiteshvara, Vajrapani, Maitreya, and Manjushri. Manjushri is the wisdom-bestowing bodhisattva, while Maitreya is the future Buddha who is yet to appear (see fig. 60). Manjushri figures prominently by himself (fig. 47) or in his angry forms, such as Vajrabhairava (fig. 98) in Tibetan art. Numerous eminent lamas (monks), including Tsongkhapa, the founder of the Geluk order (fig. 109), are regarded as his reincarnations. Vajrapani figured prominently in the early representations of the Buddha's life, especially in the Gandhara region, as the constant bodyguard of the master. In later Buddhist art he is primarily a bodhisattva.

By far the most eminent bodhisattva is Avalokiteshvara, who is the very embodiment of compassion. A frequent companion of the Buddha, he is the spiritual son of Amitabha (one of the five transcendental Buddhas), who presides over Sukhavati or the land of bliss, more commonly known as the Western Paradise. Avalokiteshvara is also the patron deity of Tibet, and the Dalai Lamas are considered to be his emanations. Likewise, the second highest monk in Tibet, the Panchen Lama, is said to be the reincarnation of Amitabha.

In a stone stele of about the tenth century from Bihar (fig. 22) the bodhisattva is shown as an elegant figure seated in the posture of grace (*lalitsana*) on a lotus, with the right leg pendant and supported by another lotus. His right hand exhibits the gesture of charity (*varadamudra*), and the left,

now broken, once held the stalk of a pink lotus which is his distinctive attribute. Although he is regally adorned, his crown of matted hair indicates his ascetic nature and he also wears the cord of a twice-born Hindu. The hairdo and the vertical third eye on his forehead are iconographic elements he shares with Shiva. However, his function as a saviour is similar to that of Vishnu and, like the Hindu deity, he is flanked here by two goddesses, the one on his right representing Tara and the other, Bhrikuti. Such conceptual and iconographical borrowings are a commonplace feature of Indian religious art throughout its history.

Although male monasticism plays a fundamentally important role in both Jainism and Buddhism, both religions came to accept the idea of divine femininity by about the fifth century. Despite the male-dominated pantheon of the Vedic Aryans, belief in the Magna Mater or the Divine Mother is both ancient and widespread in India. At the village level her worship is universal, and, therefore, it is not surprising that both Buddhism and Jainism should adopt female deities for various purposes. As early as the second century B.C., ancient tutelary deities of both sexes, called *yaksha* and *yakshi*, find eloquent expressions in the Buddhist stupa of Bharhut, and both Buddhist and Jain canonical literature are replete with allusions to shrines of goddesses presiding over towns and villages. The tutelary deity of Buddha's own town, Kapilavastu, was in fact a goddess. Subsequently, many of these ancient goddesses and their shrines became absorbed by all three religions. A new rubric called *tantra* (hence tantric) was adopted to accommodate this expansion and categorize the literature. Whatever the origin of the term or its original meaning, in the history of religion in India *tantra* is an inclusive term that was adopted by both Hindus and Buddhists. Its basic philosophy emphasizes the identity of the adept and the goal

which can be achieved by everyone with the help of the appropriate guru or teacher.

According to later Buddhism, enlightenment (*bodhichitta* = nirvana) cannot be achieved by wisdom or right action alone, but only by combining the two. Wisdom in this instance is not discursive knowledge but insight, the kind of mystical insight Shakyamuni had under the Bodhi tree. Right action is basically compassion, the essential virtue of a bodhisattva. Formulaically expressed, $W + C = E$. In visual terms the idea is represented by a male and a female in physical union (fig. 23), the male symbolizing compassion (*karuna*) and the female wisdom or insight (*prajna*). Thus, all

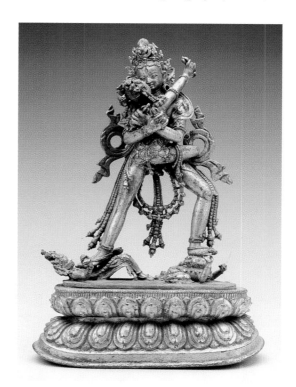

23. **Samvara Embracing Nairatmya**
Nepal; 17th century (26690.1–2)

male and all female deities in Buddhism symbolize compassion and wisdom, respectively. It should be noted though that few images showing sexual embrace have been found in India. In Nepal and Tibet, however, where the expression used is *yab-yum* (literally father-mother), the use of the imagery is much more pervasive.

The Buddhist goddess par excellence and the female counterpart of Avalokiteshvara is Tara. In her simplest manifestation, as in an impressive Tibetan bronze (fig. 24), she is depicted as a voluptuous female, seated in the meditating posture with the right hand in charity; the left once held the stem of a now missing blue lotus. Like the Hindu goddess Durga, Tara has a third eye on her forehead. (In fact, Tara is worshipped by the Hindus as well.) In Tibetan images Tara is often given two additional eyes, one on each palm, to emphasize further her all-seeing nature. It may be pointed out that although she embodies insight, she is also a saviour like Avalokiteshvara, and performs exactly the same functions.

While Tara is known both in India and Tibet, the terrifying goddess Lha-mo is very likely a Tibetan original (fig. 25). She is the female counterpart of the important protector deity Mahakala (fig. 13), and her form, as well as the macabre imagery that animates the composition, vividly demonstrates the imaginative powers of the Tibetan artists. Indeed, compared to the richness of the painted images, the textual descriptions on which they are based seem austere. Her Sanskrit name is Shridevi, which is an alternate epithet of Lakshmi who, however, is seldom represented in a ferocious form. On the other hand, Lha-mo does share some features with the Hindu goddess of death, Chamunda or Kali (fig. 15).

The ritual implement *phurbu* (magic dagger) is also characteristically Tibetan (fig. 26). It has the form of a tent-peg with a triangular blade and is

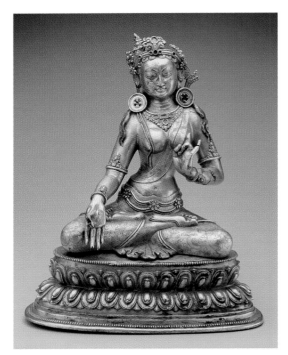

24. **Tara**
Central Tibet; 14th century (26722)

25. **Lha-mo**
Central Tibet; 18th century (26846)

adorned with highly expressive demonic heads. Tradition has it that the eighth-century Indian mystic Padmasambhava, or Guru Rimpoche in Tibetan, used a tent-peg to exorcise and control the native spirits who were obstructing the spread of Buddhism. The Sanskrit word for the object is *vajrakila*, but nothing similar has yet been found in India. In Tibet, however, it is as important an implement as the thunderbolt (*vajra*) and bell (*ghanta*), the two essential tools of Tibetan Buddhist worship. This particular metal is not only interesting for the pattern on its blade but also for

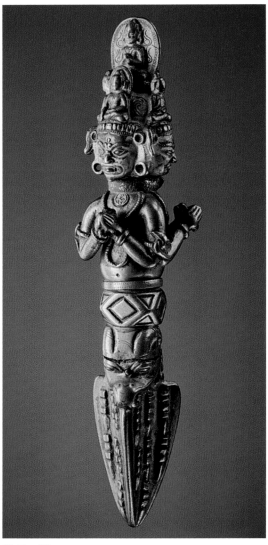

26. Ritual Dagger
Western Tibet; 15th century (26701)

the elaborate figural forms on the handle. Each of the three demonic busts have two hands holding a small *phurbu* about to be plunged. Moreover, the five transcendent Buddhas, presided over by Vairochana, adorn the finial.

Two other distinct characteristics of Tibetan Buddhism are their extraordinary veneration for reincarnated teachers, both Indian and Tibetan, and the use of mandalas or cosmic diagrams. The representations of saints and teachers will be discussed in chapter 6, but a few words should be said here about the mandala. Again, like other Buddhist concepts, the mandala also originated in India, and most of the mandalas depicted in thankas are described in Sanskrit texts which the Tibetans assiduously translated and preserved. But not a single Buddhist mandala has survived on the Indian subcontinent, which makes Tibetan mandalas highly relevant for Indian Buddhism as well. It should be noted that mandalas are also used by Buddhists of Nepal but not with the same intensity as the Tibetans.

A mandala is literally a circle, and hence any circumscribed sacred space may be called a mandala. It is principally a microcosmic reduction in two dimensions of a celestial citadel and forms a temporary abode of a deity. It is also a cosmograph that aids the individual to align his own centre with the cosmic centre. The essential form of the mandala is deceptively simple, consisting basically of a square and a circle (fig. 27). However, because it is a celestial palace and must accommodate the lord of the manor with an appropriately large retinue, the form becomes complex and ornate. Not only are there several layers of circles and squares but the mandala is provided with four highly adorned gateways in the cardinal directions. Often the innermost circle containing the central deity and his principal companions is represented as an open lotus. The citadel itself is usually painted in

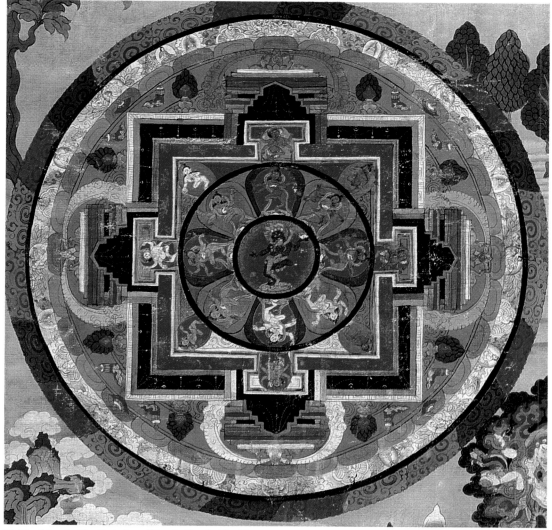

27. **Mandala of a Manifestation of Heruka** (detail of fig. 94)
Tibet; 19th century (26869)

four different colours: red, yellow, green, and blue. The gateways and the walls are filled with banners, festoons, auspicious emblems, etc., while the ground is sometimes filled with exquisite scrolling patterns. The innermost circle may or may not contain stereotyped and formulaic representations of the eight cremation grounds, but is almost always fringed with a stylized flame pattern in the four alternating colours. This is the same ring of flames symbolizing the phenomenal world that we have encountered in the South Indian Nataraja image (fig. 11). During meditation, the practitioner enters the mandala purified through the ring of fire and proceeds towards the centre to be merged into the void or *sunyata* represented by the central deity.

➋ Nature in Indo-Tibetan Art

Most readers of this book are probably familiar with the exclamatory expression, Holy Cow!, which is derived from the Hindu veneration for all bovines. Because the cow acts as a surrogate mother by providing milk for human infants, killing a cow and eating its flesh have come to be regarded as reprehensible and irreligious acts. Neither is the bull destroyed to provide meat for the table, for it too is a useful animal and a source of wealth.

Even those Hindus who eat flesh generally avoid beef, and a large number, especially the brahmins and Vaishnavas of all castes, are vegetarians. Jains are strict vegetarians, but for Buddhists vegetarianism is not obligatory, though desirable. Not only does this reflect a respect for all life but also the philosophical underpinning that distinguishes Indian culture. Indians believe in the theory of rebirth, and one can be reborn as an animal if one does not accumulate sufficient karmic merit. This is clear from the stories of the Buddha's previous births, known as *jataka*, which provided the artists in India, Nepal, and Tibet with a rich source of narrative art. In many of these birth stories the Buddha was born as an animal. The avatar theory of Vishnuism (see pp. 15–16) also reflects a similar idea, and in many instances Vishnu assumed an animal form to perform his salvific task.

Animals therefore figure prominently in Indian religious imagery, as was also the case in ancient Egypt. Like the Egyptians and unlike the Greeks, Indians preferred to graft an animal head to the bodies of their divinities. The god of auspiciousness, Ganesha (fig. 3), is probably the most familiar example of such a composite figure, although there are many others (see fig. 18, 98). Not only are deities conceived as a combination of animal and human forms in all three religions, but some are worshipped only as theriomorphs, the simian god Hanuman being the most popular example.

This deep-rooted veneration for animals probably survives from very early times, as evidenced by the material remains of the Indus Valley Civilization. Both the bull and the elephant figure prominently in the art of the Indus Valley, especially on the tiny seals. Later the bull became the mount of Shiva (fig. 9), while the majestic elephant was given to Indra, the king of gods in Vedic mythology. Throughout the ages the pachyderm has remained the symbol of royal power and

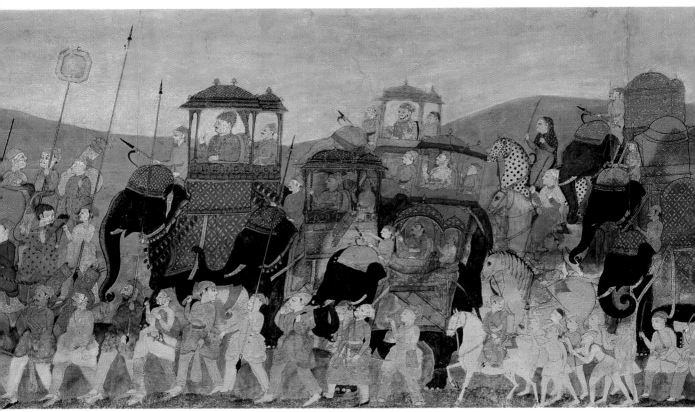

28. **Royal Procession** (detail of fig. 123)
India, Andhra Pradesh, Hyderabad; early 18th century (23577)

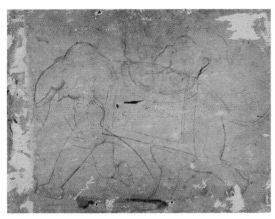

29. **Sketches of Elephants** (verso of fig. 125)
India, Rajasthan, Jodhpur, c. 1750 (23597)

pomp, and monarchs of all invading dynasties, including the British viceroys, used the elephant on state occasions to impress the ordinary citizens with their exalted status (fig. 28). It remained a popular motif in both religious and secular architecture (fig. 76) and on thrones. Both Hindu and Muslim rulers loved to own and display elephants and often had portraits of their favourite animals painted. The lively drawing of an elephant by an unknown artist in a Rajasthan atelier, though not a portrait, vividly captures the graceful and energetic movement of the animal (fig. 29).

The Buddha's mother, Maya, dreamt that the future Buddha was entering her womb in the guise

of a white elephant, which is greatly venerated in Thailand. Poets used the elephant as a metaphor for the water-laden dark clouds that roll in during the monsoon season to soak the earth and make it fertile for a rich harvest. And so an image type (fig. 30) was created where the goddess of wealth and abundance, Shri-Lakshmi, is shown being bathed by the elephants of the directions.

Although the lion is native to India (now confined only to the Gir forest in Gujarat), the animal is not represented in the Indus Valley Civilization and does not appear in Indian art until the third century B.C. when he is depicted in magnificent majesty on the capitals of the Asokan pillars. One such capital, sharing four addorsed lions, is now the national emblem of India. Very likely the use of the lion in Indian art became popular under the influence of Achaemenid Persia and the Bactrian Greeks. As in those cultures, in India the animal continued to be closely associated with royalty. It appears commonly in Kushan art at the beginning of the Common Era, both in Gandhara and Mathura, on the throne of the Buddha. Indeed, the Buddhists may have been the first to adopt the lion throne (*simhasana*: literally, lion seat) for the image of the Master (fig. 20). Like the elephant, it has remained a popular motif for both architecture and furniture and has been used in a variety of ways, both decorative and symbolic.

An exquisitely detailed fifth-century head of Vishnu from Madhya Pradesh (fig. 31) offers an ornamental but symbolic use of the lion. At the top of the god's headdress is a prominent stylized face of a lion set within an arch. Known in Sanskrit as a *kirtimukha* (face of glory), the motif is used ubiquitously in South and Southeast Asia as an apotropaic and auspicious symbol. As a mount the lion serves various deities. Seen most commonly as the mount of the goddess Durga (fig. 14), it is also ridden by Kubera or Vaishravana, the

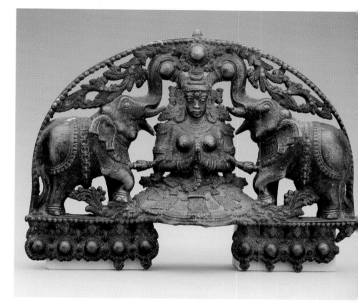

30. **Lamp Finial with Elephants Bathing Lakshmi**
India, Kerala; 16th century (26669)

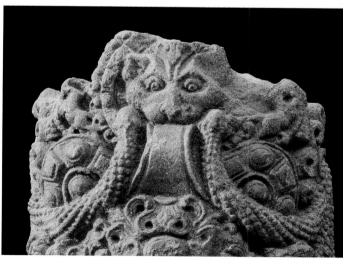

31. **Head of Vishnu** (detail of fig. 55)
India, Madhya Pradesh; 5th century (23239)

god of wealth, the Boddhisattvas Manjushri and Avalokiteshvara, and by the Jain goddess Ambika.

Indeed, in all three pantheons most deities are given animals either as mounts or as attributes. For example, the mongoose (*nakula*) eminently serves as an attribute of Kubera, also called Jambhala by the Buddhists (fig. 64), while Shiva has the deer. A rodent is the mount of Ganesha (fig. 9), and a peacock that of his brother Kumara and also of the transcendental Buddha Amitabha. Vishnu has Garuda, often represented as human with a bird head, similar to the Egyptian Horus. Like the gods, the various Buddhas and Jinas have animal symbols to distinguish them from one another. The Jinas, in fact, cannot be identified without such cognizances.

One of the most ubiquitously represented animals in Indian art is the serpent known generically as *naga* (male) and *nagi* or *nagini* (female). While the other animals, except the simian Hanuman, are seldom the focus of cults, the serpent is universally worshipped, especially in rural India. The python and the cobra are not only physically the most impressive but among the deadliest. It is not difficult to imagine how the snake would be literally feared and worshipped in a tropical country. This negative value aside, it is also considered a symbol of regeneration because it sheds its skin periodically.

It is difficult for a visitor to the subcontinent to miss a wayside shrine or *naga-koil* dedicated to the snake god. If by chance one does, one is likely to find a snake in one form or another in sculptures in temples or in museums. An important attribute associated with many deities either as a hand-held emblem or as a body ornament – as with Ganesha (fig. 3) and Shiva (fig. 10) – it is also associated with Vishnu (who lies on the serpent couch Ananta or Eternity in the cosmic ocean) as well as the Buddha and the Jina (fig. 17).

Apart from its reptilian form, the *naga* and *nagi* are also represented in Indian art as composite figures in which they are basically human with the snake hood attached to their head like a canopy. Often the hoods are multiple, numbering five or seven. In such composite forms they are usually present at the bottom of a stele, representing the nether world below the ocean. Thus, in sculpture *nagas* frequently symbolize water (fig. 62).

The intimate relation between the divine and the animal world is dramatically expressed in a remarkable Tibetan gilt bronze in the Tanenbaum Collection (fig. 32). Called Rahula, the protector of the faith and lord of lightning, the figure is a tour de force of sculptural art. Here we have the "Greek" mode of combining the two forms, with the upper part being human and the lower reptilian. A snake is also an attribute in his upper left hand. The iconography is made more bizarre with the bird's head at the summit and additional eyes delineated on his torso and the principal forehead. Although not as ubiquitous in Tibetan art as it is in India and Cambodia, the serpent is an essential feature of the iconography of the ferocious deities in Tibet (fig. 13, 25–26).

32. **Rahula**
Central Tibet; 15th century (26720)

38

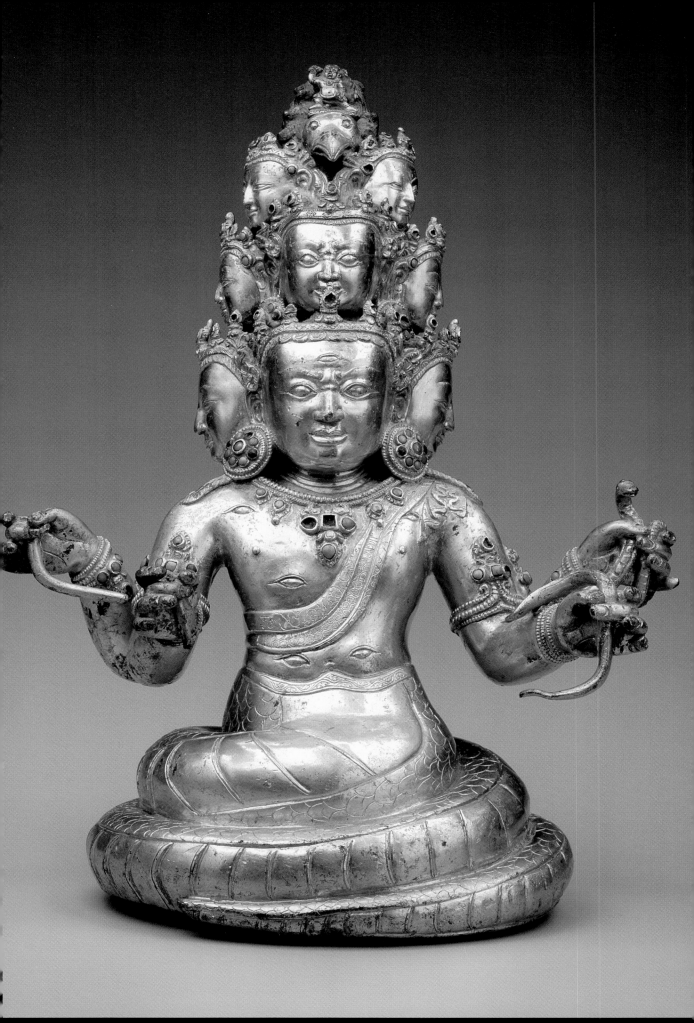

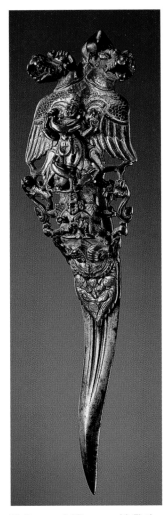

33. Ceremonial Dagger with Fluting Krishna and Heraldic Eagles

India, Tamil Nadu; 16th century (26678)

The sacred and symbolic use of a variety of animals may best be observed in a magnificent ceremonial dagger from Tamil Nadu (fig. 33). Two heraldic eagles form a splendid backdrop for the flute-playing Vasudeva-Krishna, below whom kneels the divine mount Garuda, himself a half-avian, half-human figure. On either side spring two leaping leonine forms, whose extended tongues are clearly serpentine and rest on the heads of two parrots. Finally, and appropriately, the joining of the curved blade and the hilt is guarded by the traditional lion's head or face of glory motif; this was intended to assure the dagger's invincibility.

Symbolic Nature

Similarly, other manifestations of nature, such as trees, flowers, rivers, and mountains, are both feared and admired. In the Hindu philosophical system known as *Samkhya*, Prakriti is the creative agent and is equated with nature, woman, and the Great Goddess. Every village has its sacred grove and trees inhabited by spirits, usually called *yaksha* and *yakshi*. These tree spirits are living entities who communicate with the devotees. Known in the west as "speaking trees," they fascinated the Macedonian conqueror Alexander, who, however, was not favoured with any personal apparition.

Called a *chaitya-vriksha*, a tree shrine serves as an open-air sanctuary where daily offerings are made. Such shrines have survived even in the modern city, where they may exist as little islands in the middle of a busy thoroughfare. Mystics are fond of meditating under trees, the most prominent example being the peepul tree under which Shakyamuni became enlightened (fig. 20). The tree is universally revered and is regarded by Hindus as one of Vishnu's bodies. The sacred tree is also the tree of knowledge (*jnana-vriksha*) as well as the axis mundi or cosmic pillar that joins heaven and earth. While the Buddha meditated

under the peepul tree, Krishna stands below the Kadamba tree, and Shiva sits below a banyan tree when dispensing knowledge. The theme is depicted in a small bronze in the collection (fig. 10), but the separately attached tree is now missing.

Fruits and flowers are also treated with reverence. Some fruits such as the *amalaka* (Emblic Myrobalan), the *vilva* or *bel* (wood-apple), and the lemon have great symbolic significance. The *amalaka* signifies knowledge, while the others with their numerous seeds are emblematic of fertility and the universe. These, along with the seed of the plant called *haritaki* (Terminalia Chebula), are also important in Indian pharmacopoeia. Both the *bel* and the lemon figure as attributes of deities associated with wealth, abundance, etc. The *haritaki* is the emblem of Bhaishajyaguru, the healing or medicine Buddha.

Hindus all over the subcontinent use the coconut, both husked and unhusked, for religious and auspicious occasions. The fruit rarely features in art, but in paintings the coconut palm, along with the banana, another sacred plant, is employed frequently. The most beloved fruit of the Indians is the native mango. The popular Jain mother goddess Ambika sits below the tree, and a bunch of mangoes in her hand signifies fertility. The Buddha performed an important miracle when he multiplied himself while seated under a mango tree. Both the leaves and the flower of the mango are essential in Hindu worship. The tree with its luscious fruit is frequently included in paintings, both symbolically and to add topographical veracity (fig. 77).

While fruits are optional, no worship is complete for Hindus, Jains, and Buddhists without flowers, which satisfy both sight and smell, two of the five senses. Each Hindu deity has his special flower, as well as leaves. For instance, the basil plant is regarded as the wife of Vishnu and its leaves are an essential ingredient for his worship. But basil cannot be offered to Shiva, who generally prefers white flowers. Similarly, the red hibiscus or China rose is the favourite flower of the bloodthirsty goddess Kali (fig. 15) and will not be used for Vishnu. Apart from being necessary in worship, flowers and flowering vines provide the most ubiquitous decorative and symbolic motif in Indian art.

The flower par excellence is the pink lotus (*padma*) which is an attribute of many deities with differing symbolic meanings. The sun god Surya (fig. 59) holds lotuses, because the flower opens only when the sun rises and closes at dusk. Similarly, the moon god has the water lily (*kumuda*) which blooms only at night. When held by Vishnu, the lotus represents waters; in his spouse Lakshmi's hand, it is a symbol of wealth; with the Buddhist Avalokiteshvara, it symbolizes the religion itself.

Whether the deities hold a lotus or not, it is almost mandatory for all of them, including all deified saints and teachers and even the wrathful divinities of Tibetan Buddhism, to sit or stand on the open lotus in full bloom. Indeed, in no other religious tradition are the gods portrayed so universally on a lotus base or seat as they are in the Indic tradition. The indisputable symbol of beauty and purity in the Indian mind, the cosmic nature of the flower has been eloquently expressed in the following verse:

Its seed is the god Brahma,
its nectar are the oceans and its
pericarp Mount Meru,
its bulb the king of serpents
and the space within its leaf-bud is the spreading sky;
its petals are the continents, its bees the clouds,
its pollen are the stars of heaven:
I pray that he, the lotus of whose navel forms
thus our universe,
may grant you his defence. [Ingalls 1965, p. 107]

Apart from being the repository of the universe and an allegory of immortality, the lotus is regarded as a metaphor for non-attachment, because it grows in muddy water but remains unsullied.

Even more important perhaps is the constant allusion to the lotus in devotional literature as a metaphor for the human heart, where the deity descends and resides during meditation. A typical mental visualization of a Buddhist deity, for instance, begins as follows:

First the practitioner arises from his bed and washes his face and feet, then, purified, he should go to a solitary, pleasing place, sprinkled with sweet scents and strewn with flowers, and then sit in a comfortable posture. In his own heart he visualizes the first

of the vowels, the syllable A, which transforms into the orb of the cold-rayed moon. In the centre thereof he visualizes a beautiful lotus flower....

[Beyer 1978, p. 31]

The most famous mantra muttered endlessly by devout Tibetan Buddhists is *om mani padme hum*, which means Om (the primordial sound) the Jewel and the Lotus. The jewel is the diamond represented pictorially by the thunderbolt, which is a symbol of the Buddha as well as the faith, while the lotus symbolizes the phenomenal world as well as the human heart. According to the First Dalai Lama, the lotus seat stands for "the realization of voidness."

Both Indians and Tibetans regard mountains

34. **River Goddess Ganga with Retinue, from a Temple Portal**
India, Madhya Pradesh; 9th century (23240)

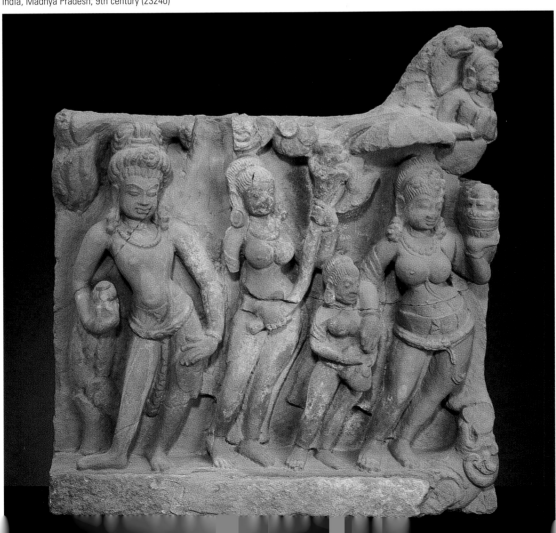

as sacred spaces inhabited by the gods and spirits. The most sacred of all mountains is the mythical Meru, the cosmic mountain that serves as the axis mundi (fig. 10). The word *meru* is also used to designate the spinal column in the human body. The Bodhisattva Avalokiteshvara's home is another mythical mountain called Potalaka, and Shiva's abode is Mount Kailash in the Himalayas (fig. 9); his spouse Parvati is said to be the daughter of the Himalayas. The Kailash peak is sacred to both Hindus and Tibetans. Apart from the mythical Mount Meru, several terrestrial hills are sacred to the Jains, the most important being Satrunjaya and Girnar.

To the Hindus the rivers are sacred as well, and the holiest is the Ganges or Ganga. Not only is the water of the Ganges necessary for worship, but dying on the river's banks guarantees liberation from the chain of rebirth. While the mountains are not personified into deities with anthropomorphic forms, the rivers are. By the fifth century it became customary to place images of the river goddesses Ganga and Yamuna, its major tributary, at the entrances of Hindu temples. Thus, the devotees or pilgrims are figuratively purified as they enter the shrine.

In a typical relief of about the ninth century that once stood at the entrance of a temple (fig. 34), the river goddess Ganga is shown as a voluptuously endowed lady with a retinue. Following the iconographic prescription, she stands gracefully on her composite *makara* mount and holds a water pot. The dwarf attendant carries her cosmetic bag, and a normal female holds the stem of a giant lotus leaf that serves as her mistress's parasol. The fourth figure is a male guardian. Often in such reliefs the makara's tail is extended with great flourish into a scrolling design symbolizing both vegetation and water. In this instance, the *naga* above the goddess's head also symbolizes water.

Descriptive Nature in Indian Art

Temple sculpture or metal images are concerned primarily with human or divine figures, and natural elements play either a symbolic or decorative role, being depicted either conceptually or as decorative design. Some animals, such as the elephant, the bull, and the buffalo, are more naturalistically rendered than others, while the lion, the deer, and the birds are only good approximations. The same holds true for plant representations: some trees and flowers are easily recognizable, while others are more generalized.

Topographical use of nature in sculpture is limited, being found mostly in narrative reliefs. Natural elements are never allowed to obscure the human or divine figures and are used sparingly. A scene in a garden may include a tree or two and a band of wavy lines with a fish or a duck as a body of water. This conceptual and reductive treatment of nature is seen even in early paintings (see fig. 35) in keeping with instructions in texts concerned with artistic theory, though not in poetical literature where nature figures more prominently. The following is a typical example:

The sky should be shown colourless and full of birds and the celestial dome should be shown with stars. Earth should be shown with forest-regions and watering-regions with their distinguishing traits. A mountain should be shown with assemblages of rocks, peaks, minerals, trees, cataracts and snakes. Forest is to be shown with different kinds of trees, birds and beasts of prey. Water is to be represented with innumerable fish and tortoises, with lotus-eyed aquatic animals and with other qualities natural to water. [Shah 1961, vol. 2, p. 133]

We will presently discuss how closely Indian artists followed such descriptions, even after coming in contact with the more realistic European tradition of landscape painting.

35. **Kosha Dances before the Royal Archer**
from a *Kalpasutra* and *Kalakacharyakatha* manuscript
India, Gujarat; 16th century (23582.3)

It is not until the late sixteenth century that we encounter the pictorial rather than symbolic or topographical use of nature in Indian paintings. The artists of the imperial Mughal atelier were the first to experiment with the technical achievements of European works, mostly influenced by prints but also by religious pictures of the Flemish school. From such sources they adopted the idea of using landscape elements in their compositions and of representing natural forms of both fauna and flora realistically.

This becomes clear if we compare two pictures of the Rajput school, one rendered in 1634 (fig. 36) and the other in the eighteenth century (fig. 37). In the earlier picture there is no attempt to create any illusionary space within the field of the picture. The only indication of the outdoors is provided by the disproportionate pavilion and the strip of sky beyond the horizon marked by a wavy white line. The monkey on the roof, though conceptually rendered, is a live creature and appears startled by something behind him. By contrast, the later picture shows a much more pictorial composition. The arrangement of the stream in the foreground, the deep grassy knoll in the middle ground, the placement of the figure, and the trees and a colourful sky with swirling clouds not only provide a more convincing physical setting with a better organization of pictorial space but create a sense of atmosphere. Even though some of the

36. **Two Women outside a Pavilion with Bed**
from a *Rasikapriya* manuscript
India, Malwa; 1634 (23606)

37. **Kamodini Ragini**
from a *Ragamala* series
India, Rajasthan, Bundi-Kota; 18th century (23590)

इसोद नीराजली पंचम कीराउ॥

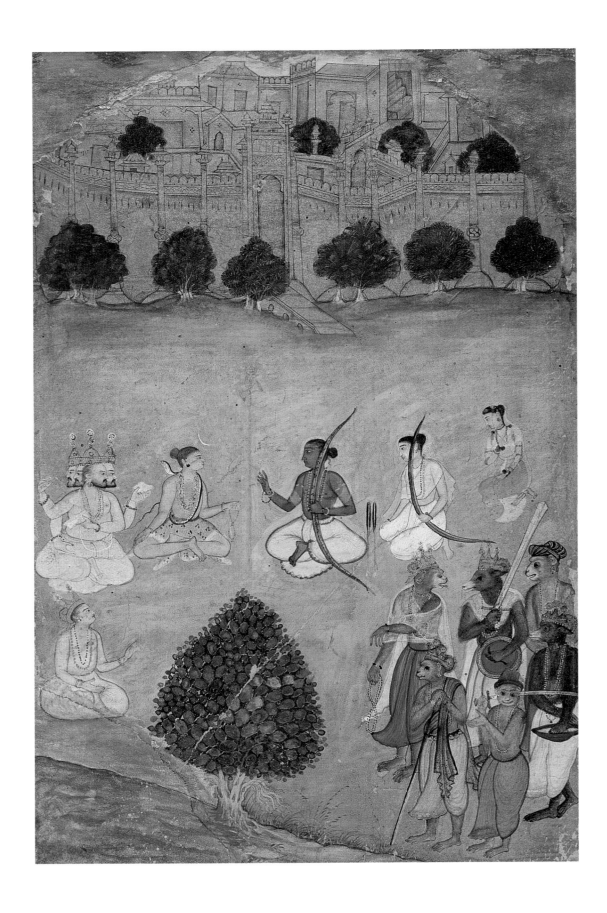

39. **Yasoda Sees the Universe in Krishna's Mouth**
from a *Bhagavatapurana* series
Northern India, Mewar(?); 1540–50 (23584)

components, such as water and trees, are still for-
mulaic and decorative, the composition is not
strongly at variance with ordinary vision. The sym-
bolic use of fauna still continues, however, in the
separation of the two peafowls gazing at each
other from two trees.

To what extent the artists of the Mughal court
adopted technical and aesthetic ideas from
European works can best be seen in an illustration
to the Hindu epic *Ramayana* rendered in sub-

imperial Mughal style (fig. 38). It differs radically
from the earlier, traditional Hindu picture of an
episode from Krishna's life, also a narrative subject
(fig. 39). The *Ramayana* picture is vertically ori-
ented, thereby conveying the illusion of space; in
the other the action takes place in horizontal regis-
ters and there is no attempt to penetrate space. The
scene from the *Ramayana* is like a presentation on
a stage, with a backdrop-like golden fort before
which the figures in the middle ground are
engrossed in conversation. The water in the fore-
ground is no longer conceptual, the leaves on the
solitary tree on the riverbank are rendered in detail
but, appropriately, the trees in the background are
more suggestive.

38. **The Gods Convince Rama of Sita's Purity**
from a *Ramayana* manuscript
India, sub-imperial Mughal; c. 1595 (23553)

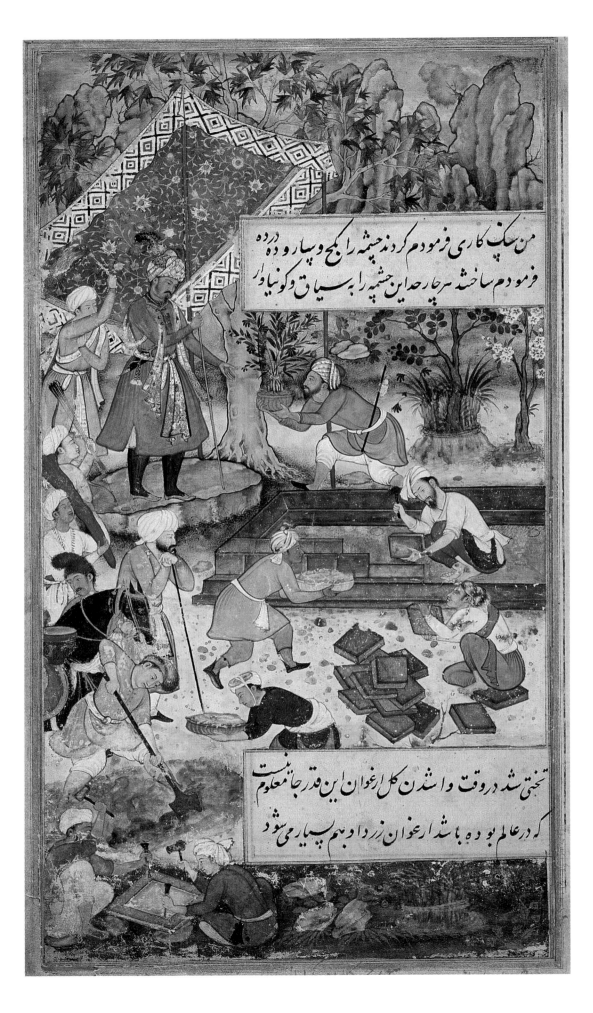

41. The Lamentation of Shirin at Farhad's Grave (detail of fig. 68)
India, Mughal, inscribed to Muhammad Fazil; 17th century (23552)

In an illustration from a *Baburnama* manuscript (fig. 40) we are given a lively rendering of Babur inspecting the progress being made in one of the gardens he built. Representation of such a mundane subject would have been unthinkable in the Indian tradition. Not only does this provide us with a slice of life – note the contrast between the sedentary supervisor resting his bearded chin on a stick and the activity that surrounds him – but it is also a good example of Mughal naturalism achieved through a combination of Persian motifs, as in the shapes of the rocks at the back and the brilliant sense of surface patterns, with some of the technical elements of European pictorialism. However, the intensity of the colouring, the absence of shadows, and the almost iconic isolation of the emperor are features derived from the Indian tradition.

40. Mughal Ruler Babur Supervising the Creation of a Garden
from a *Baburnama* manuscript
India, Imperial Mughal, attributed to Sur Gujarati; 1590–98 (23551)

One European feature adopted by Mughal artists was to enthusiastically use landscape passages to enliven the background of their compositions. A fine example of the incorporation of distant views of an imaginary landscape to enhance the sense of depth within the picture plane is a delicately rendered picture of Shirin's lamentation at the tomb of her lover Farhad (fig. 41, 68).

Another instance of European influence may be observed in the rendering of plants and animals by Mughal artists. Babur's descriptions of both the flora and fauna are so specific that neither the Persian nor the Indian mode of representation would have been adequately expressive. Even when vines, flowers, or animals are used purely for decorative purposes, as in the borders with mounts of a calligraphic panel or a portrait (fig. 42–43), they are depicted with perceptiveness and visual acuity. The animals in cartouches and the two birds perched on delicate tendrils in the mounts of the calligraphic panel clearly reflect the artist's keen eye for appearances. While some of the flowers are accurate botanical specimens, others are

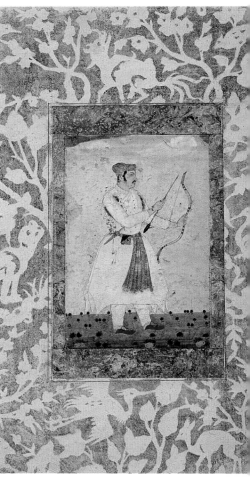

43. **Prince Daniyal with Bow and Arrow**
India, Imperial Mughal; c. 1600 (23557)

42. **Folio from the *Late Shah Jahan Album***
India, Imperial Mughal; c. 1630; Persian calligraphy by Ali (23556)

governed by the demands of surface patterns, which are what gives the mounts their aesthetic effect. Nevertheless, the forms of the plants and animals reflect the artist's ability to combine realistically rendered fauna and decorative flowers with great aplomb.

Kenneth Clark once observed, "Night is not a subject for naturalistic painting.... A large area of dark paint cannot be made to look convincing by optical processes alone; it must have been transmuted into the medium of the poetic imagination." [Clark 1966, pp. 64–65] This is precisely what several Mughal artists did from about the mid-seventeenth century, when nocturnal scenes such as the one in the Tanenbaum Collection showing a lady visiting a holy man (fig. 44) began to be painted, becoming a popular genre for the next century or so. It is in these night scenes that Mughal artists display their understanding of the interplay of light and darkness that is essential to poetizing the picture. Such evocative representations are certainly not the result of the artist's adherence to the perfunctory instructions given in Indian texts such as the following:

Night may be represented with moon, planets and stars, with people asleep or doing the usual nocturnal things.... Darkness may be indicated with men moving with the touch of the hands. The moonlight may be represented with the moon and the blooming of Kumuda (Lotus) flowers.
[Shah 1961, vol. 2, pp. 133–34]

However, such stereotyped descriptions remained the basis for the Rajput painters generally. In a picture depicting the musical mode called Nata Ragini (fig. 45), while the trees may have botanical veracity, and the luxuriant landscape with spectacular sky of reds, oranges, and whites is rendered in a highly picturesque fashion, clearly this is not a specific scene observed in

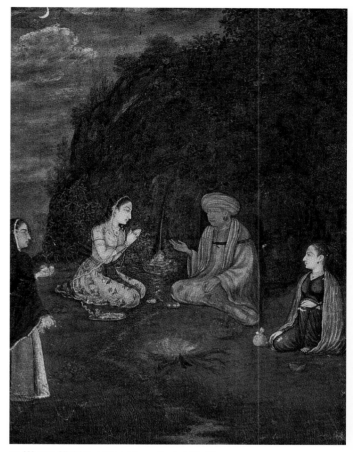

44. **Woman Visiting a Pierced-ear Yogi at Night**
India, Imperial Mughal, style of Payag; c. 1650 (23562)

nature but a landscape of the imagination. Similarly, the lively picture of the Vasanta Raga (fig. 46) provides us with a formulaic representation in which all the elements – figures, birds, and trees – create the joyous mood of spring. Just as the poet does in the following verse:

With ornaments of opening buds
dancing in the swaying wind,
their elaborate leaf painting
resplendent with rouge of pollen;
accompanied by the cuckoo's song
set in amorous mode with falling tone;
the bees appear to celebrate
the holiday of Love's revival.
[Ingalls 1965, pp. 115–16]

The sentiment in both instances is universalized rather than particularized.

Some of the most evocative representations of nature in the history of Indian art were painted by artists for the courts in the lower Himalayan ranges. These Pahari artists reveal an awareness of their surroundings, impressions of which they combined with a range of delicate visual experiences to create enchanting landscapes of poetic rapture, as may be seen in several pictures in the collection (fig. 6, 9). Not until the mid-eighteenth century did the Pahari artists start observing nature and deriving their own modes of representing landscape. Used mostly as a setting for divine play, the silvery streams, the verdant hills with snowy peaks and perennially flowering trees drawn from both fact and fantasy were brilliantly combined to create an idyllic setting for divine play.

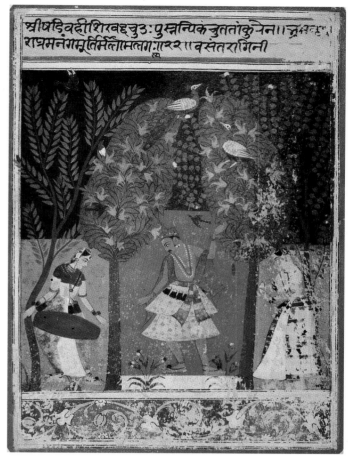

46. **Vasanta Raga**
from a *Ragamala* series
India, Malwa; c. 1660 (23611)

45. **Nata Ragini**
from a *Ragamala* series
India, Rajasthan, Kota, workshop of Sheikh Taju; c. 1750 (23593)

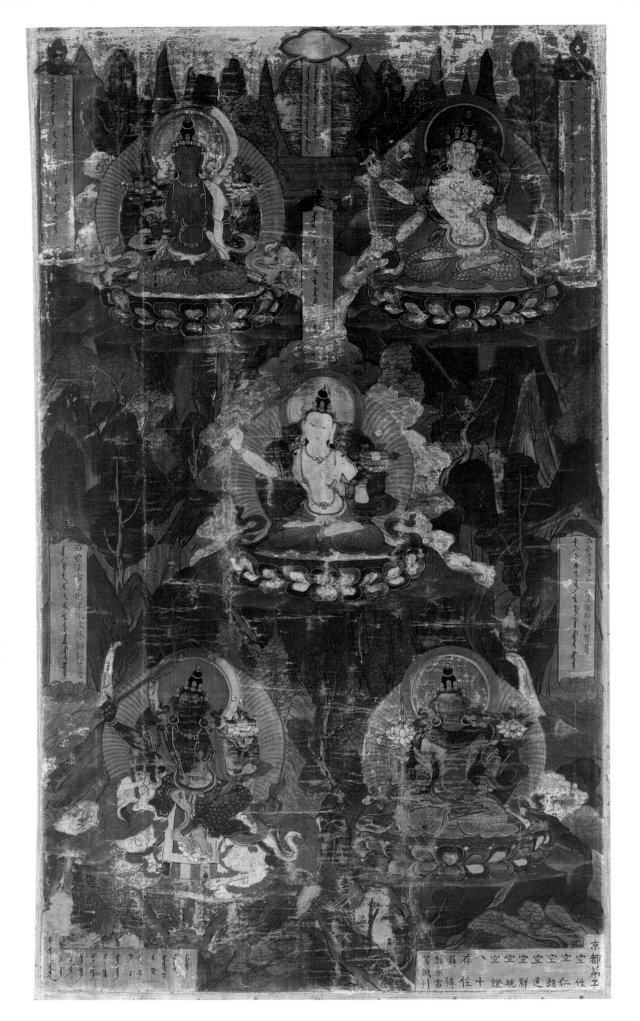

Nature in Tibetan Art

As the reader must realize by now, inheriting the Indian religions and artistic traditions, the Tibetans too used natural forms, such as animals and plants, primarily for their symbolic and secondarily for their decorative significance. Thus, all deities as well as mystics and teachers almost invariably sit or stand on either lotuses or on animals, and hold various flowers, if required, the lotus being the most common. Frequently both deities and teachers in Tibetan art (fig. 63–64, 108–110) hold two lotuses on which their attributes rest. In the early paintings one occasionally encounters a few trees or a mass of crystalline rock formations of variegated hues but landscape is unfamiliar, as the art was primarily figurative.

Exactly when the Tibetans first began to use landscapes in their thankas is yet to be determined, but there is no doubt about the source. Likely, they first became aware of landscape elements as early as the tenth century, when the monk Lume returned from Song China with Chinese paintings of arhats or lohans (early disciples sent out by the Buddha to spread the truth). Most surviving arhat paintings go back only to the fourteenth century and show familiarity with early Ming paintings. By the seventeenth century, however, the Tibetans created a distinct mode of their own which is unmistakably local, even though individual elements were adopted from the Chinese tradition.

This becomes clear if we compare a Chinese Buddhist painting of 1707 (fig. 47) with a slightly earlier thanka executed probably in Central Tibet

(fig. 48). The Chinese painting represents the well-known shrines of Manjushri situated on the five terraces of Mount Wutai Shan, in the province of Shanxi. Whether the forms of the mountains are true or not, their shapes and colouring, as well as the treatment of light, are quite different from what we encounter in the Tibetan tradition. The jagged mountain peaks, dark and ominous, come out of the literati tradition, and light has been manipulated to create a brooding, mysterious atmosphere. Such subdued, subtle colouring would be unacceptable to the Tibetan aesthetic. While Tibetans did adopt particular motifs such as the blue-green rock formations, the gnarled trees, and the cloud patterns from Ming paintings, their interpretations of these motifs are quite different.

The Tibetan artist reveals very little awareness of his own natural environment, for imitating nature was not his primary concern. He had to create a fantasy world of his own, an ideal landscape, like his Rajput counterpart, though with a different artistic vocabulary. For the Tibetan artist, nature is always suffused with clear light where shadows are nonexistent. Flowers and fruits, grazing animals and flying birds, streams of falling water or placid, limpid pools are there not to delight our senses or those of the arhats and divinities but to symbolize the harmony of nature and all its elements. The realm of reality that the Tibetan artist set out to create had to be more evocative and mysterious, and more saturated with spiritual associations than that which is familiar to us. And so there is nothing unnatural about his arhats and his gods being enveloped in clouds even while seated or standing or dancing on the ground. No attempt is made to devise any kind of optical illusion or to provide a sense of time and space, in the ordinary sense. It is a timeless universe which is recreated endlessly in the artist's mind and reflected in the thankas in myriad variations.

47. **Five Forms of Manjushri on Mount Wutai Shan**
China; dated 1707 (26879)

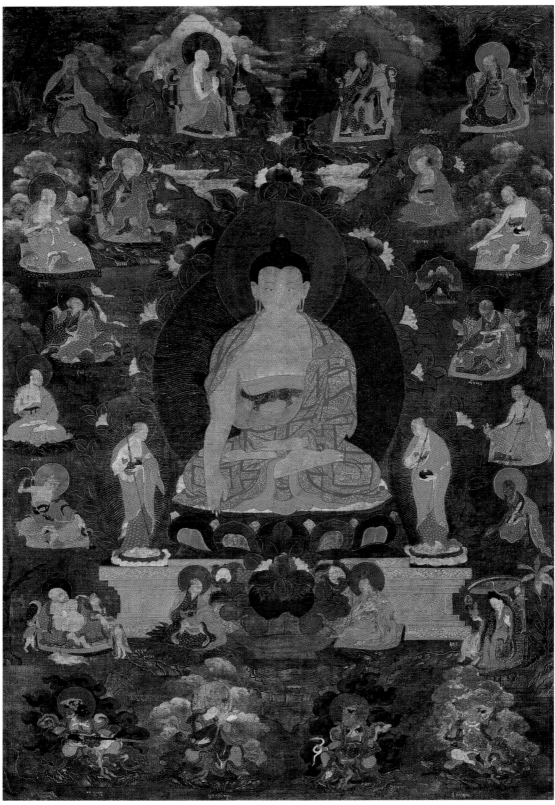

48. **Buddha Shakyamuni with Two Disciples,
Sixteen Arhats, Two Monks, and Four Lokapalas**
Central Tibet; 17th century (26835)

49. **The Fifth Dalai Lama with Scenes from His Life**
Central Tibet; 18th century (26841)

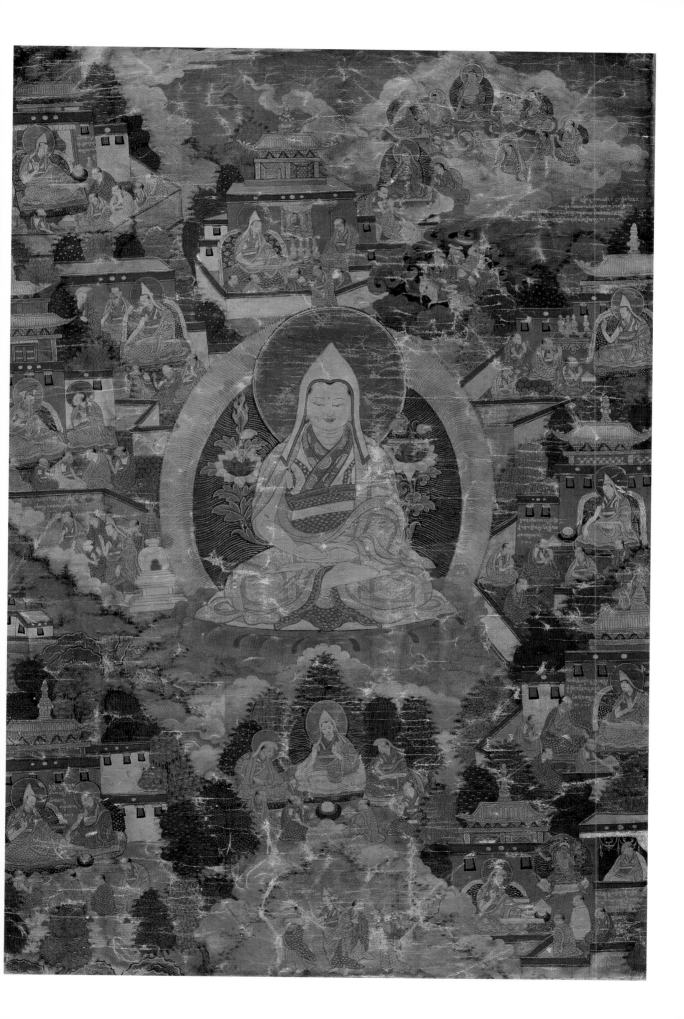

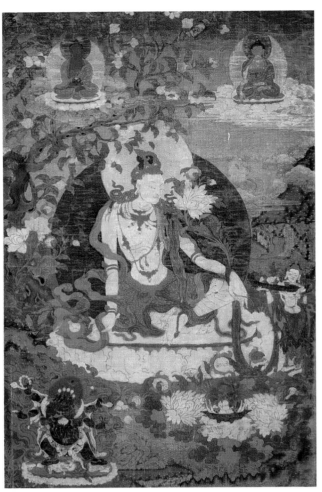

50. **Bodhisattva Avalokiteshvara with Mahakala and Two Buddhas**
Central Tibet, Tashilunpo Monastery; 18th century (26862)

Once the Tibetans discovered the aesthetic possibilities of using natural forms, both decoratively and symbolically, they were like tigers who had tasted human blood. Not only is the landscape used for narrative and biographical themes (fig. 49), but even individual deities are portrayed in imaginary landscapes where the laws of gravity and the tyranny of time do not exist (fig. 50). The floating figures or shrines in this lyrical world create their own reality. So obsessed did the Tibetan artists become with landscape elements that even mandalas (fig. 94) are seen to hover in cosmic space like spacecrafts. Even though there is no direct spatial relationship between the mandalas and the landscape in which they are placed, visually the juxtaposition looks both harmonious and convincing. It should be noted that only in certain types of Tibetan landscape paintings can Chinese aesthetics be recognized in a modified manner. One series that does reflect influences of seventeenth-century Chinese landscape painting as expounded in the theories of Dong Qichang is the well-known Narthang series of 1737 portraying teachers of the Panchen Lama lineage. The National Gallery's example depicts the Indian teacher Bhavaviveka (fig. 51), the founder of a school of Buddhist philosophy known as Madhyamika. Shorn of the supernatural elements, such as the inclusion of Nagarjuna, the originator of Madhyamika philosophy, and Samvara in *yab-yum* above and Mahakala below, the picture would be a perfectly acceptable representation of a scholar seated in an idyllic garden. However, this kind of deft and congruous mingling of realistic passages with surrealistic elements may be characterized as the Tibetan artist's distinctive manner of illustrating through visual means the specifically Buddhist concept of the non-dual nature of reality.

51. **Bhavaviveka, the Indian Teacher**
Central Tibet, Tashilunpo Monastery; 18th century (26865)

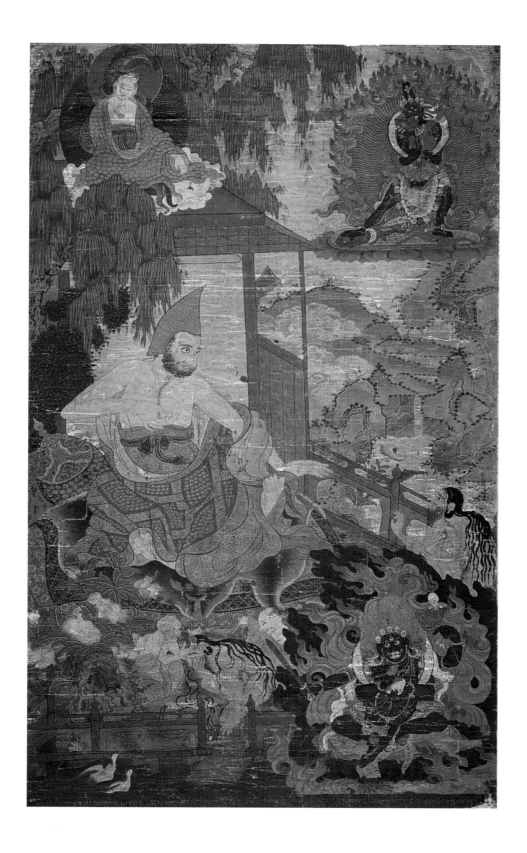

❸ Religious Sculpture

Almost all sculptures in the Tanenbaum Collection are carved in stone or cast in metal. As the stone sculptures are from different regions of the Indian subcontinent, they are of various colour, texture, and hardness. The metal sculptures are from India, as well as Nepal and Tibet, and were cast in the lost wax or *cire perdue* process. Each is thus one of a kind.

While the stone sculptures belonged to temples, the metal images were either ex-voto offerings at shrines or were used in domestic worship. One way to distinguish the two kinds of metal sculptures is by the condition of the surface. A well-rubbed surface, especially the face, indicates use in a domestic shrine, where the image would have been bathed and anointed every day (fig. 4).

In most books on Indian and Himalayan art, the word "bronze" is used almost as a generic term to denote all metal sculptures. The principal content of most bronzes is copper, which is mixed with various elements in differing proportions in different regions. This often gives a distinctively localized surface colour to the bronzes. Bronzes of Nepal and Tamil Nadu have a much higher copper content and often are reddish in colour or develop a rich green patina if buried for a long time in the ground. The artists of Gujarat and Kashmir, on the other hand, preferred brass, while gilding over copper alloy seems to have been especially favoured by

the Tibetans. In fact, by and large, the Buddhists in India, Nepal, and Tibet appear to have been fonder of gilding their images than the Jains and Hindus. Tibetans also liked to use gold paint and pigments for the hair of their deities. Indeed, stone sculptures in all three countries were commonly painted, as may be seen in temples still in use for worship, and in those built in North America today.

The form of a temple sculpture is often determined by its architectural placement and function. A richly figurative arch from an eleventh-century temple (fig. 52) affords some idea of the forms of the fully developed temple and the iconographic complexity of the decorative program. Three small shrines with columns and superstructures are faithful miniature replicas of larger temples. Two have identical superstructures with curvilinear towers of a sort popular across northern India and known generally as a *sikhara*. The arch is adorned here with other architectural forms, such as a prominent horseshoe-shaped motif known as a *gavaksha* or

52. **Arch with Vishnu's Incarnations, Planetary Deities, and Celestials** India, Gujarat; 11th century (23258)

chaitya-window, and with stylized vine motifs on the recessed bands. At the summit is a ribbed cap imitating the form of the fruit *amalaka* (see p. 41). The central shrine has a different superstructure of a stepped pyramidal form. Most temple complexes in the north use variations of these two forms, and the towers are often adorned with figural sculptures of gods and celestials.

Several sculptures in the collection (fig. 58–59, 62) may well have adorned similar subsidiary shrines on the external walls of temples. The three deities represented here are avatars of Vishnu: (from left to right) Vamana, Parasurama, and Rama. The arch also gives the viewer some idea of the rich density of the sculptural program in an Indian temple. Apart from the three shrines, almost every available inch of space is covered with figures competing for attention. The central band contains the eight planetary deities, led by the sun god (see also fig. 59). They include the seven planets corresponding to the seven days of the week and Rahu,

the demon that causes eclipses. Always included in a temple, the planetary deities are revered by followers of all three faiths, in Nepal and Tibet as well. The remaining figures are celestials or angels of both genders: some bring floral offerings and others provide music. At the apex of the arch is a *kirtimukha*, or face of glory motif, which protects the shrine.

One significant difference between the stone and metal images is in the size. The metal sculptures are a great deal smaller. Generally, there is little stylistic difference between a stone or a metal image from a given area. Nor did variations in the materials engender stylistic diversity. However, differences in functions did influence the forms in many instances.

Because stone sculptures were meant mostly for temple walls, they are frequently in the nature of deeply carved reliefs, the figures being attached to their back slabs. Even when the figures have been liberated from their backgrounds (fig. 3, 22, 62), the backs are rarely finished. By comparison,

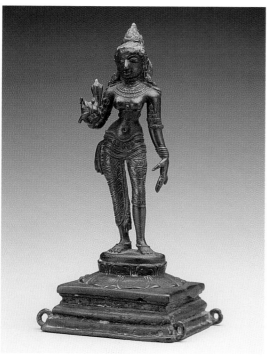

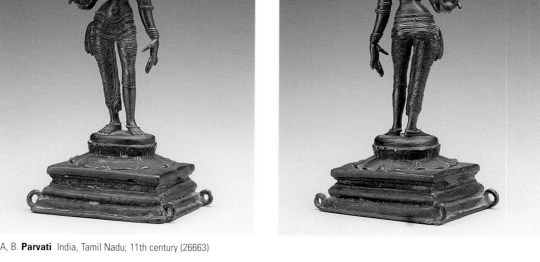

53A, B. **Parvati** India, Tamil Nadu; 11th century (26663)

the bronzes have better finished backs and appear to be objects in the round. However, they were usually wrapped in cloth and their backs were rarely seen as they may be in museum displays. In the case of Jain altarpieces (fig. 16) donative inscriptions were often added to the back. In Tibetan bronzes, inscriptions usually occur around the bottom of the lotus base (fig. 112).

During the Chola period (c. 970–1279 A.D.), the artists in Tamil Nadu created bronzes modelled and finished both in the front and the back. However, they too were clothed, whether taken in procession or at rest in a temple. A diminutive bronze Parvati in the collection provides some idea of the aesthetic sensibility of the Tamil artists of the Chola period (fig. 53A, B). The charming figure stands with naturalistic grace on a lotus base. Fully modelled both in the front and back, it is enriched with deep and articulate incising of the garment.

The earliest sculpture in the collection is a head of a deity (fig. 54) from the Mathura school of

sculpture of the Kushan period (c. 50–250 A.D.), when the city was one of the most important commercial and cultural centres in the subcontinent. It probably also served as a southern capital of the Kushan empire and enjoyed a cosmopolitan atmosphere. Having to cater to various religious communities as well as political and commercial interests, the city became the experimental laboratory for Indian iconography. Mathura sculptures of the Kushan period are characterized by swelling volumes and sturdy limbs, well-articulated features with wide open eyes establishing direct eye contact with the viewer, and a strong physical presence. Not only are the figures represented with heroic proportions and stances, but the sense of physical grandeur is often enhanced by heavy sashes and prominent turbans with large, crestlike medallions in front. Beginning with the second-century B.C. Buddhist monument at Bharhut in Madhya Pradesh and through the Kushan period, most Indian gods wear turbans, which has remained the

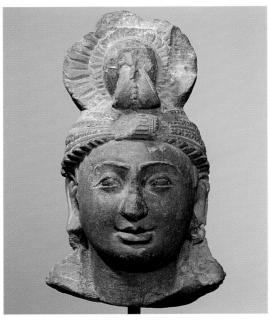

54. **Head of a Bodhisattva**
India, Uttar Pradesh, Mathura; 2nd–3rd century (23233)

55. **Head of Vishnu**
India, Madhya Pradesh; 5th century (23239)

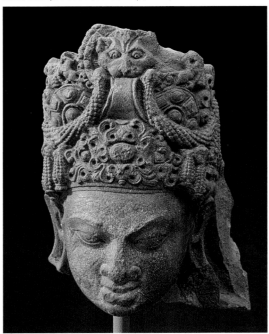

headdress of preference for the common man as well as princes. On ceremonial occasions Indian maharajas still wear their colourful turbans. In the art of Kushan Mathura, a crown or diadem begins to appear occasionally on the head of Indra, the chief of the gods, and Surya, the sun god. By the Gupta period (c. 300–600 A.D.) the turban is abandoned for a crown or tiara for most deities, except those who have ascetic coiffure. The Tanenbaum head could have belonged to a bodhisattva or a Vishnu, the former being more likely.

The transition from a turban to a diadem can be seen on the head of what must once have been a fine Vishnu image from the central region of the subcontinent (fig. 55). The form of the simple turban is now almost lost in the profusion of jewellery, diadem, and garlands that constitute a complex headgear. In addition, the crest is now carved into an expressive lion's face from whose mouth the garlands emerge. The shape and features of the faces are not significantly different in the two heads, but the expression on Vishnu's face is certainly more introspective, though the eyelids are not yet half-closed as they are generally in Gupta period sculptures.

Apart from this sensitive head, the collection includes at least two other sculptures of the Gupta period: a relief showing Kubera, the god of wealth (fig. 56), and a demure lady standing against a circular column rising from a pot (fig. 57). The Kubera is carved from a buff sandstone of the kind popular in the Sarnath region of Uttar Pradesh, while the rust-coloured stone from which the celestial lady is carved points to the Madhya Pradesh as its source.

The figure of Kubera almost certainly once graced a subsidiary shrine, perhaps in a Shaiva temple. Customarily, he is shown as a prosperous man with a rotund belly. Only a modest diadem adorns his head, his luxuriant hair cascading down his

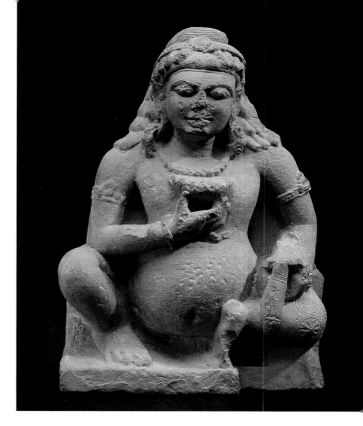

shoulders in sausage-shaped curls, reflecting a popular hairstyle in the Gupta period. The broken object in his left hand may have been a club, and the lotus cup in the other would hold liquor, which he is fond of imbibing. In a later bronze representation from Tibet (fig. 64) the god still has a belly but holds the jewel-bearing mongoose in his left hand and the three jewels of Buddhism in the other.

Shy and elegant, with a well-proportioned, suavely modelled, and simply adorned body, the goddess (fig. 57) is a typical example of the feminine ideal portrayed in the art of the Gupta period. Both poets and artists alike in India were fond of buxom women, as evidenced by this short verse by the poet Bhagura of unknown date:

Your breasts, oh slender maid,
resemble an elephant's cranial lobes
You are as it were, a pool
shaken by the elephant, Youth, who plunges therein.
[Ingalls 1965, p. 170]

Or again, an unknown poet provides a number of analogies from nature to describe the physical charms of a female body:

These [thighs] *are plantain stems;*
this pair [breasts] *an elephant's cranial lobes;*
here is a lily to toy with; and clearly here the
autumnal moon [face].
But what does the world take to be of surpassing
beauty in a graceful woman?
That there is in her something ever subservient
as it were,
and yet, as it were untamed. [Ingalls 1965, p. 171]

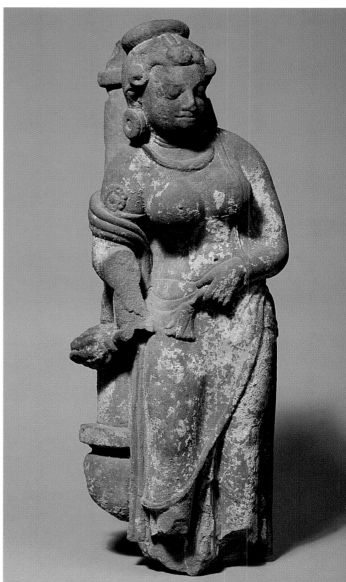

56. Kubera, God of Wealth
India, Uttar Pradesh; 6th century (23234)

57. Celestial Lady with Lotus Blossom
India, Uttar Pradesh; 6th century (23238)

A glance at the later sculptural representations of females, whether mortal or divine (fig. 24, 53, 61), and whether from India or Tibet, will make it clear that they all conform to the same ideals that are extolled in the verses above. Physical charms and sensuous elegance are the *sine qua non* of most female forms even when they are divine figures. As is evident from the charming Chola Parvati (fig. 53) or the goddess Lakshmi in a relief from perhaps Rajasthan (fig. 61), no matter what the stylistic differences, the figures always reveal the same ideal features. Large breasts, narrow waists, and broad hips are imperatives; but otherwise, the relationships of the parts to the whole, the proportions, the facial features, ornamentation, and clothing differ from region to region, and even within a region, from workshop to workshop. Even a cursory comparison of the South Indian Parvati (fig. 53) with the two Tibetan Taras (fig. 24, 63) strongly reveals these regional variations.

Not only do the verses quoted above provide the poet's ideal of feminine form, but texts of artistic theories and techniques generally use similar analogies from nature to describe both genders. These descriptions served as verbal schemata that likely were used universally across the subcontinent. Every limb is described with reference to shapes and forms in nature. Thus, apart from the more common analogies for the thighs, breasts, and face as given in the verses above, the lotus bud, the fawn's eyes, and a certain variety of fish are recommended for the eyes, the sesame flower for a woman's nose, the parrot's beak for that of a man, the conch shell for the neck, and the bull and the lion for a man's shoulders and waist. It may be noted that, except perhaps for the lion, most of these forms were easily accessible to the artists, who could use them to delineate or construct their ideal image.

The exact identification of the Gupta period lady (fig. 57) is difficult, but very likely she represents the goddess Lakshmi. Her broken right hand grasps the handle of a fly whisk and the left holds a water lily. It should be noted that in some Gupta period coins, as the goddess of sovereignty, Lakshmi is seen holding a fly whisk. The manner in which she holds the flower is unusual and clearly here she is sporting it playfully, as is implied by the Sanskrit expression *lilakamala*. With her eyes half shut, she exudes a sense of gentility, as if "there is in her something ever subservient." She may have been part of a stele representing the god Vishnu, although the presence of the column behind her might indicate the use of the piece as an architectural segment, in which case she may well be simply a celestial lady or an indolent female (*alasa-kanya*).

Several sculptures in the collection belong to the post-Gupta period (c. 600–800), when the Gupta aesthetic was still strongly felt and the regional characteristics were not as pronounced. The earliest example is a partially preserved sculpture of Shiva and his spouse Parvati (fig. 8). This kind of formal portrait of the divine couple, usually seated on the bull, was an invention of the Gupta period and became an essential feature of Shaiva temple iconography. One wonders if the work called *Kumarasambhava*, in which the great Sanskrit dramatist and poet Kalidasa (fl. c. 400) rapturously describes the marriage of Shiva and Parvati, did not contribute to the popularization of this theme in Indian art. The intimacy between the two is expressed in several subtle ways in the sculpture. Parvati sits demurely on Shiva's lap and while nervously playing with her fingers places her right elbow on one of his broad shoulders, while one of his left arms embraces her lovingly from the back. Despite Shiva's divine attributes, the representation is essentially human.

A similar humanistic interpretation can be offered for another post-Gupta relief (fig. 34) representing the river goddess Ganga. Except for the mythical *makara* below her feet, there is very little in this relief that announces the divine nature of the lively group. There can be little doubt that the underlying concept is that of a princess walking languorously with a pot to a river – perhaps to perform a rite or to bathe – accompanied by a maid carrying her cosmetic bag and another holding a parasol to provide shade. The male could be an ascetic watching in admiration. While river goddesses begin appearing in Gupta period temples, such elaborate compositions as this were introduced somewhat later.

Whether from central India or Bihar, the sculptures of the post-Gupta period share certain common stylistic features. Irrespective of gender, there seems to be a predilection for thick-set, somewhat stocky, and heavily proportioned figures. Compared with the measured elegance of the postures of the Gupta period figures, the preference now is for curvaceous and opulent forms with exaggerated poses. Ornaments and adornments, however, are still restrained in the Gupta manner, and the principal deities are rarely accompanied by more than two acolytes, as may be seen in two complete sculptures in the collection.

One (fig. 58) is probably from the same region as the river goddess relief and once belonged to a subsidiary shrine in a Shaiva temple. It represents Bhairava, an angry form of Shiva. Only the face and the snake serving as a diadem demonstrate the figure's wrathfulness; otherwise, his well-proportioned body could have belonged to any benign deity. His elegant stance is enhanced by the graceful placement of his lower left hand on his left thigh. With the right he holds a skullcup, as if about to drink. Especially noteworthy are the slender, long fingers of both these hands, as if literally

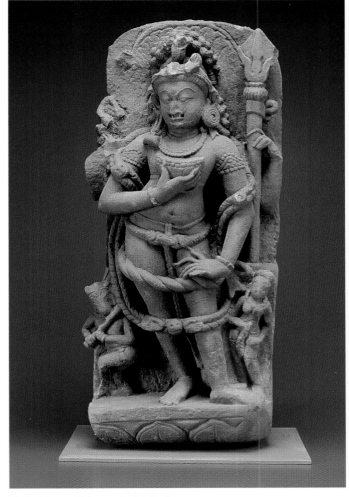

58. **Architectural Fragment with Bhairava**
India, Madhya Pradesh; 8th century (23241)

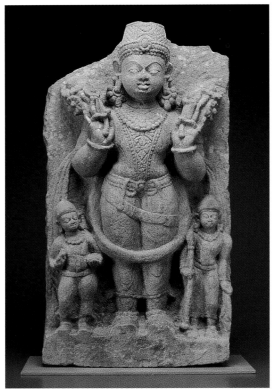

59. Sun God Surya
India, Bihar or Uttar Pradesh; 7th century (23259)

imitating bean-pods, the suggested analogy in nature for fingers. The trident in the upper left hand is rendered prominently, but the attribute in the right hand is broken off. The elegant curls of the hair have now become more luxuriant than in the Gupta period figures (fig. 56), and a simple lotus serves as a halo. The attendant on his left is a female and the other is a celestial musician (*gandharva*) with a horse's head, playing a flute as he dances.

The second sculpture was almost certainly used in a subsidiary shrine, very likely in eastern Uttar Pradesh (fig. 59). The greyish stone is rather coarse grained and the details are not very sharply delineated. Characteristically, the sun god as well as his acolytes are dressed in long tunics, pyjamas, and boots. This mode of dress is common in the northwest of the subcontinent and was probably popularized by the Central Asian peoples, such as Scythians and Kushans, who came to the region around the beginning of the Common Era. As is to be expected, Surya's coat is more elegant than those of his acolytes. He is further distinguished by an ornate crown, while the attendants wear conical hats like Scythian caps. Surya holds two bunches of lotuses with both hands. His plump companion on his right is Pingala, a celestial bookkeeper, who holds a pen and a book; the other is Dandi, the doorkeeper, who appropriately holds a spear.

Roughly contemporaneous to the Surya is a fine bronze sculpture from the northwest of the subcontinent depicting the future Buddha Maitreya as a bodhisattva (fig. 60). From the sixth until the eleventh century, Kashmir and its neighbouring region, the valley of Swat (now in Pakistan), remained important centres of religious and artistic activities. While both Buddhism and Hinduism flourished in the Kashmir valley, Swat appears to have been especially influential in developing and disseminating tantric Buddhist

ideas to Central Asia and Tibet. Apparently, there were important centres of bronze casting in both valleys, but Kashmir was likely the principal source. Both areas supplied bronzes to the Tibetans, without whose zeal for Buddhism little would have been known today about the bronze tradition of Kashmir and Swat. When these areas became Islamicized after the eleventh century, many of the bronze images found refuge in Tibetan monasteries.

Whether cast in Swat or Kashmir, the Tanenbaum Maitreya is an elegant example of the Kashmiri style. Details such as the stylized, artichoke-like petals of the lotus base, the openwork rope motif of the seat, the articulate treatment of the garment and the hands, the swollen, fleshy cheeks, and inlaying with silver and copper are some of the distinctive characteristics of Kashmiri-style bronzes. The subtle plastic qualities of the form are also noteworthy, combining the naturalism of the earlier Gandharan sculpture and the strong linearism of the Gupta style.

By the tenth century Indian sculpture became more elaborate both in iconography and decorative pattern, as may be seen in several examples in the collection (fig. 3, 52, 61–62). Like the temples themselves, the stelae became more ornate and the composition often crowded with numerous figures occupying all available space. In order to accommodate the figures, multiple recessed planes were created, which also imparted additional depth to the relief. Sometimes the back slab was cut away around the central figure (fig. 22, 62) to create a crisper outline of the form as well as to provide visual relief. The postures of both males and females were exaggerated, at times to an unnatural degree, to provide greater contrast to the rigidity of the central figures, except when the deity is involved in a heroic act. Ornamental exuberance became the norm, paralleling a similar development

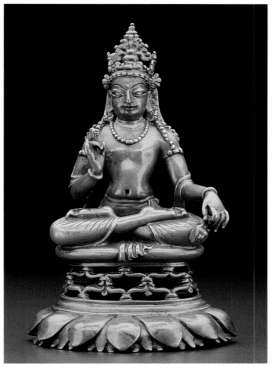

60. **Bodhisattva Maitreya**
India, Kashmir, or Pakistan, Swat; 7th century (26649)

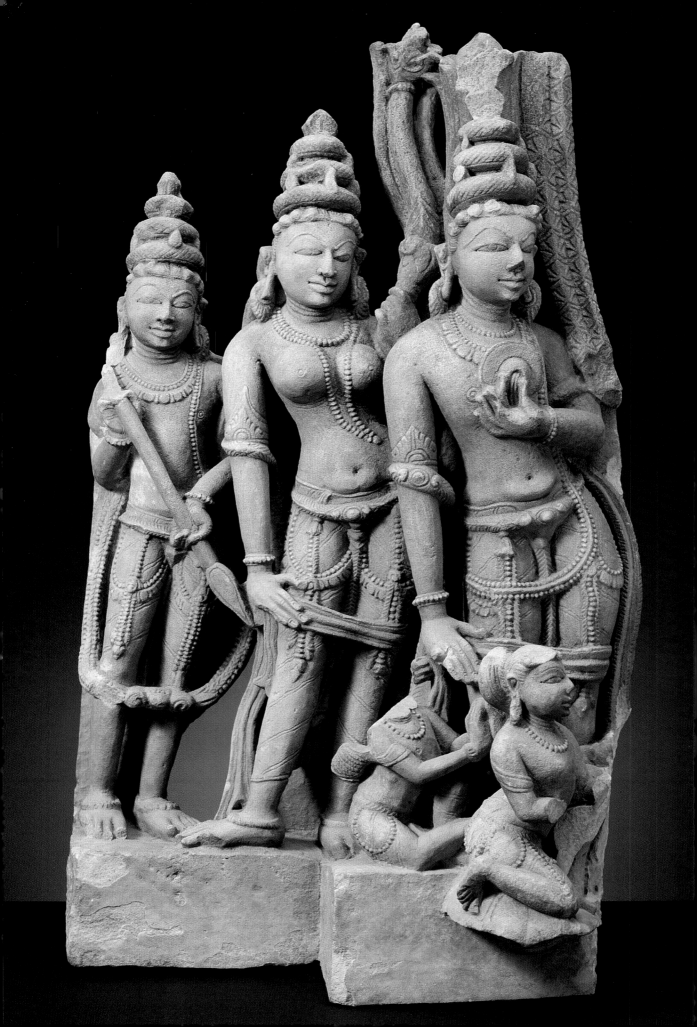

in Sanskrit literature. In both artistic forms the same themes and conventions continued to be used repeatedly and at the risk of being overworked. Fortunately, there were enough talented artists all over the country who rose above the stultifying influences of rigidity and repetitiveness and provided fresh interpretations.

One such artist must have been responsible for the charming but fragmentary sculpture (fig. 61), probably from western Rajasthan. It shows three standing figures, a female between two males, each receding figure a little smaller than the one in front. All three sway to their left, rhythmically, like well-coordinated dancers. The figure in front holds a wheel to his chest, which helps to identify him as Sudarsana (good looking), the personified form of Vishnu's wheel. Thus, the sculpture represents the lower right portion of what must have been an impressive image of Vishnu. The lady must then be identified as the goddess Lakshmi holding the stalk of a lotus plant. The spear bearer, holding the weapon in an unusual manner, is very likely a guardian attendant. The two figures gracefully seated in the foreground are idealized representations of donors.

Generally in most reliefs the figures are shown strictly frontally (fig. 58–59), whether seated or standing. Sometimes, however, a theme required a more dynamic presentation. In one such form, that of Vishnu's Boar avatar (fig. 62), the deity is portrayed as a heroic figure with one leg placed firmly on a lotus on the base and the other on a smaller lotus supported by a pair of *nagas*. Towering over all the others who crowd the stele, Vishnu's body is contorted and twisted to create a dynamic contrast with the quieter, placid figures all around. The

heroic image of the deity is enhanced by the energetic posture and the torso of the body, the careful disposition of the arms – especially the one placed firmly on his right thigh and the upper left bent at shoulder level – and the solid boar's head turned in profile. His cosmic form is further emphasized by the giant stalk and leaf of the lotus which serves as his parasol, and the diminutive figure perched on his left elbow. Although damaged, she represents the personified form of the earth, who subsequently became one of the god's wives.

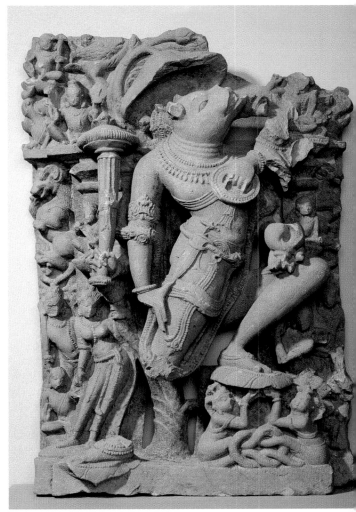

61. Architectural Fragment with Attendants of Vishnu
India, Rajasthan(?); 10th century (23256)

62. Boar Incarnation of Vishnu with Audience
India, Madhya Pradesh; 11th century (23251)

His principal wife, Lakshmi, stands with a prominent swing of her hips beside his right leg. Replete with images of other avatars, attendants, rearing lions, and *makara* heads, this buff sandstone stele epitomizes the style of sculpture that prevailed in Madhya Pradesh at the time, a more familiar example being the wealth of sculptures that adorn the celebrated temples at Khajuraho.

While Hindus and Jains in Central and Western India were busy building temples, in the east, especially in Bihar and Bengal (West Bengal and Bangladesh), Buddhism was enjoying its Indian summer on the subcontinent. This was largely because of the enlightened patronage of many of the rulers of the Pala dynasty (c. 750–1150), many of whom were devout Buddhists. Even those who were not devout encouraged the faith and supported the Buddhist religious establishments. It was a particularly glorious period for the major monasteries, such as Nalanda and Vikramasila, a Pala foundation, in Bihar, and Somapur (Paharpur) in Bangladesh. And, of course, the situation of Bodhgaya, the Buddhist Mecca, helped to make the region attractive to pilgrims from all over the subcontinent and abroad. These visitors then returned to their homelands with souvenirs in the form of portable images, which probably served as visual models for their own artists. The Buddhist art of Pala India was an especially rich source for the art of Tibet and, in a limited way, for Nepal.

Two stone sculptures of the Pala period in the Tanenbaum Collection do indeed portray Buddhist subjects and have already been introduced (see pp. 26–29). Both are probably from the region around Bodhgaya and are carved from the hard black phyllite popular in both Bihar and Bengal. In fact, the colour and nature of the material do indeed distinguish the sculpture of these two states from the Central Indian schools or from

neighbouring Orissa. The material also contributes to the crisp articulation of the decorative details, which appear sharper and more animated than similar features carved in softer sandstone as in Uttar or Madhya Pradesh. When polished, the stone acquires almost a metallic sheen that enhances the texture and tactile quality of the surface.

The stele with the Buddha might well be regarded as the hallmark of Bodhgaya sculptures, as the scene is intimately related to the site. In this classic image of the Buddha's enlightenment the historical is combined with the transcendental and the particular with the universal. The idealized figure of the ascetic is modelled in fluid volumes that only suggest the flesh under transparent robes, a feature inherited by Pala artists from Sarnath sculptures of the Gupta period. Yet, the smooth contours of the body are informed with a vital, spiritual energy, and the introspective mood is enhanced by the eyes looking down at the tip of the nose. The animated rearing lions on the sides and the bottom only accentuate the austere serenity of the Buddha.

In contrast, the stele with the Bodhisattva Avalokiteshvara and two goddesses is made livelier not only by the sinuous and curvaceous forms of the figures but also by the scrolling vegetation along the base. Moreover, the voids around the principal figure define the silhouette more sharply and create the illusion of three dimensional form. The sense of mannered elegance is further conveyed by the somewhat tall and elegant proportions of the figures, which seem to have been infused with the organic rhythm of plants.

Several Tibetan bronzes in the collection belonging to the twelfth–fourteenth centuries reflect strong influences of the Pala tradition. Among these, the Mahasri Tara (fig. 63) and the Jambhala (fig. 64) are especially fine examples. They are from Central Tibet, where the faith was

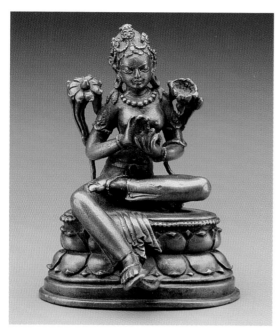

63. **Tara**
Central Tibet(?); 12–13th century (26704)

64. **Jambhala, Buddhist God of Wealth**
Central Tibet; 13th century (26699)

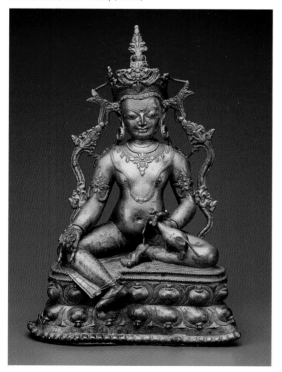

firmly re-established in the eleventh century by the Indian teacher Atisa Tipankara of the Vikramasila monastery. While the influence of Kashmir remained confined largely to Western Tibet, because of Bodhgaya and several famous monasteries Bihar and Bengal remained a primary source for religion and art in Central Tibet until the Indian establishments were destroyed by the Muslims. Neither of the two bronzes, however, is an exact copy, although the Tara has greater affinity with Pala sculpture than the Jambhala. The colour and texture of the metal, the proportions and expressions of the figures, the treatment of the lotus bases and details borrowed from other styles, especially from Nepal, help to distinguish these bronzes as Tibetan. Nevertheless, the close stylistic and iconographic relationship with the Pala tradition remains indisputable. In both, the fluid, curvaceous outlines of the supple, elegant forms, reflecting the rhythmic movement of the flowers attached to their arms, are reminiscent of the stone Avalokiteshvara (fig. 22).

④ Indian Painting

The earliest Indian paintings in the collection consist of illustrations of the sacred books of the Jains known as the *Kalpusutra* (fig. 65). Although these books are made of paper, they use the format of the earlier palm-leaf books. While there is no early example of palm-leaf books in the collection, an idea of their appearance can be gleaned from a fine and complete Orissan manuscript from the nineteenth century (fig. 66).

It is not a typical manuscript, as the text is not written in a linear fashion across each page but in little medallions placed in a decorative setting of foliage, with birds in the margins. However, it does provide a good idea of the shape of each folio, which is long and narrow. The binding is also unusual, as it is held together with strings to fold and unfold like the bellows of a concertina. The more normal mode in early palm-leaf manuscripts was to stack the leaves and tie them loosely with strings going through at two equidistant places. Usually the manuscripts were protected by two wooden boards.

Orissan manuscripts differ from those in the north in the mode of writing as well. While in Bihar, Bengal, and Nepal, from where a great deal of illuminated manuscripts have survived, the text was written in ink with a pen, in Orissa it was first scratched with a stylus and then ink was applied. The pictures too are drawn and coloured in this manner. Orissan manuscripts also differ in the subject matter. The texts they illustrate are almost unique to the region, as indeed is the distinctive style with lively, wiry figures and sharply delineated plants and animals, infused with verve and energy. Both the subject matter and the technique, which results in a highly linear definition of the forms, account for the animated character of these diminutive pictures. Colours are used sparingly and with lesser intensity than in either Jain or Buddhist pictures. These particular illustrations, also accommodated in roundels like the text, are of the avatars of Vishnu and have been discussed elsewhere (see pp. 15–16). Revealing staunch conservatism, Hindus in many parts of the country continued to use palm leaf to write their holy texts well into the nineteenth century, long after paper and even printing had been introduced.

From about the fourteenth century the Jains, especially in Gujarat where the Muslims introduced both paper and bound books, increasingly adopted paper, which was probably cheaper and easier to

65. **Kalaka and the Shahi King** (above); **Kalaka Converts Bricks to Gold** (below)
from a *Kalpasutra* and *Kalakacharyakatha* manuscript
India, Gujarat; 16th century (23582.2)

use. The flourishing merchant class was eager to spend money in acquiring religious merit, and the easy way to do so was to commission books of sacred texts and present them to the monks. Jain religious institutions always contain a library, which is usually a rich repository of books of all kinds. It is also common in the Jain community to have such books read on special occasions during which the picture is upheld as a visual supplement.

Even after adopting paper, the Jains remained attached to the palm-leaf format. The folios retained their rectangular shape and horizontal orientation, but because of greater width the illustrations are generally larger than those on earlier palm-leaf folios. Probably because of the thinness and fragility of paper, the strings and their holes were abandoned and the folios simply stacked between two boards, usually wrapped in cloth. However, memories of the string holes continued to linger sometimes in red dots or in decorative designs, as in the pages illustrated here (fig. 65).

Not only does the diamond motif occur in the centre of each page but it is repeated in the outer margins. Both the form of the script and the mode of writing differ radically from Orissan manuscripts. On these pages the writing is done mostly in black and red in eight lines in the conventional method, but other colours are also used.

The three illustrations in these pages are on one side, clearly separated with a red border. Two of the pictures have been described elsewhere and here only the illustration from the *Kalakacharyakatha*, or the story of Kalakacharya, will be identified. This tale of the celebrated teacher Kalaka's rescue of his sister, who was a nun and had been abducted by a king called Gardhabhilla, has acquired more than didactic importance among the Shvetambara Jains and is frequently appended to the *Kalpasutra*. In the picture reproduced here Kalaka confers with the Shahi ruler of Ujjaini to seek his help, and then in the bottom register miraculously converts earthen bricks into golden ones to pay for the

Shahi's troops and the forthcoming battle.

While the portrayal of two separate episodes in a single composition is not uncommon, usually each frame contains one incident, as may be seen in the other miniatures (fig. 18, 35). The figure of the Shahi King was derived from an Islamic source, but otherwise these paintings show little Islamic influence. The colouring is limited mostly to blue, white, yellow, green, and red, the last being the preferred hue for the background. In this instance, the blue appears to be lapis lazuli, which, together with the use of gold in the decorative pendants in the margins, indicates that the book was commissioned by an affluent person. The postures and gestures are usually stereotyped and rigid, except in scenes set in the dance and archery context (fig. 35), where the two figures seem to be involved in a lively pas de deux. Not only do the richly patterned dresses imbue the pictures with a sense of opulence but they are an important source for the history of Indian textiles, for which Gujarat was an important centre. A cliché of the figural forms in Jain pictures is the incongruous manner of showing the further eye fully extended beyond the outline of the face when the figures are presented in profile, except the divine messenger Harinaigamesha (fig. 18), other animals, and the Shahi and his followers. They are always shown in full-face view with both eyes looking in the same direction, usually to their left.

In a mid-sixteenth-century picture from the tenth book of the Hindu *Bhagavatapurana*, a text that extols the life of Krishna (fig. 39), we encounter a style of painting that still has some resonances with Jain pictures but also shows some significant differences. The horizontal orientation and the unbound nature of the book remain unaltered, but the picture is now freed from the text, which has been placed on the back, making the composition much larger. The composition is still

66. **Manuscript with Vaishnava Text** (see also fig. 5)
India, Orissa; 19th century (23641)

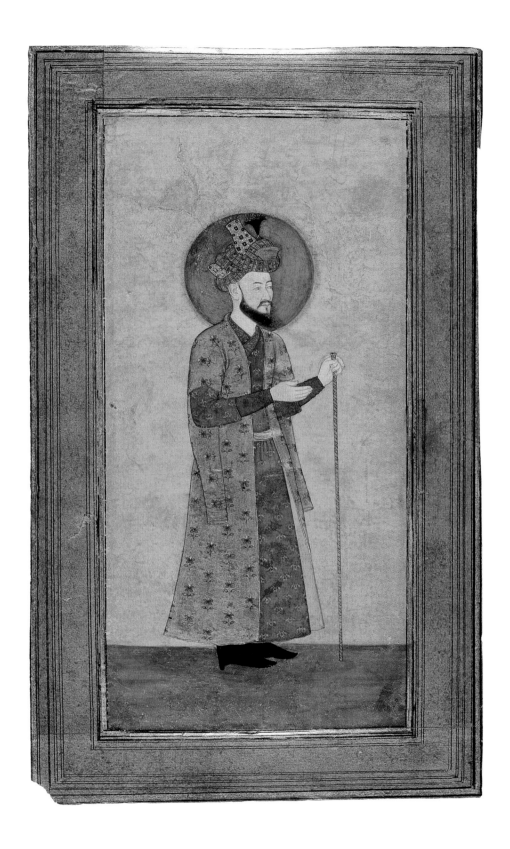

divided into two horizontal registers, though not as rigidly, and an attempt has been made to create a sense of space, if not depth, by incorporating architectural forms, furniture, a tree, and patches of different background colours. The figures, however, are represented in a single plane and there is a summary effort to depict a sky. Clearly the style has adopted and modified elements from both the earlier Jain tradition and the illustrated books of the Muslim patrons. The most important is the separation of text and picture, which is what the young emperor Akbar's artists would do on a much larger scale with the famous *Hamzanama* book, a decade or so later.

The third member of the Mughal dynasty, Akbar (r. 1556–1605), was not only the greatest Mughal but one of the most brilliant monarchs that the subcontinent has produced. The dynasty was founded by Babur, who came from Central Asia and had Mongol (whence Mughal) blood in him. Even though a ruthless military general, Babur was a sensitive and literate man whose memoir, the *Baburnama* (see fig. 40), is one of the finest works in that genre. Babur's son Humayun was also a cultured man of refined taste who was extremely fond of books. In fact, he fell and died in his library. The collection includes a fine full-length portrait of Humayun (fig. 67) of about the mid-seventeenth century, when Shah Jahan (1628–1658) was the emperor. Dressed in Central Asian attire and turban, Humayun looks more like a Turkish prince than an Indian. Indeed, upon losing his throne to the Afghan Sher Shah in 1540, he left for Persia with few men and resources. On the way Akbar was born in the deserts of Sind. While in Persia, thanks to the generosity of Shah

Tahmasp, Humayun not only gathered sufficient men and supplies to enable him to regain his lost patrimony in India, but he was much impressed with Persian court culture. Books and libraries interested him particularly and besides bringing back books, he also invited two Persian masters, Mir Sayyid Ali and Abd as-Samad, to join him in India.

Humayun died in 1556, soon after regaining his throne, and the crown was passed on to the young Akbar who was only fourteen. By the time of Akbar's death in 1605, the small kingdom he had inherited had been expanded to include almost all of the subcontinent, excluding the far south but including much of present-day Afghanistan. While the world has known many great rulers who can match or exceed Akbar's military and administrative achievements, and while others may have welded disparate kingdoms into an empire if not a nation-state as astutely as Akbar succeeded in doing, few could at the same time claim to have inspired an entirely new tradition of painting as Akbar did.

A semi-literate man, he had an indomitable urge to learn, and like his father nourished a passionate love of books. He was quick to take advantage of the presence of the two Persian masters, and even in the unsettled condition of the state, commissioned several illustrated manuscripts, the most ambitious of which was the *Hamzanama* text. In order to meet the demand, a large number of native artists were recruited to work under the Persian masters. These artists had been used to painting Jain and Hindu religious texts or books for Muslim patrons in a hybrid mixture of the Indian and Persian traditions, and palace murals, whose styles did not differ from the book illustrations. And yet what we see in the early Mughal pictures is a completely new style, more painterly than anything created to date, and with a new vision and fresh vigour that reflect a new way of

67. **King Humayun**
India, Imperial Mughal; c. 1650 (23561)

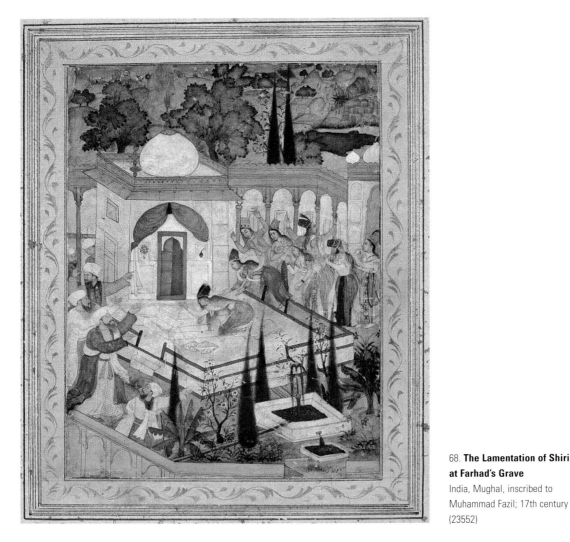

68. **The Lamentation of Shirin at Farhad's Grave**
India, Mughal, inscribed to Muhammad Fazil; 17th century (23552)

looking at pictures. The man whose aesthetic sensibility and vision made this pictorial revolution possible was Akbar himself.

It was Akbar's curiosity about other religions and cultural traditions that made him take note of whatever European works of art that came his way, probably in his early years. These were passed on to the imperial workshop, where the pictures and prints were studied and copied, even by accomplished artists, knowing their master's taste for the exotic. A comparison of any Mughal picture of the Akbar period, such as the *Baburnama* (fig. 40),

the *Ramayana* (fig. 38), or Shirin's lamentation (fig. 41, 68), with the mid-sixteenth-century *Bhagavatapurana* illustration (fig. 39) will demonstrate how dramatically the direction of Indian painting changed due largely to the curiosity of a single patron. The change occurred not only in technical matters such as perspective rendering of space, integration of landscape elements, and more observed rendering of nature, more pictorial compositions, and the introduction of portraiture, but it also encouraged a new attitude towards painting, especially in the court and among the elite. While

illustrated books were produced for Muslim as well as Hindu and Jain patrons prior to the arrival of the Mughals, there is little information about the close interaction between artists and patrons, who appear to have been satisfied with the current styles. Both Akbar and his son Jahangir (r. 1605–1627) took a keen interest in the artists and their personal styles. They were connoisseurs, and their strong ideas and tastes contributed significantly to the distinctive character of Mughal style. Jahangir (fig. 69) is characteristically shown in a portrait with two attendants examining a gem, probably a ruby. Both he and his son Shah Jahan prided themselves on their ability to judge gemstones, a fact often recorded in flattering royal portraits.

Apart from producing illustrated books on history, Persian poems and epics, fables and romances, Akbar's studio, known as the *Kitabkhana*, also produced a large quantity of portraits (see chapter 6). Indeed, this kind of avid interest in portraiture and histories – of the past as well as of their own reigns – was a novelty in the Indian tradition. No patrons before them, either Hindu, Muslim, or Jain, had evinced any interest in the past or in contemporary events and personalities. Only from the Mughal period does Indian painting provide us with a rich resource to appreciate the secular life and mores of Indian society, both Hindu and Muslim. While an illustration such as that from the *Baburnama* (fig. 40) gives us a fairly true picture of labourers engaged in constructing a garden, it is during the reign of Jahangir that independent genre paintings began to be produced, to be mounted and assembled in albums *(maraqqa)*.

These lavishly produced albums contained genre pictures and portraits, as well as specimens of calligraphy that were highly prized by Muslim patrons. Often the calligraphies were by Persian masters who were not necessarily contemporaries. In fact, Muslim bibliophiles may well be considered

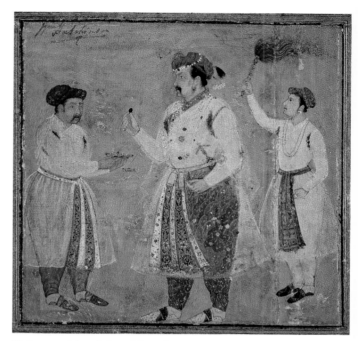

69. **Emperor Jahangir Examining a Gem**
India, Imperial Mughal; 1625–50 (23558)

to have instilled the passion for collecting objects from the past among the Indians. There are several fine examples of such calligraphic specimens (known as *wasli* or *qit'a*) in the Tanenbaum Collection, two of which are illustrated here (fig. 42, 70). As is the case with such Islamic calligraphic works, great care is taken not only to write the words beautifully but also to embellish the environment with vegetal and cloud patterns, delicately drawn and subtly coloured and enriched with gold. Often also the mounts in such imperial albums contain extraordinary examples of animal studies, or vignettes of highly perceptive and detailed human portraits, or copies of European subjects against a background of delicate arabesques of floral patterns.

Following their imperial overlords, the Rajput rulers of the realm also became interested in painting, retaining artists at the courts. The Rajput states

Although artists could not have been eyewitnesses to the goings-on in the closed apartments of the women in Mughal and Rajput palaces, their representations of gender-related subjects do not indicate unfamiliarity. Several pictures in the collection, especially of the eighteenth century, provide us with both the physical activities and mental diversions of the women, who generally led a secluded life confined to quarters where only the ruler and their close male relatives were permitted access. Although very few are known, female artists could have rendered some of these studies of life in the harem, while selected male artists could have gained access on special occasions, or they could have drawn imaginary pictures based on detailed descriptions.

By serendipity rather than design, a number of pictures in the collection provide us with vivid glimpses of life in the *zenana*, as the woman's world is called. In an Akbar period Mughal picture (fig. 71) two women embrace while others watch. Originally perhaps a part of a manuscript, it later found its way into an album belonging to the rulers of Oudh, whose seals are stamped on the mount. The pictorial composition, the expression of emotion, and the heavy shading of the figures are characteristic of Mughal innovations.

While this may be an generalized and imaginary picture of a meeting, or reconstruction of a harem, the Mughal concern for emotional acuity and the bustle of a busy occasion is graphically depicted. One cannot presume that a male artist was anywhere near the *zenana* while a mother nursed an infant (fig. 72), or accompanied a princess on her visit to a holy man at night (fig. 44), but both have

70. Calligraphy by Mahmud ibn Ishaq al-Shinabi of a Persian Poem (verso of fig. 68)
Persia; 16th century (23552)

were scattered widely over Rajasthan, the contiguous regions of Gujarat, Madhya Pradesh, and Uttar Pradesh, and in the Himalayan foothills (in today's Jammu and Kashmir and Himachal Pradesh). The interest, however, was not equally sustained in all the states at all times but varied according to the personal predilection of individual rulers. While the Mughal influence introduced certain genres related to the heroic and courtly life and portraiture, by and large the Rajputs continued to be attached to religious themes. However, in Hindu society the borderline between the sacred and the secular has always remained unfenced, and the two intermingle in Rajput pictures as well.

71. Gathering of Women on a Terrace
India, Imperial Mughal; late 16th century (23269)

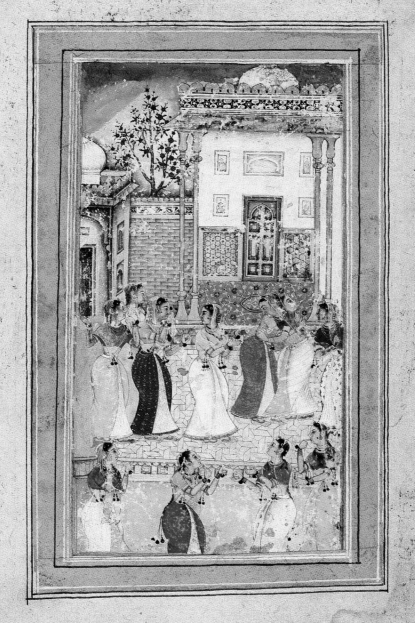

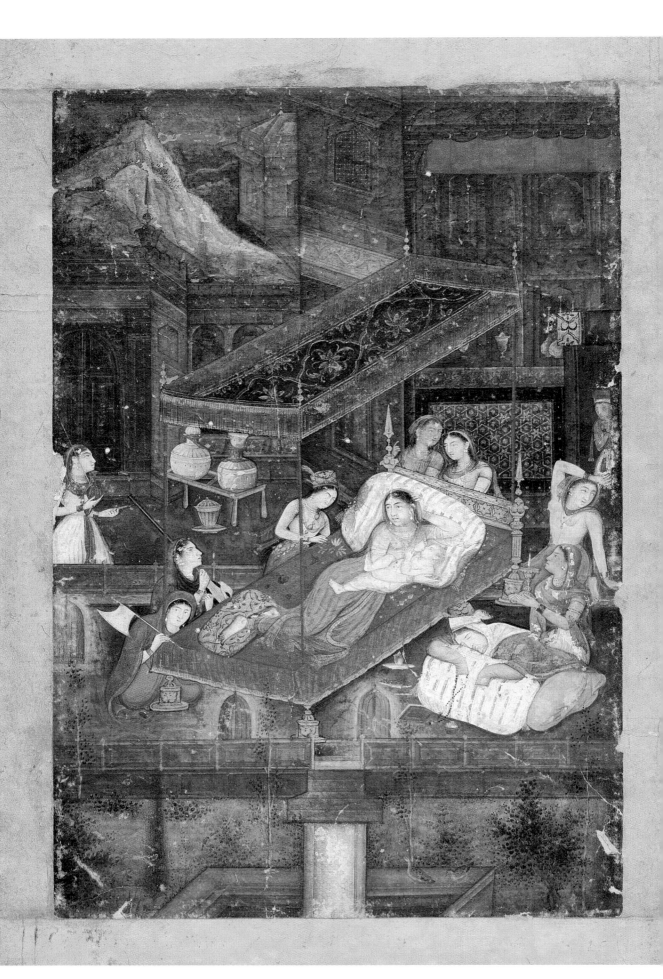

the appearance of observed scenes. The first is a rather rare subject but the second became popular from the period of Shah Jahan, even though royal visits to holy men and shrines began much earlier, in the reign of Akbar. The lamentation of Shirin at the tomb of her lover (fig. 68), although a fictional subject, is yet another fine example of a Mughal picture that recreates the realistic mood and immediacy of a particular occasion.

An eighteenth-century picture painted in the Mughal style is a rare but well-observed depiction of a Hindu bridal scene (fig. 73). While the bride, wearing a fine yellow sari, stands on a stool and looks into a mirror, a number of other women form a circle around her, either as attendants or simply as spectators. A solitary, elderly, turbaned male, perhaps a gardener, holds a flowering vase, as if offering it to a deity. The bride is a princess, judging by the regal trappings carried by the two attendants immediately behind her. Thus, there is an "iconic" element in the composition which also indicates a Hindu patron, although the figures are all drawn in the Mughal style. Not only is this a rare genre picture, but the various utensils and offerings placed on the platform make it an interesting example of a still-life as well. Finally, the picture is unusual in that it shows an interesting admixture of styles. The figures in the foreground, especially the male, seem clearly to have been lifted from an early Mughal painting.

Pictures showing court women engaged in various sports and pastimes were popular with both Mughal and Rajput artists. In a Bundi painting (fig. 74) a lady amuses herself with cavorting pigeons as she prepares for a tryst. One maid is busy attaching ornaments to her right foot, another offers her a glass of wine. A third stands before her waiting for her mistress's command. The mood here is clearly of anticipation, for the lady has a smiling face. In a second picture of the

72. **Nursing Woman with Attendants on a Palace Terrace**
India, Imperial Mughal; 1625 or earlier (23560)

74. **Entertainment with Pigeons**
India, Rajasthan, Bundi-Kota; 1725–50 (23592)

73. **A Hindu Bridal Scene**
India, later Mughal; c. 1725 (23570)

same school (fig. 75) a lady standing on a carpet and supporting herself on a fan hanging from a tree is offering what seems to be a string of pearls to a crouching female. Interestingly, two male musicians are included in the scene, and one wonders if the female receiving the ornament isn't being rewarded for her singing. In comparison, perhaps a yogini or a princess in the guise of one sits directly below the tree, and a young lady with lotus buds and protected by an old nurse approaches from behind the musicians. Some cups and bottles on a tray and a small dog placed before the heroine impart a votive character to the scene.

Although mansions and palaces were large, generally the living quarters for the females were inadequate, with rather small rooms that tended to be hot and humid. A great deal of time was spent in open courtyards well shaded by large trees, and in enclosed gardens and terraces with small but elegant pavilions. A terrace was the desired venue to enjoy the cooling breeze that usually wafted over a body of water such as a river or a man-made lake before reaching the apartments. Indeed, most Rajput palaces in the plains were built beside an enormous lake which not only kept the settlement cool but was the principal source of water as well.

In a lively picture from the desert state of Jodhpur (fig. 76) we are given a glimpse of a princess swinging in the late afternoon as the monsoon clouds roll in menacingly. From the attitude of the attendants and some of the attributes the festive nature of the occasion is evident. The swinging lady is probably aware that her lord is watching her from an upper window of the mansion. The picture is also of interest as it provides us

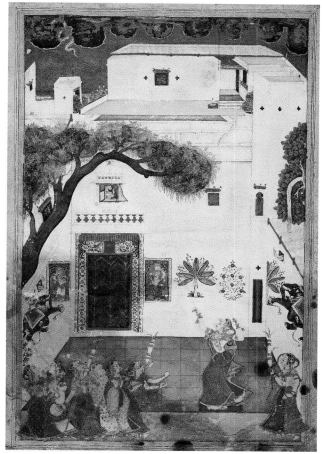

76. **Ladies Celebrating in a Courtyard**
India, Rajasthan, Jodhpur; 18th century (23602)

75. **Ladies on a Terrace with Two Male Musicians**
India, Rajasthan, Bundi-Kota; 1725–50 (23591)

with glimpses of the murals that adorn the walls.

In a richly detailed picture from the Deccan (fig. 77) two ladies sit on a couch on a terrace covered with beautiful floral tiles. In the foreground is a rectangular lotus pool, and behind the terrace are banana plants, a flowering tree, a coconut palm, and a fruit-laden mango tree onto whose branches two parrots, symbols of conjugal bliss, are about to descend. The two-storied pavilion has wide arches filled with glass bottles and ceramic jars, which was a common mode of decoration in wealthy mansions. The two ladies are diverting themselves by listening to music and drinking, but their attitude reflects unrequited love. In an early eighteenth-century Mughal picture (fig. 78) the location is also a terrace and a woman provides the music, but the mood of the picture is so different. A young prince is unsteadily proceeding to a pavilion to continue to indulge in the pleasures of the night. He may well be slightly intoxicated, as he is being helped by one woman while leading another. Unlike today, women provided much of the music, especially in the *zenana*.

Despite Mughal influences, Rajput patrons were generally more conservative and preferred that their pictures depict an ideal rather than the real world. Thus, even if historical accounts of their reigns were written, they were not illustrated, and only select themes related mostly to festivals and courtly activities, and formal portraits, were commissioned. Sometimes an artist may have chosen a subject to his own liking as a gift (*nazarana*) to his ruler on a birthday or new year's day, but even these are not remarkable for thematic originality, except when the patron was a true connoisseur.

One subject that was especially popular with the Rajput courts of the Mewar and Bundi-Kota schools is the hunt. For a Rajput, hunting was not only a favourite pastime but a ritual act associated with cosmic power embodied in the Great Hindu

78. **Prince with Two Ladies and a Female Musician**
India, later Mughal; c. 1725 (23566)

77. **Ladies Being Entertained on a Terrace**
India, Deccan, Shorapur(?); 18th century (23576)

79. A Raja Hunting Boars
India, Rajasthan, Kota; 18th century (23594)

80. **Lady with a Crane beside a Pool and a Man Hunting Antelope** India, Rajasthan, Ajmer(?); c. 1750 (23604)

Goddess Durga (fig. 14). But while Mughal pictures of the hunt are characterized by meticulously observed details and palpable excitement and dramatic flair, the Rajput paintings, even when of a specific hunt, have an aura of detachment and serenity about them which makes the representations more romantic. A bold but simple (usually Kota hunting pictures have a great deal of vegetation and rocky landscape) Kota hunting scene (fig. 79) is about as realistic as such pictures get. It may not represent a particular hunt, but it certainly captures the energy of the chase with conviction. Most of the tension, however, is conveyed by the animals, while the hunters appear almost dispassionate, as if they are engaged in a ritual act, like

Durga killing the buffalo.

Compared to the straightforward composition of the Kota boar hunt, the deer hunt from an unidentified Rajput atelier is much more intriguing (fig. 80), both visually and iconographically. Not only do we see a complete disregard for realistic elements, but there seems to be no interaction among the figures. In the foreground is a lotus tank with a frolicking elephant and a floating toy boat, as three women watch impassively from a pavilion. On the far side of the tank a lady languidly turns her head to her left while she feeds a crane. If she has been startled by the gunshot, her face betrays no emotion. His face equally expressionless, the prince stands with his smoking gun

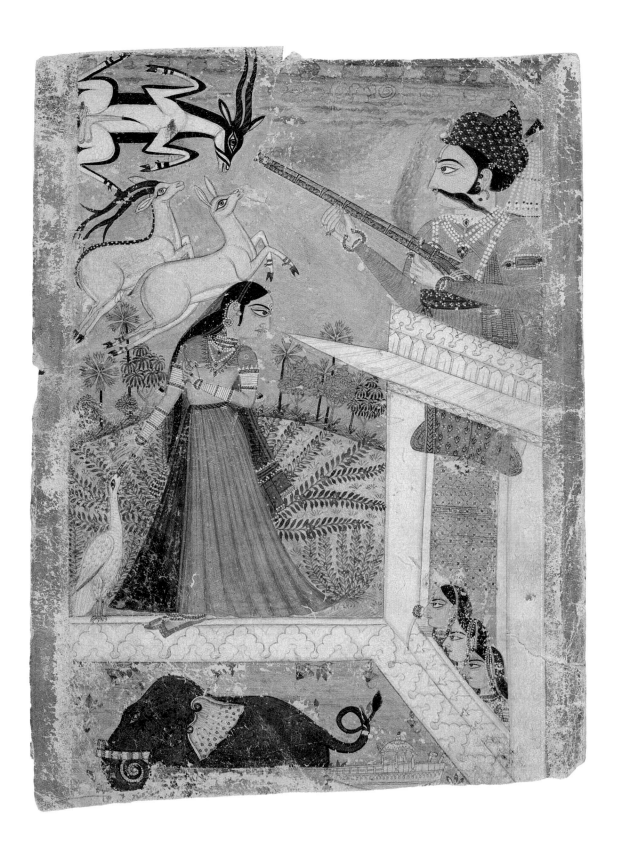

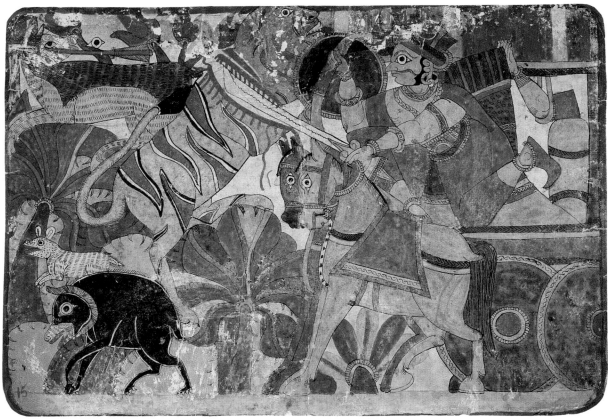

81. **Warrior Killing a Tiger,** from a *Mahabharata* series India, Andhra Pradesh or Maharashtra; 19th century (23617)

on the roof of the pavilion. He has shot the black buck in the chest, and the animal is on his back with his erect penis ejaculating as he expires. A pair of deer leap across the landscape to escape the hunter's shot. Indeed, the rendering of space as well as topographical elements, and the placement of the figures, has no relation to optical veracity at all and makes the picture almost surrealistic.

A third depiction of a hunt in the collection is neither in the Rajput nor in the Mughal style but belongs to a large series of pictures that were used by storytellers to illustrate their narratives (fig. 81). The series is known by the name of Paithan, the town in Maharashtra where the pictures were discovered. Stylistically, however,

they are related to other similar folk paintings and puppets used by bards extensively across the Deccan. The style is characterized by vigorous and bold images of strident but vibrant colours that fill the entire surface of each composition. Although most fauna are rendered conceptually, they are highly energized, while the flora are usually presented as imaginative designs. Altogether, the Paithan pictures are animated patterns of form and colour that delight us with their whimsy and surprise us with the unexpected.

Apart from hunting, which satisfied their heroic urge, Rajput princes were fond of literature and music. They commissioned books of both religious and secular subjects, a large number of which

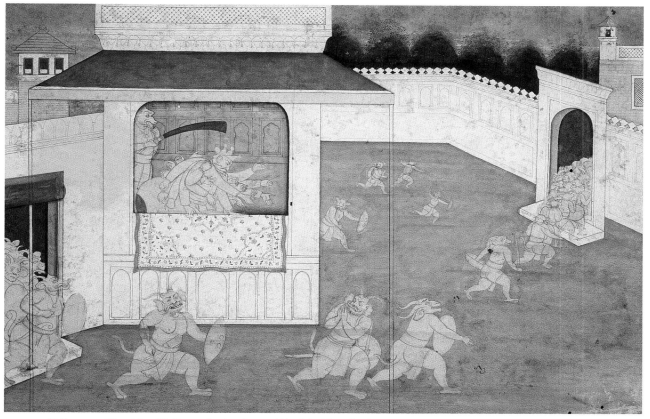

82. **Banasura Dispatches His Demon Armies,** from an *Usha-Aniruddha* series India, Himachal Pradesh, Guler; late 18th century (23628)

were illustrated. Even if a prince was not particularly interested in art but preferred poetry or music, he would commission relevant books and pictures from artists in his employ. Besides, like the astrologer, the pundit, and the musician, an artist was also a status symbol for a court.

The Rajputs do not seem to have shared the Mughal's interest in history. Rather, they continued to commission illustrated copies of religious texts concerning Krishna, the cowherd god of Mathura and Vrindavan. The two most favourite were the tenth book of the *Bhagavatapurana*, which narrates in great detail the legendary life of Krishna, and the *Gitagovinda*, a lyrical erotic poem about the love of Radha and Krishna composed in

the thirteenth century by Jayadeva. Even the great epics *Ramayana* and *Mahabharata* were not as popular as these two books. However, certain episodes from the epics, such as the story of Nala and Damayanti, proved to be popular in certain areas and specific literary compositions about them were illustrated. One Pahari picture in the collection (fig. 82) is from a series involving Banasura, a multi-armed titan who was a great devotee of Shiva. In what appears to be an unfinished picture, Banasura is seen urging his animal-headed followers to go to war. From the second half of the eighteenth century the artists in the hill states became particularly fond of rendering mythological subjects in a realistic style (see also fig. 6).

Most of the Rajput pictures in the collection depict poems related to love or musical themes where romance predominates. The text of this romantic literature was written in the Hindi language and many of the poets were patronized by the princes. Indeed, the adoption of this vernacular language rather than the courtly Sanskrit contributed largely to the sweeping popularity of the Vaishnava religion, and especially the intensely devotional cults of Rama and Krishna. The Vaishnava saints of northern India seem to have taken a leaf from the Tamil saints of south India who had popularized both the Shaiva and Vaishnava faiths by singing the praise of the deities in Tamil and other local languages rather than Sanskrit. This made the hymns and the stories much more accessible to the broader public who knew no Sanskrit.

While the artists did produce individual works of art showing romantic situations on a purely mundane level, what was of greater interest was to depict the idealized love between the divine Krishna and Radha. They were portrayed as archetypal hero and heroine, and their love came to be regarded as a metaphor of the relationship between the human soul (*jivatma*) and the universal soul (*paramatma*). The erotic flavour (*sringararasa*) of the picture depended very much on the literary source used by the artist. If the burden of the poem, as is the case with Jayadeva's *Gitagovinda*, required sexual explicitness, then that's what the artist depicted. But, by and large, most poems and pictures are concerned with moods and emotional states rather than overt sexuality.

One of the earliest works in Sanskrit devoted to the theme of love is the *Amarusataka* (Amaru's Centum of Verses). Almost nothing is known about the poet or his date but very likely he lived before the eighth century. The work remained popular down to the seventeenth century when an album of pictures illustrating the verses was prepared in the Malwa region, probably at the court of Orcha. The two folios in the collection are from the second part of the book which deals with love in separation (*vipralambha*), the first part being devoted to love in union (*sambhoga*), the two broad divisions of the theme in Indian poetic tradition. It should be noted that the *Amarusataka* is also interpreted as a poem whose underlying message concerns yogic union of the human and the divine.

The verse on top of the folio illustrated here (fig. 83) describes the situation as follows:

When the lover had returned, she passed the day with difficulty filling her mind with hundreds of daydreams; and then entering the pleasure house, she saw that her obtuse attendants lacking all sagacity carried on a long conversation; the slender-bodied one, whose heart grew impatient for enjoyment of love, cried out, "Oh, something has bitten me!" and hurriedly tossing her silken scarf extinguished the lamp. [Devdhar 1984 (1959), p. 102]

Curiously, the iconography of the picture seems to bear little relation to the contents of the verse. No companions are shown prolonging the heroine's agony and certainly no lamp is being blown out. Instead, two men are engaged in a conversation outside, while the lovers seem to exchange pleasantries inside the pleasure house.

A second Sanskrit work about the mystical and metaphorical interpretation of human love which proved to be popular with seventeenth-century patrons, especially in the hills, was the *Rasamanjari* (Spray of Flavour) by the poet

83. **A Man and a Woman Converse inside a Pavilion**
from an *Amarusataka* manuscript
India, Malwa; c. 1660 (23612)

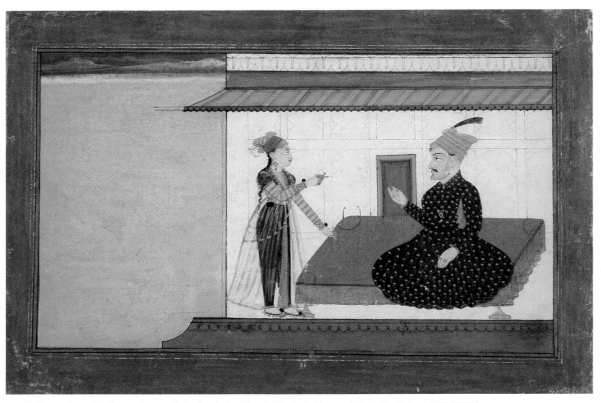

84. **Uttama Nayaka,** from a *Rasamanjari* series India, Himachal Pradesh, Nurpur, attributed to Golu; c. 1710 (23625)

Bhanudatta who lived in the fifteenth century. The Tanenbaum Collection includes a folio from a series painted in the state of Nurpur early in the eighteenth century (fig. 84). The text on the back identifies the scene as *uttama nayaka*, or the excellent hero. The verses however, do not match the published versions of the *Rasamanjari* text. In any event, typical of this series, the composition is spare with a simple pavilion in which the male is seated on a large red bed against a white wall perforated by a disproportionate door. The outside is painted in a flat, saturated greenish-yellow with a narrow grey-and-white strip of sky above. The male in this series is said to have been modelled on the Nurpur ruler Dayadhata, and one wonders if the queen was the model for the heroine. Characteristic of early Pahari pictures, she is petite but strong willed.

The most popular work of this genre was the *Rasikapriya* (Connoisseur's Beloved) by Keshavdas (c. 1554–c. 1600), a court poet at Orcha in Madhya Pradesh. The book was completed in 1594 and dedicated to Prince Indrajit. The dedicatory copy has not survived, nor do we know if it was illustrated. If so, likely the pictures looked very similar to two *Rasikapriya* illustrations from a large series produced in 1634 somewhere in the region (fig. 36, 85). In both illustrations the verses describe the symptoms of madness displayed by the hero, in this case Krishna, because of lovesickness. As is customary in the text, the symptoms are being

85. **Women Converse in a Pavilion with Bed as Krishna Waits outside,** from a *Rasikapriya* manuscript
India, Malwa; 1634 (23606)

98

॥ कृष्ण कौ प्रकास छंन उनमादा॥ उठ=पउठ प्रकासित वातनि
लोक=प्रलोक की वात सरीसी॥ रोवत हैं कव हुं हसि गावतना
वत लाज की छोडी छ रीसी॥ काहु कैंच सोच सकौ वुन के

सबदे पत=पवतदे हमैं सीसी॥ वास की वाइ कि कोम की
प्रेम कि हे हरि की मति कौ हु हसीसी॥ ७ ६ ५॥ ५

described to Radha by one of her close companions. Included in one picture, Krishna is absent from the other while the companion describes his lunatic behaviour. Characteristic of Malwa paintings, the compositions are starkly simplified with a few animated figures represented against brilliant but clearly separated monochromatic patches of colour. It should be noted further that in most series of this kind, the composition varies little from picture to picture.

Divine love is also the theme of the impressive assemblage of lyrical verses composed by Surdas (c. 1478 – c. 1580?) a well-known Hindi poet who was a contemporary and follower of the famous Vallabhacharya (1478–1530), the founder of the Vallabha Sect of Nathadwara, near Udaipur. Surdas is said to have been born blind, but this is unlikely since his perceptive descriptions of nature could hardly have been imaginary. He lived around Vraj all his life, and sang the glories of Radha and Krishna, but especially the former. The compilation of his songs, one of which is brilliantly illustrated here in a painting rendered in Mewar around 1700 –25 (fig. 86), is known as *Sursagar*, or Ocean of Melodies.

The verse occurs towards the end of the narrative, when, after a long period of separation, Krishna and Radha meet briefly in Kurukshetra and unite for the last time before parting forever. As part of their divine sport (*lilahava*), they exchange roles to demonstrate to one another that they are not two personalities but one. The artist has shown this not only by reversal of roles and attire but also by changing their complexions. Although the scene takes place at Kurukshetra, they are made to make believe that they are in their beloved Vrindavan or Vraj. Each episode in the verse is portrayed either against the flat red arch or a leafy dark green background, thereby creating a rhythmic surface pattern. The blind poet is also included at the bottom right corner singing his lyrical poems, as if watching on his mind's stage the divine play.

While the Reversal of Roles might be considered a moving picture of successive frames, two of the most beautiful Indian paintings in the collection could then be characterized as examples of still pictures (fig. 87–88). In both, Radha and Krishna are gazing intently at each other. The Rajput picture, perhaps from Datia, is the earlier of the two and was meant to have a text, as is indicated by the yellow band above. We do not know what the exact verse was meant to be, but surely the flavour of both pictures is reflected in such lines as the following from Jayadeva's *Gitagovinda*:

His passion was influenced by the glances of her eyes, which played like a pair of water-birds with azure plumage, that sprout near a full-blown lotus on a pool in the season of dew.... Govinda [Krishna]*, seeing his beloved cheerfully serene, her lips speaking desire, thus eagerly addressed her: "Why are those eyes half-closed? Are they ashamed of seeing a youth to whom thy careless resentment gave anguish? O! let affliction cease and let ecstasy drown the remembrance of sorrow."* [As quoted in Spink 1971, p. 79]

Visually, however, the two pictures achieve their aesthetic effects in very different ways. In the earlier picture (fig. 87) Radha and Krishna are seated in a giant lotus that rises from a pool or river. The presentation clearly hints at the iconic, even though they interact with one another as a very human couple, as if a prince and princess are

86. **Radha and Krishna Exchanging Clothes and Reversing Roles**
from a *Sursagar* manuscript
India, Rajasthan, Mewar; 1700–25 (23586)

87. **Radha and Krishna** India, Rajasthan; c. 1700 (23616)

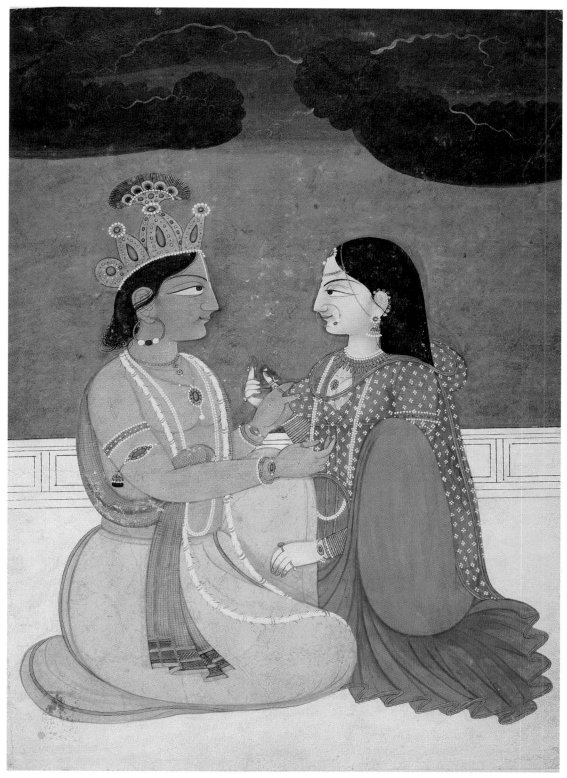

88. **Radha and Krishna** India, Himachal Pradesh, Kangra; c.1875 (23637)

in dalliance in a formally laid, well-manicured garden. Indeed, two palace ladies or companions of Radha watch the progress hidden by trees. Even the scale of the figures is in keeping with the idyllic landscape in which they are placed. It is a clear day, with a clear sky, and all is well with the world.

In the Pahari picture (fig. 88) we are not only given a close-up view of the divine lovers but they are less formal. And yet, Krishna's representation is iconographically more correct. Whereas the male in the other could represent simply a prince, here his dark complexion, yellow *dhoti*, and tiara with the peacock-feather plume leave no room for ambiguity. The scale of the figures is heroic but the mood is more intimate, as Krishna begins his love play by caressing Radha's left breast. As they look into each other's eyes, one feels Krishna might well be thinking, "let me thus remove the thin vest that enviously hides thy charms. Blessed should I be, if those raised globes were fixed on my bosom...." [As quoted in Spink 1971, p. 79] Even though here also the faces are almost expressionless, the mood is charged with a stronger erotic flavour, enhanced by the dark, swelling monsoon clouds symbolizing the season of love.

Love in all its manifestations and moods also plays an important role in classical Indian music and its constituent modes or melodies which are known as *raga* (male), *ragini* (female), and *raga-putra* (son of Raga). Each of these melodies can be associated with a time of day, a season, a particular mood or situation. Each is also conceived as a personality, depending on the gender, although it should be emphasized that every *ragini* is not always portrayed as a female. Apart from its musical nature, a *raga* is also described in a verse which was then transformed into a visual picture by the artist. A complete series of *ragas* and *raginis* is known by the expression *ragamala*, or a garland of *raga*. It should be noted though that neither the

titles nor the verses make sense always, and, at times, the word and the image seem not to coalesce. Moreover, the iconography of the modes can differ significantly from one region to another and from one literary tradition to another, which adds to the confusion. There was also no consistent tradition of adding labels or texts to the pictures, which, together with close iconographical similarities, often makes exact identification difficult.

Figure 46 illustrates Vasanta Raga or Spring melody, which is variously a celebration and a characterization of the season. The Sanskrit text above is partly damaged but describes the mode as the god of love roaming the forest:

His topknot, bound with peacock's feathers, is erect; his face, because of the burgeoning mango-shoot, is as a flower. Elephant-like, in the forest joyfully he wanders among the gopis, (such is) Vasanta Raga.
[Ebeling 1973, p. 116]

The picture, however, differs from the text in that it shows the personified Vasanta not as lovesick and wandering, but as dancing while two women provide accompaniment, as is generally described in Hindi texts. There can be little doubt that the series was painted in the same workshop, if not by the same artist, as the *Amarusataka* illustrations (fig. 83). Noteworthy are the two trees immediately above the dancer. The mango blossoms are stylized and can be recognized only from the reference in the text.

The intimate relationship between love, whether human or divine, and nature is the burden of several other *ragamala* pictures in the collection.

89. **Todi Ragini**, from a *Ragamala* series
India, Malwa; c. 1650 (23613)

In a sombre picture from Malwa (fig. 89), a solitary lovesick lady, personifying the mode Todi, is shown roaming the forest in the company of a pair of antelopes. Indeed, the faunal couple serves to emphasize her loneliness, and interestingly, it is the buck with whom Todi is shown interacting. The abrupt bending of one tree only above the lady is not just an expression of artistic whimsy but probably an indication of nature's sympathy for the lovesick maiden. Most textual descriptions, such as the following, emphasize her melancholy mood and unrequited love:

Divided from her darling, most unhappy in love,
like a nun renouncing the world
This Todi abides in the grove and charms
the hearts of the does.
[Translated by A.K. Coomaraswamy, and as quoted in Pal 1978, p. 128]

Love in separation is also the theme of the Kamodini Ragini (One who excites desire) from a series painted in Bundi-Kota in the eighteenth century (fig. 37). Seated on an oval carpet in a forest clearing beside a river, the lady fondles a flower while awaiting the arrival of her lover. As a Hindi text, followed both in Bundi-Kota and the Jaipur area, tells us, the beautiful lady, stricken by Cupid, sits gracefully in the wood and looks all around to see her lover approach.

Interaction with nature is much more dramatic in another picture from the same series (fig. 90) depicting the mode Madhumadhavi (The sweet Madhavi creeper). It's the rainy season, and as the thunder claps and the lightning strikes, the peacock on the tree screams and the lady scurries towards the pavilion to seek shelter. A Hindi poet, however, interprets her haste in a more romantic manner: "When the lightning flashes, she twists her body, [because] her passion is excited by the sight of the closely grouped (leaves) of the tamala tree."
[Ebeling 1973, p. 122]

From mid-eighteenth-century Kota comes another animated picture (fig. 45) showing a princess on a horse fighting a man, while a second warrior lies slain in the foreground. Even though there is no label and the horse rider is a female, the scene very likely depicts the *ragini* known as Nat or Nata, meaning actor or performer. This is one of those strange iconographies that seem to make little sense, for although characterized as a *ragini*, the personification is generally male. Furthermore, he is always riding a horse and fighting one or more warriors, which seems to have little to do with the title of the mode. In any event, there is at least one known Hindi tradition that describes the *ragini* as a female riding a horse, though she is not engaged in a battle. Rather, she is said to be a skilled acrobat, which is more appropriate for the title. Whether male or female, the *ragini* is said to be saturated with love.

Romantic mood is certainly the burden of a Deccani *ragamala* picture (fig. 91) which also is unlabelled. It shows a prince seated on a carpeted terrace offering some wine to an approaching woman, while another lady stands behind and fans

90. **Madhumadhavi Ragini**
from a *Ragamala* series
India, Rajasthan, Bundi-Kota; 18th century (23589)

91. A Prince on a Terrace with Two Female Attendants
from a *Ragamala* series
India, Andhra Pradesh,
Hyderabad; 19th century (23633)

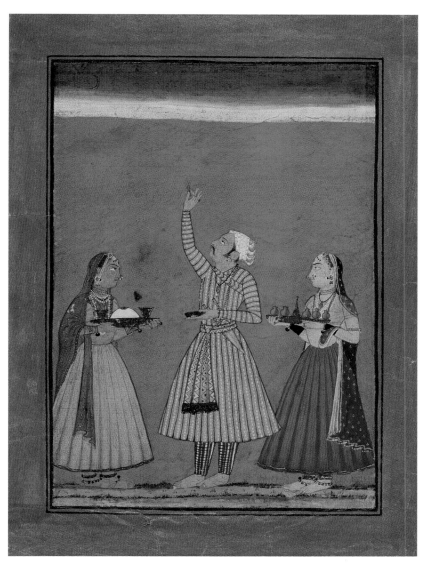

92. Shri Raga Chandra
from a *Ragamala* series
India, Himachal Pradesh, Bilaspur;
late 17th century (23614)

him with a *morchaal*, or peacock feather fan. This appears to be a Deccani variation of the major *raga* known as Malkos. In the text, however, the man is supposed to offer a betel-quid to the lady, but here a drink seems to be substituted.

A man and two women also form the subject matter of a Bilaspur *ragamala* picture of the late seventeenth century (fig. 92). Here too, the princely male is involved in making an offering from laden trays held by his female companions. The object of his attention is the sliver of a moon in the sky. Hindus, of course, worship the moon god, while for Muslims the sighting of the new

moon launches their month-long fasting and feasting called Ramadan. This is, however, clearly a Hindu ritual which seems more devotional in character than romantic.

All in all, *ragamala* pictures are unique to the Indian artistic tradition. It is the only form of art that combines poetry and paint to convey the mood of a melody. It appears to have gained momentum in the early seventeenth century and remained enormously popular with music-loving patrons for the next couple of centuries. It was an interest that was shared by both Hindus and Muslims.

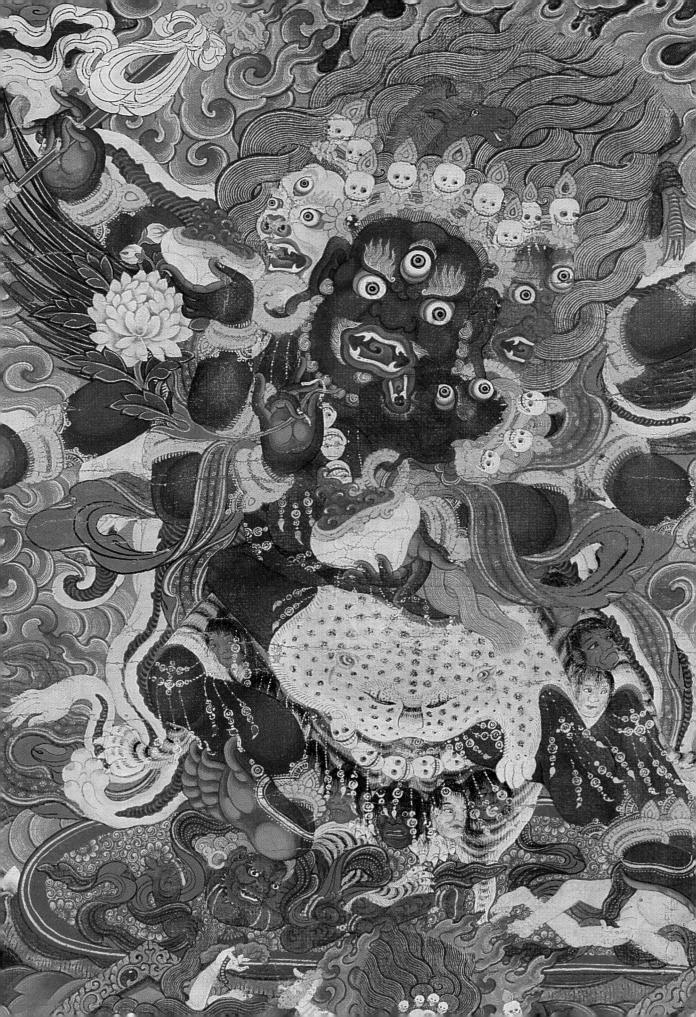

⑤ Tibetan Painting

The Tanenbaum Collection includes a large group of Tibetan paintings belonging mostly to the seventeenth through nineteenth centuries, precisely the period when the Geluk order, founded by Tsongkhapa (1357–1419), gained both temporal and spiritual authority over the land. Some of the paintings have been mentioned in chapters 1 and 2 and others will be discussed in the following chapter. Here an attempt will be made to provide a few general remarks that will help the reader better appreciate the unique qualities of the Tibetan painting tradition.

There is no gainsaying the fact that the most distinctive and familiar form of Tibetan art is undoubtedly the *thangka* or *thanka* (literally, a "rolled up image"). A scroll painting, generally with a vertical orientation, it is rolled up when not in use or during transportation. While the basic idea of such a painting on cloth was introduced with Buddhism from India – the form is encountered in other cultures as well – the Tibetans seem to have given it a special place in their spiritual pursuits. It would not be an exaggeration to state that every home in Tibet, whether a building or a tent, is likely to contain at least one thanka. The wealthy and the elite would own several and sometimes complete series, while monasteries were rich repositories where thankas were owned institutionally as well as by individual monks.

In India the ruling classes and the elite were the major patrons, but in Tibet everybody patronized thanka painters. While some professional artists generally set up permanent shops at monasteries and the principal commercial and urban centres, others went to remote regions of the vast country in search of patronage from the nomads. After satisfying one community, they would move on to the next. The thanka also differs significantly from the Indian paintings we have been looking at, both in size and support. The size of a thanka can vary from about fifteen centimetres square to over a dozen metres in height, whereas an Indian picture is rarely more than forty centimetres high. The support of a thanka is usually cotton or linen, and occasionally silk, whereas Indian pictures are painted on paper. The thanka is hung on a wall, but the Indian picture is viewed intimately while held in the hand at an oblique angle. Indian pictures depict religious themes as well as a wide range of secular subjects and genres. The thanka, on the other hand, is

always religious in content and can be consecrated and used just like an icon in ritual worship. Once common all over India, such paintings on cloth and wood panel can now be seen in certain regions only, such as the Nathadvara shrine in Rajasthan, Puri in Orissa, Tanjore in Tamil Nadu, and in Jain religious establishments. Thus, only from the thankas can we learn about the lost art of religious painting on cloth of both the Hindus and Buddhists of India.

Both professional artists and monks painted thankas, although there were more of the former than the latter. Some of the important stylistic innovations, however, are attributed to monk artists. The eighth Karmapa (suborder of the Kagyu order) hierarch, Mikyo Dorje (1507–1554), is said to have inspired the Karma-gadri style, which reinterpreted natural elements from contemporary Chinese paintings and perhaps even borrowed from the Indian tradition to create a vivacious and colourful landscape tradition in Tibet. This remained the principal style in the eastern Tibetan provinces of Kham and Amdo. In its turn, the Karma-gadri influenced the style of painting that developed in the central Tibetan region, especially around Lhasa where the Geluk monasteries were dominant. Called by the Tibetans Menri (and New Menri) style, it is characterized by strong, bright colours, bold figurative forms, and restrained natural elements added as decorative design rather than to meet topographical needs. It is this style which spread all over Tibet along with the expansion of the Geluk order and may be regarded as the truly national style of the country.

The majority of the thankas in the collection were rendered in Central or Southern Tibet in either the Menri or New Menri styles. Among the other styles represented are the Karma-gadri and the Sakya, which was developed for the Sakya monasteries in south-central Tibet. A distinctive

school of painting developed in Western Tibet as well and is represented in the collection by at least one thanka rendered in the sixteenth century in the kingdom of Guge (fig. 103), before the region was overwhelmed by the Menri style. Except for the clouds enveloping the central triad, the style continues to be strongly figurative.

One of the earliest examples of a thanka in the Tanenbaum Collection is a well-preserved mandala made for a monastery of the Sakya order, such as Ngör (fig. 93). Very likely it was painted in the last quarter of the fifteenth century and fortunately still has its original mounts attached. These consist of two slightly flaring bands of blue cloth, not the elaborate mounts of Chinese brocade that became so common after the sixteenth century. Ever since the foundation of the Sakya monastery in 1073, the Sakyapas seem to have been especially partial to the Newars of the Kathmandu Valley, who are among the principal traders in the Shigatse and Gyantse region. Newar artists also played a key role in building and decorating Sakya monuments. The Tibetans therefore call this style Bal-ri or the Nepali style. It is characterized by very fine and meticulous drawing, figures with strong Newari features, deep, resonant colours with a penchant for a crimson red and turmeric yellow, and intricate scrollwork that fills the background and gives the impression of a delicately embroidered lacework.

93. **Mandalas of the Ngör Cycle according to Sakyapa Teachings**
Central Tibet, Tsang region; 1475–1500 (26828)

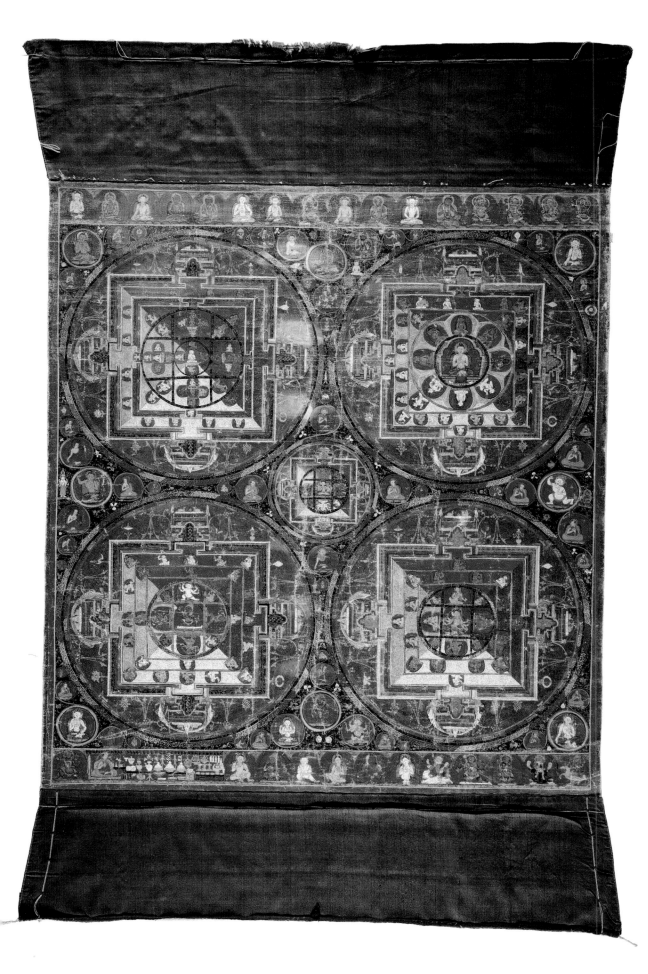

In this particular example five mandalas are arranged symmetrically and surrounded by numerous other deities and monks. Characteristic of such mandalas, two registers of still more deities and monks are accommodated at the top and bottom. The bottom panel includes a formulaic scene of consecration which is particularly elaborate in this beautiful thanka. The background is largely green, and characteristically, the square celestial mansion is divided into yellow, red, green, and white wedgelike segments. As the mandala is a symbol of stability, clarity and order are a *sine qua non* of its composition.

Although theoretically the artists had no freedom to alter the basic form of the mandala and its component elements, a second example of multiple mandalas in the collection (fig. 94) differs visually from the earlier Sakya example. Not only is a spatial sense added with the introduction of landscape elements, but the mandalas themselves have completely different appearances. The ornamentation within the mandalas is not as exuberant, and the design is less overpowering. Some of the individual elements, such as the gateways, the lotus petals, and the flame pattern surrounding the mandala, differ noticeably. Even though an extra circle with the stereotyped representations of the four cremation grounds is added between the ring of fire and the lotus, the space within the mandala, as well as without, appears more open. The colours are softer and pastel-like and contribute to the overall tranquillity of the representation. Directly below is the ferocious figure of white Mahakala, one of the most important protectors of religion in Tibetan Buddhism.

The presiding deity of all four mandalas is Hevajra, in four different emanations in sexual union (*yab-yum*) with his spouse Nairatmya (no-soul). He is the central figure of the *Hevajratantra*, an esoteric text necessary in the highest form of yogic praxis (*anuttara*). The monk seated on a throne in the centre of the thanka is probably the practitioner for whom the painting was rendered, perhaps to extend his life since the figure directly above him and floating in the clouds is Ushnishavijaya, the goddess of longevity.

94. **Four Mandalas of Four Manifestations of Heruka**
Tibet; 19th century (26869)

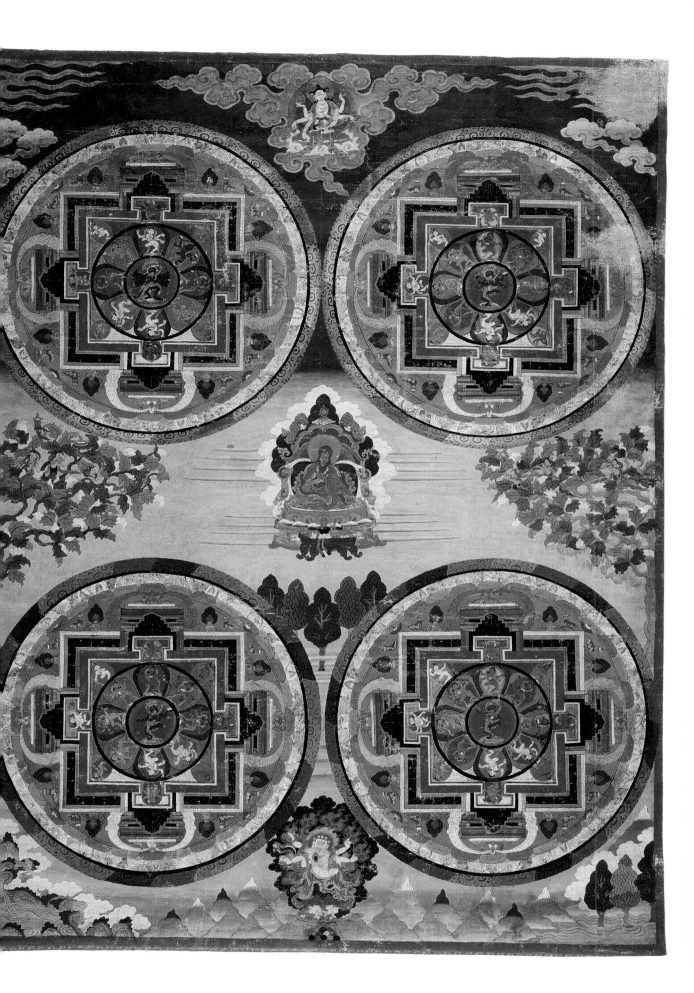

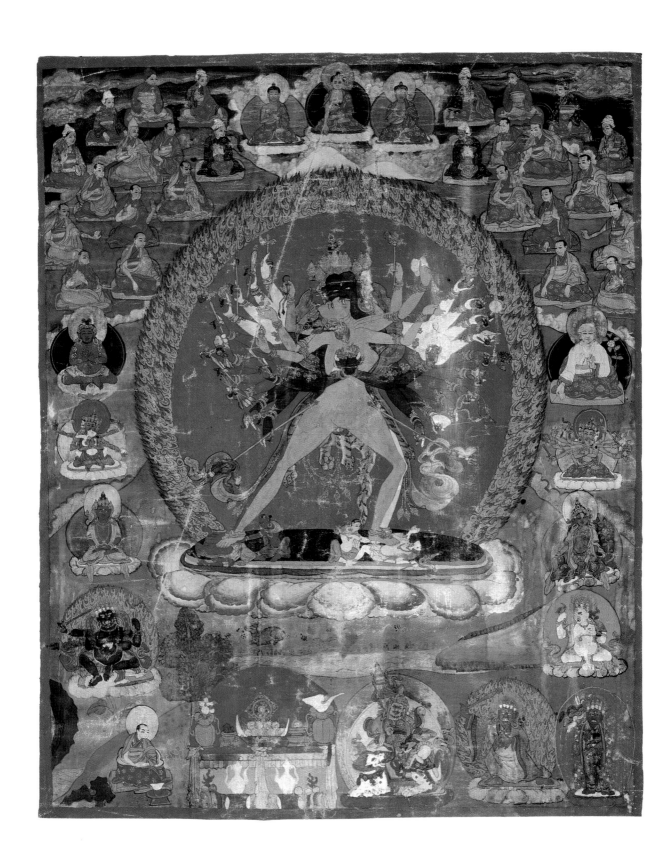

Symmetry and visual order are essential elements of most Tibetan thankas depicting divine themes and teachers. In a sense, even when a thanka does not represent a mandala, such as that depicting Kalachakra and retinue (fig. 95), the figures are distributed around the central couple in an orderly, symmetrical fashion, repeating the pattern of the flaming aureole behind. Indeed, in most thankas this circular arrangement of figures underlies the geometric configuration of the composition. Also, in this thanka we encounter another unique feature of Tibetan paintings. Surrounding the central pair are large groups of lamas or monks, as well as some Buddhas and deities watching the epiphany. This is called an assembly field, which is its own realm of reality where time and space in the mundane sense have no validity. To my knowledge, only the Tibetans created such timeless cosmic realms in their thankas. Moreover, in keeping with the Tibetans' extraordinary veneration for gurus or religious preceptors, the human teachers are always given the most exalted position in the surrealistic assembly field.

Another fine example of such an arrangement of teachers may be seen in a striking thanka of Naro Dakini, probably from Eastern Tibet (fig. 96). The majority of the figures grouped around the upper half of the thanka are lamas. Not only are they prominent outside the shrine but also among the figures in the second storey. It should be noted that only Hevajra (upper left corner) and Chakrasamvara (upper right) are shown as active figures, otherwise the celestial

96. Naro Dakini with Retinue and Spiritual Leaders
Eastern Tibet; 17th century (26873)

95. Kalachakra with Retinue and Sakyapa Monks
Eastern Tibet; 19th century (26854)

realm is a sea of tranquillity. Most of the dynamic deities are accommodated in the lower half of the thanka, with the exception of the reposeful figure of the officiating monk at the bottom right.

An unusual feature of this thanka is the rich use of architectural forms of Chinese design to set off the figures. Each of Naro Dakini's two companions and the deities along the bottom, which include divine protectors and the dancing skeletons – Chitipati and spouse – are given their own shrines. Appropriately, the shrine of the lord of the cremation ground is surrounded by a frame of skulls. The unknown artist of this handsome thanka rendered in Eastern Tibet not only had an imaginative eye for design but also a brilliant sense of colouring. The rigid and linear forms of the architecture provide a wonderful foil for the rhythmic and dynamic dancing figures, while the bright red, orange, and gold are richly contrasted with the white, green, blue, and black.

It is interesting to compare an almost contemporary Central Tibetan thanka of the same subject (fig. 97). Not only are the two iconographically quite different, but both stylistically and aesthetically they are a world apart. This thanka was commissioned for Gelukpa use, as is clear from the inclusion of the figure of Tsongkhapa on the upper left. Moreover, its figural simplicity indicates a different iconographic tradition than the more complex Eastern Tibetan example. No architectural forms are used and the figures are given more space. Topographical elements, such as the row of decorative trees in the foreground, the gently rising grassy knoll, and the clouds floating in a wide, blue sky, are better articulated. The most note-

worthy difference between the two thankas is in their colouring. Not only are the tonalities of the colours distinctive, but in the Central Tibetan example the various shades are used with greater regard for contrasting darker and lighter areas.

Nowhere do the Tibetan artists' imaginative powers find more dramatic expression than in the thankas depicting angry deities. These deities are of both genders, although the majority are male. The naked Naro Dakini, striking a militant posture, brandishing a chopper, and drinking blood from a skullcup, is one eminent female figure (fig. 96–97). Another, typically Tibetan and much venerated, is the goddess Lha-mo (fig. 25), who even chomps on the severed limbs of her own son. It is reassuring to know that such deities are harmless for the believers, and the blood and flesh they consume with such evident relish are only of the enemies of the religion.

Certain visual conventions and motifs are used repeatedly for representations of these awesome deities. They generally have multiple limbs, some with animal heads, such as Vajrabhairava with a yak's head (fig. 98) and Hayagriva with a horse's head (fig. 99). They are always shown in a belligerent posture with or without multiple legs, trampling on various creatures, all representing evil forces, both physical and mental. Sometimes they ride on animals (fig. 25), in which case they sit in an aggressive attitude with the body twisted violently and frontally, as if engaged in combat. Their arms, equipped with various weapons, and their faces with gnashing teeth, much facial hair, and three round eyes, add to their awesome character. The complexions of these ferocious emanations are almost invariably black, dark blue, or red. They may be portrayed by themselves or in *yab-yum*. Whether alone or with a companion, the figures are always set off against a fiery aureole with varied shapes and hues.

97. **Naro Dakini and Retinue with Monks and Dancing Skeletons**
Central Tibet, Ü region; 17th century (26836)

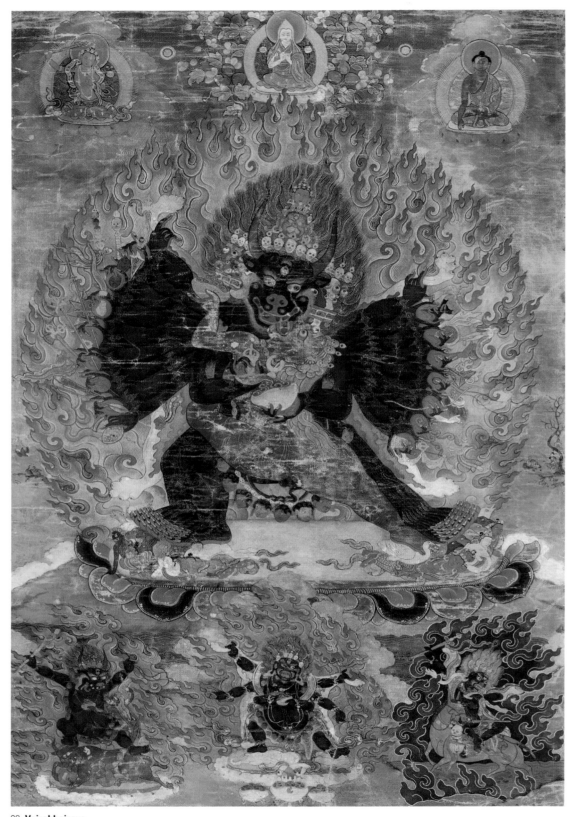

98. **Vajrabhairava**
Central Tibet; 18th century (26838)

99. **Hayagriva, a Protector Deity**
Tibet, Tsang region; 18th century (26881)

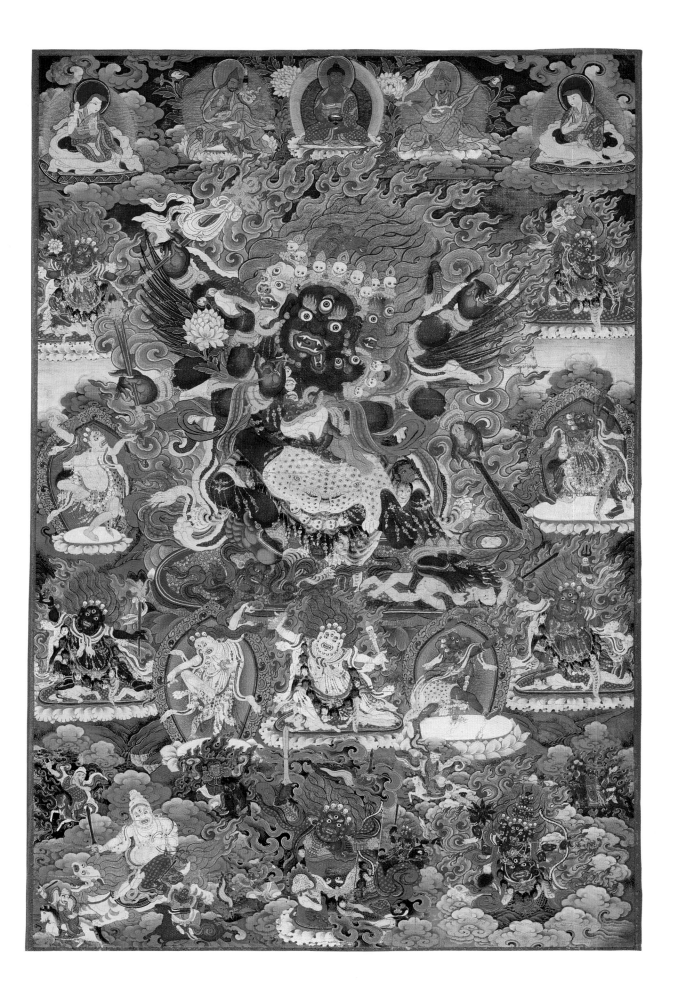

Usually in such thankas the artist himself is not responsible for the visions represented, as was the case with the nightmarish images of Bosch or Goya. These images are therefore not the reflections of the artist's subconscious nor are they expressive of his inner tensions or anguish. The bizarre visions were conjured up by monks and mystics, who then expressed them in vivid language as follows:

You, the glorious rDorje grags mo gyal
When angry at the enemies,
Riding, you ride on flaming chain-lightning
From your mouth issues a fire-cloud such as appears
at the end of a kalpa,
From your nose smoke comes forth,
Fire clouds accompany you at the back.

...

Devilish birds and jackdaws are fluttering around,
Black birds with yellow beaks descend in succession,

...

The galloping horses of the btsan *are dashing away.*

...

By you and your retinue,
Those are subdued who try to inflict harm to the
Buddhist religion,
And who disturb the monastic communities.

...

Drink quickly the warm blood of their hearts....
[Nebesky-Wojkowitz 1956, pp. 196–97]

It is astonishing how compellingly the Tibetan artist gave such powerful expression to images that originated in someone else's dreams, mystical visions, or perhaps even the subconscious.

Although the basic ingredients may have been the same and the artists may have had little freedom to alter the iconographic descriptions, it is remarkable how varied the representations are even within a given stylistic convention. Three thankas in the collection are roughly contempora-

neous and all are from Central Tibet. One represents Vajrabhairava (fig. 98), another portrays Hayagriva (fig. 99), and the third, a tutelary deity of the Nyingma order (fig. 100). The deity may represent a form of Vajrapani, just as Vajrabhairava is an angry emanation of Manjushri. Noteworthy are the Buddha figures he holds as attributes in many of his hands, as weapons against the forces of evil and ignorance. Indeed, except for the fact that the Nyingmapa thanka has a few more figures, stylistically it and the Vajrabhairava are closer to each other than they are to the Hayagriva. Nevertheless, there are perceptible differences between them, though mostly restricted to minor motifs, such as the lotus bases, the colour of the flames – pungent orange and red in one (fig. 100) and of more muted but variegated hues in the other (fig. 98) – and details of landscaping.

The thanka of Hayagriva (fig. 99) shows both a more crowded field and a much wider range of colours. Because Hayagriva has a larger retinue, the composition has accommodated a greater variety of angry deities. Several of them are represented in unusual postures with more contorted bodies, thereby making the composition busier and more energized. The flame motif is used less exuberantly by this artist, who, however, was obviously fond of cloud formations, which are not only employed more abundantly but painted in psychedelic colours.

100. **Yontan Gyila, a Tutelary Deity of the Nyingma Order**
Central Tibet; 18th century (26848)

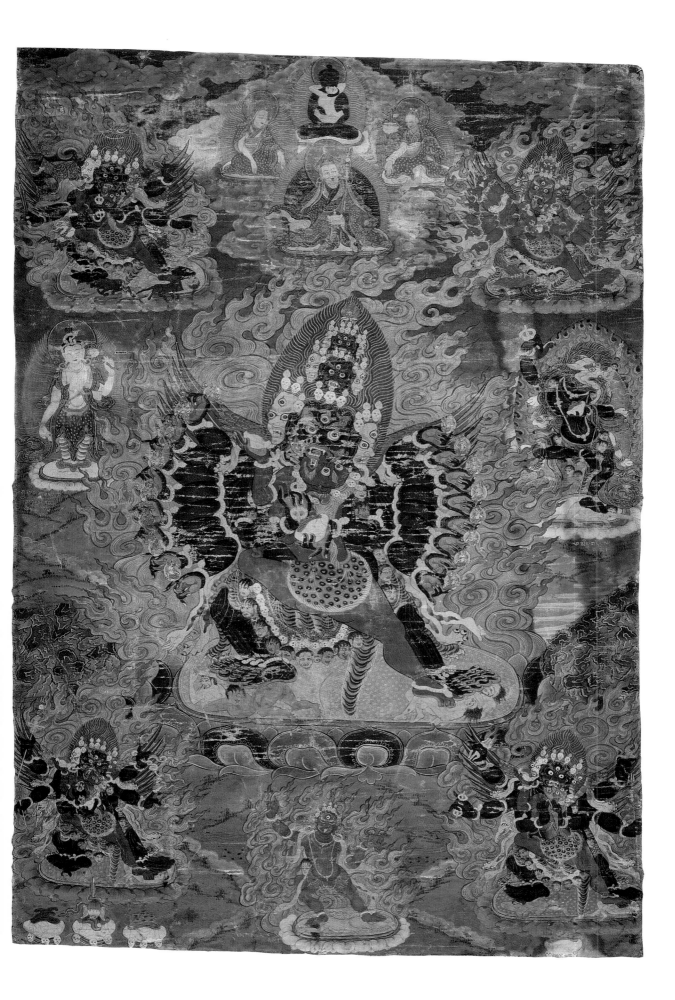

A small but delicately rendered painting from Eastern Tibet (fig. 101) is a perfect example of a gifted Tibetan artist's ability to combine surrealism and expressionism in a detached but evocative manner. Against curling and leaping tongues of purplish-grey flames swaying to the left, the red-coated and -hatted figure of a menacing Tibetan deity riding a black pony moves from left to right. This interactive motion between the figures and the fiery aureole – invariable in all such thankas – is taking place in an idyllic landscape of overlapping hills inhabited by predatory animals, scavenging birds, and menacing black horses with red manes, as well as blood-filled skullcups and a *chöten*, all symbols of cremation grounds. Below the main figure's horse's hoof is a sumptuously laid offering table filled with ritual implements, a remarkably perceptive rendering of a Tibetan still-life. A figure in a yellow robe and with a green halo sits besides a table and proffers a white scarf to the divine apparition he has the privilege of witnessing. The realistic and perspectival rendering of the table with its contents appears conspicuous amid the utterly surrealistic representation of everything else in the composition.

It is clear that the Tibetan artist was not persuaded that the purpose of a painting was to imitate nature and the phenomenal world in which he lived, either in the Chinese manner or in the European-influenced Indian mode. He knew that "all the multiplicity of appearance exists as nothing but the nature of his mind" and therefore was free to create a higher realm of self-radiant reality.

101. **A Protective Deity**
Tibet; c. 1800 (26884)

6 Portraiture in Indo-Tibetan Art

One of the earliest and most unusual works of art in the Tanenbaum Collection is a moulded tile that was once used as a floor covering in a fifth-century Buddhist shrine at a place called Harwan in Kashmir (fig. 102). It shows repeatedly a crouching ascetic in the middle, busts of two confronting couples in dalliance along the top, and a row of naturalistically rendered ganders carrying water lilies with their beaks at the bottom.

Although the human figures are not portraits in the Western sense, they could be realistic representations based on close observation. The ascetic's emaciation and foetal position are exaggerated to graphically express the effects of mortification of the body, while the heads above have sufficiently different features to indicate that even if they are types they were perhaps drawn from life.

Such realistic portraiture is unusual in India before the genre was introduced by the Mughal emperor Akbar. Portraits of individuals do exist going back at least to the Kushan period, in coins as well as sculpture, but mostly they are idealized representations conforming to types. Kings had to look regal, the queens and goddesses were often indistinguishable, and saints had to appear saintly. Most classic instances of such idealized and generalized representations are of Mahavira and Buddha Shakyamuni, two historical figures. When the need arose around the beginning of the Common Era to portray both in art, the artists used the model of a meditating yogi embellished with a number of supernormal signs to divinize them. This is how we encounter all the Jinas and all the Buddhas throughout the ages, with some distinctive variations to distinguish the different figures.

In a sixteenth-century thanka from Guge in Western Tibet (fig. 103), the Buddha Shakyamuni is shown primarily as an ideal yogi seated in meditation on a throne, as in the much earlier Pala image from Bihar (fig. 20). While an alms bowl in his hand emphasizes the mendicant nature of a monk, his robes are sumptuous. His two disciples on either side and the sixteen arhats in the upper segment are all depicted as monks like their master, but without his cranial bump. Following the Indian tradition, there is little attempt to distinguish their physiognomies, even though all were historical figures. However, each is given attributes which either display his idiosyncratic character or symbolize an important event in his life, just as Shakyamuni's hand gesture and the presence of the tiny figure of

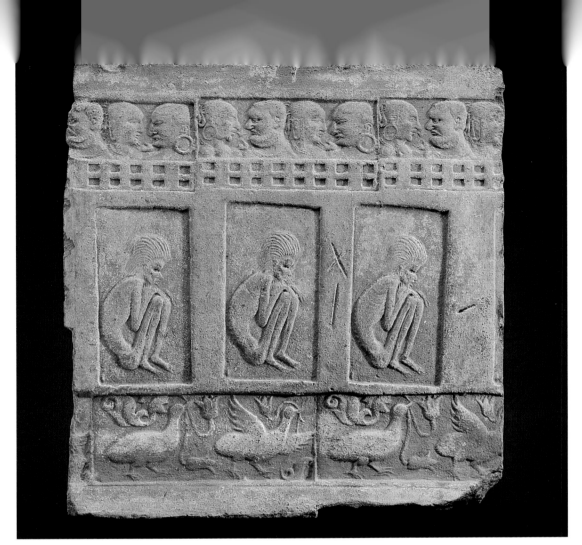

102. Tile with Conversing Figures, Ascetics, and Geese
India, Kashmir, Harwan; 5th century (23236)

104. Shaiva Saint Sambandar
India, Tamil Nadu; 17th century (26673)

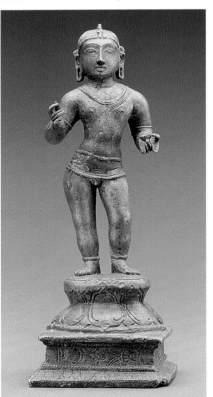

the earth goddess on the textile overflowing the throne signify the occasion of his enlightenment.

That this was also the case with saints and mystics of the Hindus in India is clear from a small bronze from Tamil Nadu representing the seventh-century saint, Sambandar (fig. 104). During his short life of only sixteen years he composed numerous devotional songs in praise of Shiva, whose ardent follower he was. He also is said to have converted the Jain Pandya king to Shaivism, which helped to spread Shaiva influence in the region. The most significant event of Sambandar's life occurred when he was three. One day his father left him alone in the temple compound to go bathing. Hearing the boy cry, Parvati came down to pacify

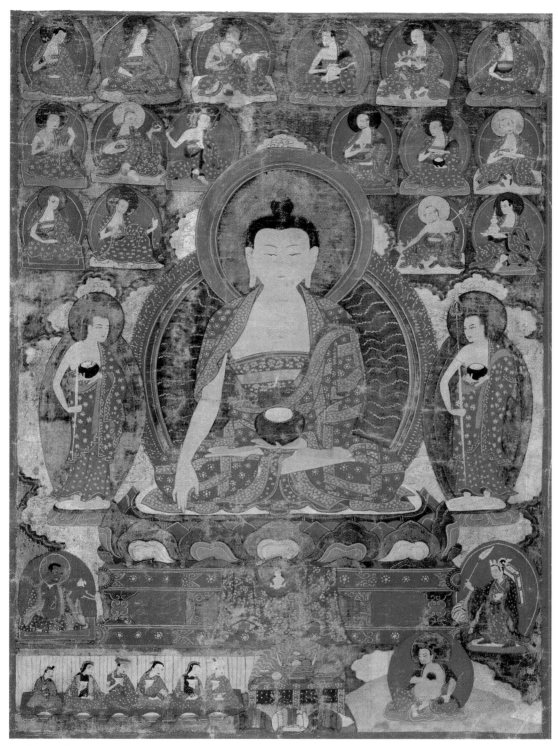

103. **Buddha Shakyamuni with Disciples and Donors**
Western Tibet, Guge; c. 1500 (26826)

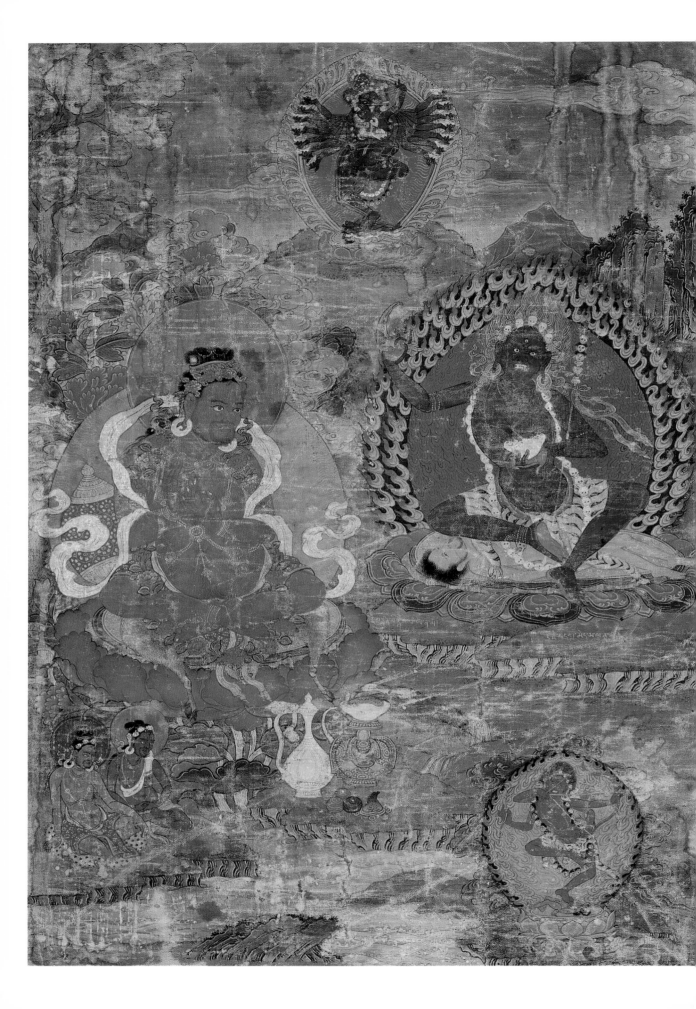

him with her own milk. When the father returned and found the son content with a cup of milk in his hand, he asked what happened. Sambandar recounted the miracle and pointed to the sky to indicate divine intervention. This incident is encapsulated in the representation. Characteristically, he is shown as a naked child holding a cup in one hand and pointing to the sky with the other.

Tibet

The same principle was followed in Tibet. A sixteenth-century Tibetan bronze portrays the Mahasiddha Virupa, an Indian mystic, as a lifelike yogi, but certainly the representation is not a portrait (fig. 105). The expression *mahasiddha* is generally translated as the Great Attainer, but what it implies is a free-thinking, highly individualistic, eccentric, mystical teacher who has mastered the various yogic techniques and attained unusual magical and spiritual powers. Thus, Virupa is portrayed typically as a yogi, seated on an antelope skin and wearing a yogic strap and cross belts. The use of floral ornaments as well as his fondness for liquor are indications of his eccentricity. In his left hand is a cup, and with his raised right hand he is preventing the sun from setting, since the barmaid had threatened to stop serving him at sunset. His face with silver-inlaid eyes with their penetrating gaze betray his anger as well as spiritual powers.

Alternatively, Virupa can be portrayed in a less combative mood, as we see in a near contemporary thanka that once must have belonged to a series of eighty-four mahasiddhas (fig. 106). Here the representation is more conventional, and his hands make the classic Buddhist gesture of teaching as he beholds the image of the dakini Dorje Dakmema. A *dakini* is a tantric goddess of immense power who is an indispensable spiritual companion of a mahasiddha. Along with two other yogis and the goddess Kurukulla below, and the god Heruka

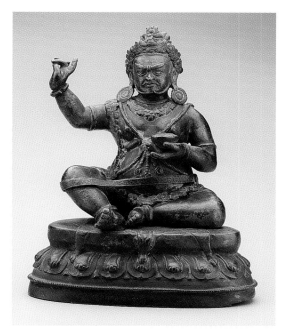

105. Mahasiddha Virupa
Central Tibet; 16th century (26710)

106. Visions of Mahasiddha Virupa
Tibet; 17th century (26832)

above, Virupa and the Dakini share a characteristically evocative Tibetan landscape in the Karmagadri style. The figures, however, are painted in the Menri style of Central Tibet.

Another group of historical figures especially venerated by the Tibetans were the arhats. Also known as *lohan* or *lou-han* in China, an *arhat* is a venerable being who has achieved a very high level of spirituality but at the Buddha's request postpones his own nirvana in order to carry his messages to the four corners of the globe. Thus, arhats may be characterized as "mortal bodhisattvas." The group includes a number of important disciples of the master, including his son Rahula. Theoretically, there are hundreds of arhats – and in China as many as five hundred are represented in art – but in Tibet usually the group numbers only eighteen. Apart from the Guge thanka (fig. 103), a second example in the collection portrays the group (fig. 48) in a slightly different compositional arrangement.

Unlike the mahasiddhas, the arhats are generally shown as elderly monks. There is no doubt that the Tibetans were strongly influenced by the Chinese Lohan cult and artistic traditions. Although Tibetan literary tradition distinguishes three types of arhat paintings – the Indian, the Chinese, and the Tibetan – no representation of an arhat can be identified as Indian in origin. Moreover, no depictions of arhats in Indian art have yet come to light. While the Guge painting may continue the early Tibetan – and perhaps Indian – mode of composition, strongly figural and hieratic, the figures themselves and their clothing betray no trace of Indian influence. In the second thanka (fig. 48) the style is purely Tibetan, with naturalistic representations of the arhats in an engaging landscape setting. There is even an attempt to diversify and articulate the facial features of the arhats as individuals.

As was the case with the mahasiddhas, the arhats too were often depicted in smaller groups in a series of thankas. In such instances (fig. 107) three or four arhats are accommodated along with several other figures in a rich landscape where natural elements are given greater prominence. The arhats, however, each do their own thing without any interaction, although they do seem to be responsive to their attendants who are always engaged in various activities. In this particular example there are a couple of gods represented in the conventional manner, and three Tibetan masters float in the clouds above. What is unconventional and refreshing in such paintings, and also in thankas depicting individual or small groups of mahasiddhas, is the asymmetrical placement of the arhats. This results in lively confrontations in which the vertical and horizontal elements are made to interact harmoniously with the diagonal. There is no centre in such paintings, and the eye follows the zigzag path smoothly and rhythmically, with the arhats as milestones until they reach the summit of the hilly landscape.

While each representation of an individual master is in one sense a synoptic way of depicting a distinctive episode from his life, the lives of certain individuals were expressed in greater detail. In early Tibetan thankas we generally encounter only the life of Shakyamuni narrated at some length, usually in compartmentalized compositions in a strongly figurative style. From about the sixteenth century, however, the narrative mode combining landscape elements became popular, first in

107. **Four Arhats with Attendants, Deities, and Tibetan Teachers**
Central Tibet, Tashilunpo Monastery; 18th century (26861)

108. Padmasambhava with Scenes from the Life of an Unknown Monk
Central Tibet; 18th century
(26840)

109. Tsongkhapa with Scenes from His Life
Central Tibet; late 18th century
(26853)

Eastern Tibet in the Karma-gadri style and thence in Central Tibetan paintings. While early Karma-gadri-style thankas depict mostly the past and present lives of Buddha Shakyamuni, in the eighteenth century the lives of Padmasambhava and Tsongkhapa also became popular.

Of the two, Padmasambhava is the earlier figure (fig. 108). An Indian mystic, he was invited to Tibet in the eighth century, and with his magical powers subdued the local spirits who were obstructing the progress of Buddhism. In India this remarkable man is forgotten, but in Tibet he is universally venerated as a second Buddha and is considered the founder of the Nyingma order. The account of his life, however, is hagiographical rather than biographical.

Tsongkhapa is a less shadowy figure and is probably the most influential native religious personality the country has produced (fig. 109). Although not an innovator, either in doctrine or ritual, he was a great reformer who introduced discipline in a religion that was spinning out of control. The order he established became known as the Geluk, whose monks are distinguished by their yellow hats. In due course they became the largest and predominant religious order in the

country, and their chief hierarch, the Dalai Lama, also became the temporal ruler of the land. The abbot of the Tashilunpo monastery, the Panchen Lama, is the second-ranking religious leader.

While Padmasambhava is a legendary figure, one would have thought that Tsongkhapa's representations would have been modelled after a more authentic likeness rendered while he was alive. Like the Buddha, both Padmasambhava and Tsongkhapa are idealized and divinized figures distinguished by their attributes. Both are seated in meditation postures but have different coloured robes and hats. Padmasambhava exhibits the turning the wheel of Law gesture with both his hands, while Tsongkhapa displays the teaching gesture with his right hand and holds a book in his lap with the left hand. As befitting a Vajrayana celebrant, Padmasambhava's emblems are the thunderbolt and the bell, while Tsongkhapa's are the flaming sword and the book, both attributes of Bodhisattva Manjushri, whose emanation he is.

Principal incidents from their spiritual lives surround each in rich architectural and landscape settings. Each episode is depicted in a vignette and is an independent, complete, miniature composition, skilfully separated from the next by architectural elements or natural forms. The overall effect seems as if each is witnessing his entire spiritual life unfold before his mind's eye as he sits in meditation. Many of the important scenes are identified by inscriptions.

This type of composition became formulaic for most biographical thankas. It is also employed in depicting the life of the Fifth Dalai Lama in another thanka of the same style (fig. 49). In the centre is the Lama himself, seated in meditation but with Manjushri's attributes. Indeed, so similar is the representation to Tsongkhapa that a precise identification would have been difficult without the inscriptions.

Even if Tsongkhapa is depicted as a youthful, idealized monk, the Tibetan tradition did render portraits of their historical figures. This is especially true of bronzes that were cast, probably posthumously, to commemorate an eminent teacher. While the practice may be traced back to at least the thirteenth century, and earlier still to Pala India, in point of fact it became popular only in the last few centuries or so. One thanka (fig. 110) and several bronzes (fig. 111–112) in the Tanenbaum Collection attest to the wide prevalence of the practice. Generally, only the faces are individualized, the degree of verisimilitude depending on whether the portrait was rendered in the sitter's lifetime or soon after his demise by an artist who had observed the model at close proximity. Fortunately, dedicatory inscriptions are often added at the bottom of the bronzes, which help us to identify them as specific individuals. Only rarely can a figure be identified without an inscription. So distinctive is the head and the girth of his body in an impressive gilt bronze (fig. 111) that he can easily be identified as the Fifth Dalai Lama (1617–1679).

The thanka (fig. 110) which may be from Western Tibet and shows strong influences of the Sakya style at Gyantse differs from the bronzes in its iconographic elaboration. Otherwise the central figure strikes exactly the same posture as the bronze figures. This formal and strictly frontal meditative posture appears to have been mandatory for Tibetan portraits of religious hierarchs, leaving no doubt about the iconic nature of the representation. The favoured gesture is that of turning the

110. **Sakyapa Hierarch Kunga Nyingpo**
Central Tibet, Tsang region; c. 1500 (26827)

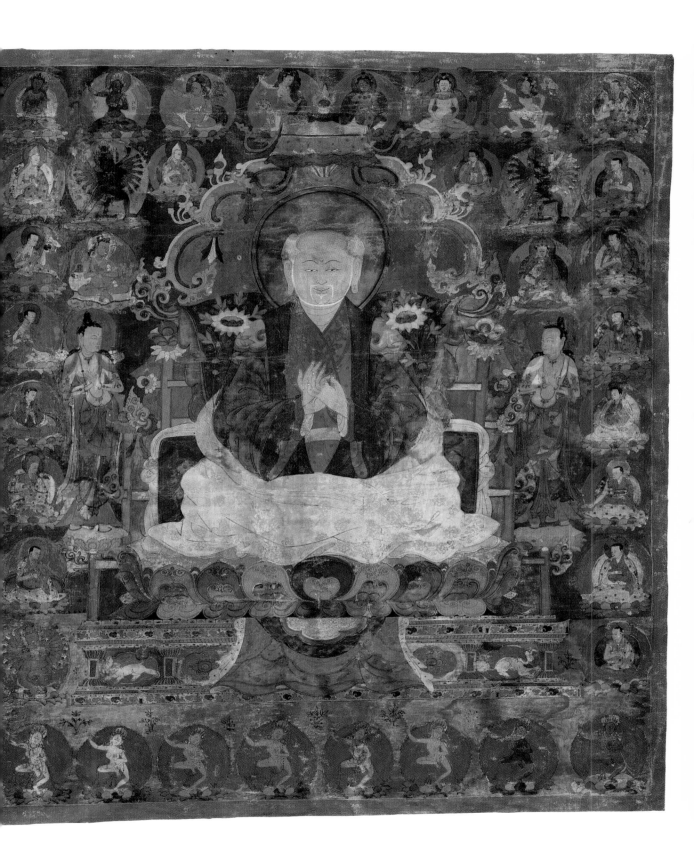

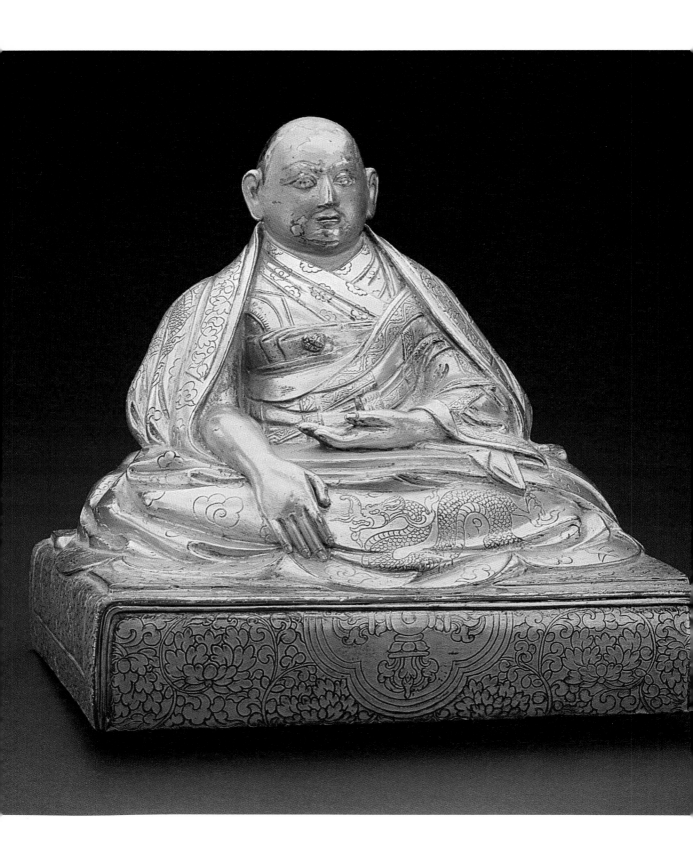

113. **Kongton Chöje's Robe** (detail of fig. 112)
Central Tibet; 14th–15th century (26717)

wheel of Law, clearly announcing the sitter's role as a great teacher. The Fifth Dalai Lama, however, makes the earth-touching gesture, generally the prerogative of the Buddha Shakyamuni (fig. 20).

Also characteristic of such representations is the voluminous treatment of the robes, which usually consist of sumptuous material. Details of the textile designs are meticulously rendered both in the painted and sculpted versions. The designs on the robes of Kongton Chöje are especially striking, with figurative forms (fig. 113) including a Jambhala. The prominent motif on the brocade robes of the Fifth Dalai Lama is a dragon. This is one of several known Chinese bronzes of the Lama, and the group may have been commissioned by the Ching emperor for distribution to various monasteries after the pontiff's death.

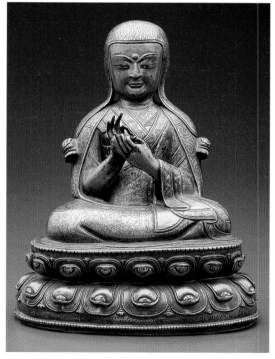

111. **The Fifth Dalai Lama**
Eastern Tibet; late 17th century (26728)

112. **Sakyapa Teacher Kongton Chöje**
Central Tibet; 14th–15th century (26717)

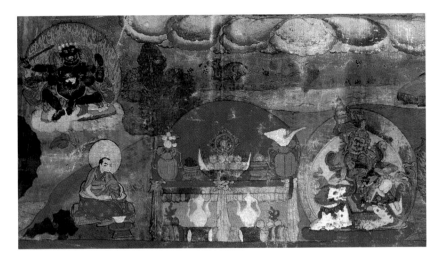

114. **Celebrant at an Altar**
(detail of fig. 95)
Eastern Tibet; 19th century
(26854)

115. **Donors** (detail of fig. 103)
Western Tibet, Guge; c. 1500
(26826)

Just as the line of demarcation between the sacred and the secular is blurred, so also the divine and the mortal realms in tantric philosophy are intertwined. After all, according to tantric belief, every human being has the potentiality of divinity or Buddhahood within him or her. This is nowhere more graphically represented than in the Tibetan lineage thankas, where gods and mortals occupy the same space, with mortal teachers often enjoying the most exalted status. While the identity of the Fifth Dalai Lama with the Buddha is emphasized by the gesture of his right hand, in the thanka (fig. 110) the eminent Sakyapa hierarch's "Buddhahood" is indicated by the presence of the two bodhisattvas

on either side of the elaborate throne. At the same time, the head, despite the idealized eyes and brows, is clearly a realistic representation.

Tibetan thankas also include figures of officiating celebrants or donors, but rarely are they true likenesses. The celebrant is usually represented on his own, engaged in performing rituals before an altar (fig. 114), while the donor, accompanied by his spouse and children, is shown seated in a group. The Guge thanka of the Buddha and the arhats includes a large group who may be identified as royalty (fig. 115) by comparison with other such representations. Characteristically, the ruler wears a Persian Safavid-style turban with a short baton,

116. **Base of Avalokiteshvara Stele** (detail of fig. 22) India, Bihar, Gaya or Patna district; c. 1000 A.D. (23261)

but the ladies are all dressed in typically Western Tibetan costume.

This kind of stereotyped and generalized portrayal of the celebrants and donors goes back to Indian art. The Jains were particularly diligent in representing their donors prominently in their temples. Both Hindus and Buddhists also added tiny figures of donors, with or without celebrants, in their sculptures. In the Buddhist stele from Bihar (fig. 116) the donor's kneeling figure is hardly visible in the luxuriant vegetation, but in the fragmentary Hindu sculpture (fig. 117) the figures are better preserved. In Tibet, however, donors or celebrants are rarely included in sculpture. Both in thankas and Indian stelae the donors, though in a minor position, are always integrated into the divine field. While they do not form a part of the religious subject, their inclusion assures their permanent presence in the sacred realm as perpetual recipients of divine grace.

India

While the Tibetan practice of depicting true likenesses of their religious hierarchs may have been due to close contacts with the Chinese courts during the Yuan and Ming periods, in India the inspiring source was the Mughal emperor Akbar. It was Akbar's sense of diplomacy and statesmanship that

117. **Architectural Fragment with Attendants of Vishnu**
(detail of fig. 61)
India, Rajasthan(?); 10th century (23256)

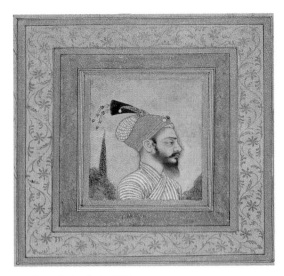

118. Portrait Head of a Noble
India, Deccan, Golconda(?); 1650–75 (23564)

119. Falconer in a Yellow Garment
India, Imperial Mughal; c. 1625 (23555)

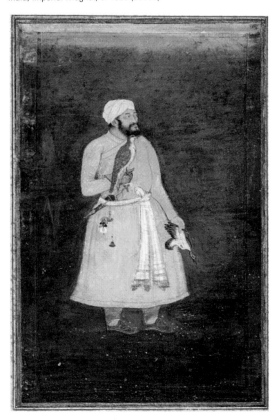

led to his desire to have portraits of all his important courtiers and generals taken to make it easy for him to recognize them. By the 1580s he presided over a huge empire, parts of which were months' journey from Agra or Lahore, or wherever the imperial camp happened to be at the moment. Officials and governors were often away for years and so an album of portraits was a helpful tool for a conscientious and astute ruler. While the inspiration for the practice was the emperor himself, the visual source was European art in the form of prints, as well as miniature portraits that were available from visiting Europeans. At least one sensitively rendered portrait of an unknown Mughal, a prince or noble, in the collection (fig. 118) is indeed a true miniature. However, diminutive as it is, this portrait executed around 1650–75 epitomizes the dramatic difference between portraiture in the Indo-Tibetan tradition and the Mughal style.

Most Mughal portraits are full-length formal representations of princes and courtiers who are shown standing. The convention established during Akbar's reign seems to have altered little until the end of Aurangzeb's reign (1658–1707). The sitter is shown with feet and head in complete profile but with the body sometimes given almost in a three-quarter frontal turn. The portrait of a falconer (fig. 119) is an exception in that even his face is depicted in three-quarter profile. He seems to have been walking with his falcon and a dead duck when he stopped in his tracks, perhaps distracted by something in the distance. The dark, monochromatic background, however, provides no other clue as to the narrative content of the picture, the time of day, or the topography.

In most pictures (fig. 67, 120–121) the person portrayed stands looking right or left against a pale green or uncoloured background. His attire, turban, sword, and dagger are indicative of his aristocratic status. Sartorial particulars are rendered in

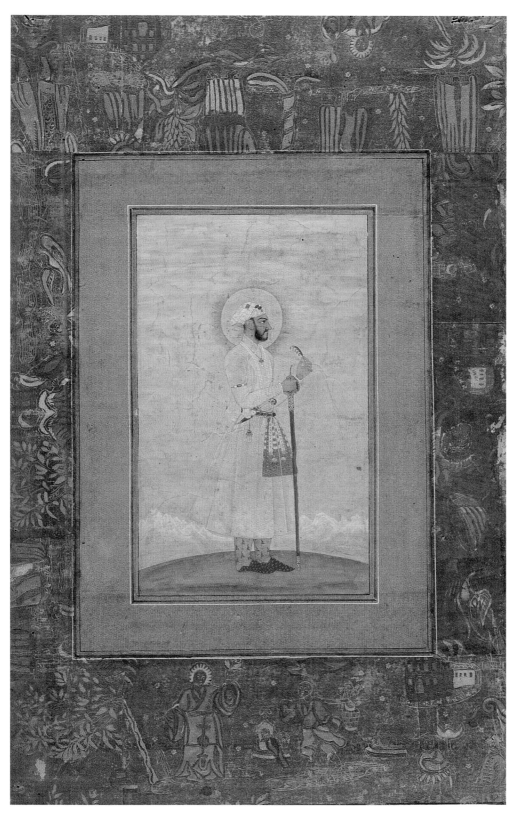

120. **Ali Mardan Khan** India, sub-imperial Mughal; c. 1650 (23563)

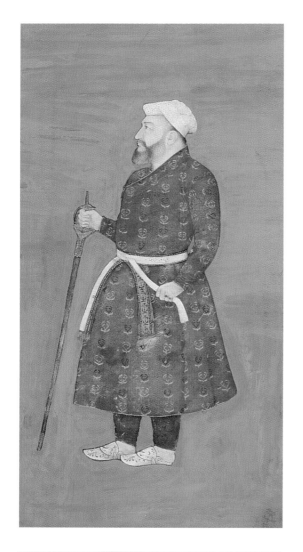

great detail, a fact that impressed the Dutch master Rembrandt, who owned several such portraits. Since the proportions of the figures vary considerably and the heads are individualized, it is clear that the Mughal artist was usually familiar with his subjects. However, almost every figure has the same impassive expression on the face and there is no eye contact between the viewer and the subject, who remains a remote, almost an iconic image. Even though the figures can be identified by inscriptions, as several in the collection are, and we know their histories, their portraits do not enlighten us a great deal about their personalities or their psychological profiles.

One portrait in the collection is inscribed to Abu'l Hasan, one of the masters of the imperial atelier (fig. 121). The son of the Persian master Aqa Riza, Abu'l Hasan was a favourite of Emperor Jahangir, who considered himself to be the greatest connoisseur of art, and was honoured with the title *Nadir al-Zaman*, or wonder of the world. While not one of his masterpieces, the portrait is nevertheless more sensitively and meticulously rendered than others. As is usually the case with Abu'l Hasan's pictures, he manages to provide texture to the materials of his subjects. Moreover, he has also succeeded in portraying a man of strong resolve through the subtle expression of the face, the determined manner in which he holds the sword and grips one end of his cummerbund.

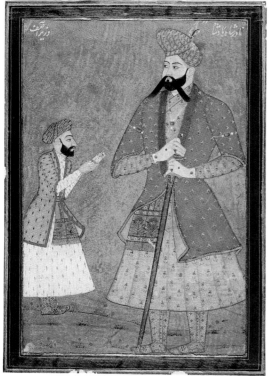

121. **Asaf Khan(?)**
India, Imperial Mughal; c. 1650 (23565)

122. **Nadir Shah of Persia with His Chief Minister**
India, Deccan, Golconda; 1675–1700 (23574)

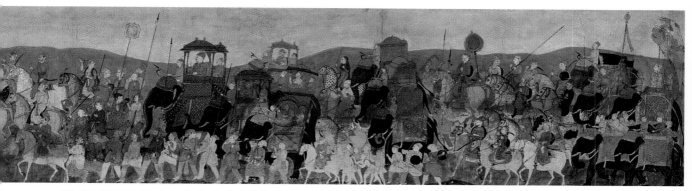

123. **Royal Procession** India, Andhra Pradesh, Hyderabad; early 18th century (23577)

Two paintings in the collection depict more lively subjects than straightforward formal representations. In one of these Jahangir (fig. 69), wearing unusually colourful pyjamas, examines a ruby from a plateful of gems proffered by an attendant, while another keeps the flies away. Indeed, while single portraits were confined to the courtiers, members of the imperial family were often shown holding full court or in less formal circumstances, as in this picture, where an aspect of their personality is emphasized. The second example is also in the Mughal tradition but was painted in the Deccan in the last quarter of the seventeenth century (fig. 122). While the two figures do interact, the disproportionate contrast between their sizes is not a trait commonly encountered in Mughal painting. The colossal figure is Nadir Shah of Persia, who sacked Delhi in 1739 and carried away a large number of books and albums. The picture may allude to the loss of books to this invader, for the smaller man identified as *wazir asaf*, or the chief minister, is seen offering three books to his master.

Some of the largest and most impressive ceremonial pictures were painted not for the Mughal court but for those of the Deccan. These were often in the form of long horizontal scrolls or banners of either cloth or paper. The subject usu-ally was a procession of some kind involving the ruler with an enormous retinue of men, elephants, and horses. In the example in the Tanenbaum Collection (fig. 123) the ladies of the court are also part of the milieu, travelling in covered palanquins. Although the scene vividly captures the pomp and bustle of such occasions, and especially the ponderous pace at which such unwieldy and large processions moved, it also betrays the entrenched conservatism of the Indian aesthetic tradition. The representation is no different than similar processions depicted on the gateways of the Buddhist stupa Sanchi almost two thousand years ago.

It should be clear by now that most portraits discussed so far are of men, thereby making the gender bias obvious. The mode of travel for women in the procession tells its own story, for both in Muslim and Hindu elite societies women led a sheltered life and rarely revealed themselves before strange males. Thus, there was no question of their portraits being taken, unless they were favourite dancing girls, musicians, or courtesans. Realistic portraiture of individual women of either the Mughal or the Rajput families is rare indeed, unless of course they were rendered by female artists. Even then it is unlikely that such portraits

124. **Portrait of a Lady**
India, later Mughal; 18th century (23568)

would have had a wide circulation in what was essentially a man's world. However, generalized pictures of life in the harem are not uncommon and several have been discussed elsewhere in this book. Only one depiction of a woman (fig. 124) is included here as a possible portrait, almost certainly of a beautiful courtesan. Although this portrait is an example of the eighteenth-century Mughal style either at Delhi or Oudh, it is quite typical of the genre that began to capture the imagination of the Mughal artists and patrons as early as the reign of Shah Jahan. The dissolute atmosphere that prevailed at both Mughal and Hindu courts after Aurangzeb appears to have made the genre popular.

Following their imperial overlords, the Rajput rulers also began to collect Mughal portraits as well as to commission their own. The conventions generally established by the Mughal artists were followed but with some modifications. In keeping with the traditional aesthetic norm, Rajput portraits show a greater degree of idealization and glamorization of the sitter, especially of royalty and if the picture is a formal court portrait. A fine example of such an idealized portrait in the collection is that of Bakhat Singh from Jodhpur (fig. 125). This kind of bust had its origins in Mughal pictures of Jahangir, who loved to appear in an upper window of the palace to allow those who had gathered outside to catch a glimpse *(darshan)* of the imperial visage, as one does in a temple. Because it is a bust, the head is magnified enormously to present the sitter as a larger than life figure.

125. **Maharaja Bakhat Singh of Jodhpur**
India, Rajasthan, Jodhpur, c. 1750 (23597)

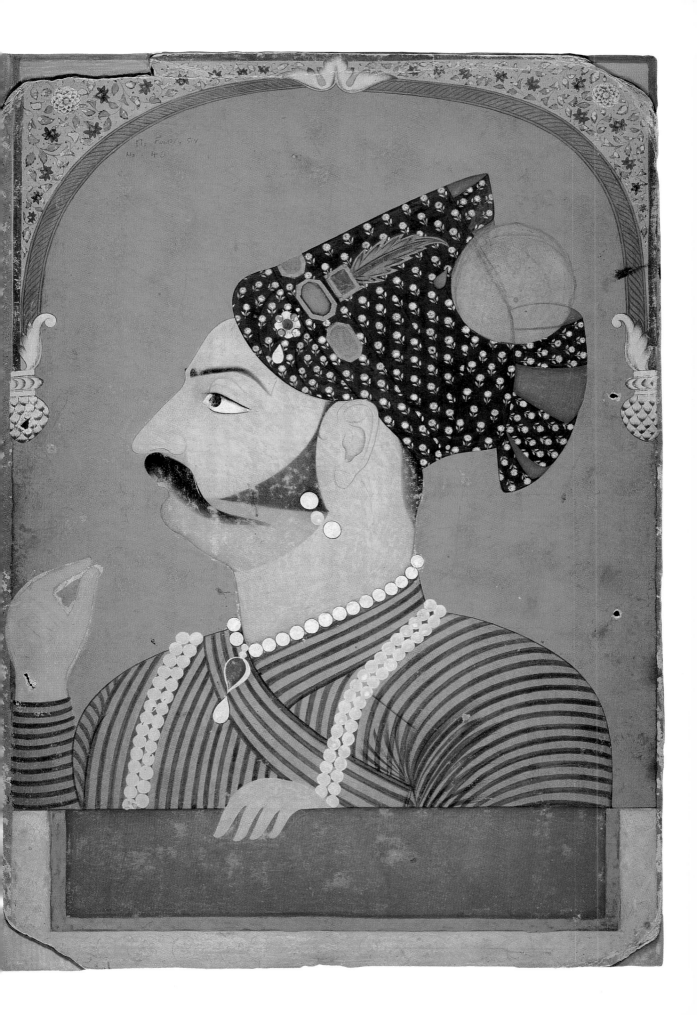

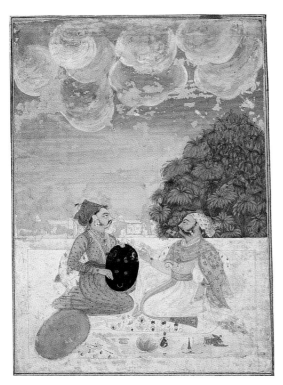

126. **Kesri Singh of Bikaner and a Guest on a Terrace**
India, Rajasthan, Bikaner; c. 1675 (23573)

127. **Raja Sidh Sen of Mandi Smoking a Hookah**
India, Himachal Pradesh, Mandi; c. 1700 (23627)

Another variation on the theme, also adopted from Mughal tradition, was to show two figures engaging in a tête-à-tête, usually on a balcony (fig. 126). In this Bikaner picture, a school that remained especially faithful to Mughal conventions, Kesri Singh (the figure on the left) is informally meeting with another prince on a terrace. Although the visitor offers a flower to Kesri who holds a shield, and an open container of betel-quids (*paan*) and bottles of attar of roses are symbolic of an amiable occasion, the faces do not betray much emotion of one kind or another. One wonders if the expressive clouds in the blue sky are given prominence to convey a message of mounting tensions in the minds of the conversationalists below.

By contrast the two portraits of rulers, one from Mandi in the hills (fig. 127) and the other from Bundi in Rajasthan (fig. 128), convey a more relaxed atmosphere. Both monarchs are, of course, seated on terraces and are enjoying their waterpipes (*hookah*). The Bundi ruler has an attendant using the fly whisk, while Sidh Sen is by himself. However, both make virtually the same gesture with their left hand, which may indicate a conversation with an unseen guest, or more likely, appreciation of a musical performance. It should be noted that neither grasps the snake of the hookah; while the Mandi ruler holds it with his mouth, the Bundi ruler's snake remains vertical, miraculously suspended. Other than the right hand of the Bundi ruler, which seems rather awkwardly done, the portrait is well painted with much attention to detail. In keeping with the Mandi style, the other portrait is rendered with less finesse but with greater fluency and vigour.

The final portrait from the Tanenbaum Collection included in this book is not really of a ruler but of a royal horse (fig. 129). It has already been noted that both Mughal and Rajput rulers

148

128. **A Raja Smoking a Hookah** India, Rajasthan, Bundi; 19th century (23634)

were enormously fond of their pet animals, especially the elephant and the horse, and would often have their portraits painted. This particular picture is from Kishangarh, where a very romantic style of painting developed in the mid-eighteenth century with strong influences from the slightly earlier Mughal paintings of the first decades of the century. Kishangarh artists were particularly fond of creating elegant landscapes with highly expressive, brilliant skies of reds, oranges, and yellows, as may be seen above the horse and the groom. Also characteristic of Kishangarh portraits of horses, the lower half of the animal was painted red. Otherwise, however, the horse is very likely drawn accurately from life, and certainly this unknown master was as good a horse painter as any. Along with the horse,

his keeper has also been granted immortality by being included in the portrait. One assumes that this too is an observed representation of a particular groom rather than a typological figure.

Ultimately, and despite the infusion of a massive dose of European naturalism through Mughal masters, this horse portrait, like most others painted for both Mughal and Rajput patrons, never lost the decorative flair and preference for the universal that have remained fundamental to the Indian aesthetic. There is a stillness and repose about these delineations of particular people, animals, and events that brings them closer to the world of myth than reality. But then in India the two can never be clearly separated.

129. **Portrait of a Horse and Groom**
India, Rajasthan, Kishangarh; 18th century (23595)

**SOUTH ASIAN AND HIMALAYAN
SCULPTURE
STONE AND WOOD**

Head of a Bodhisattva (fig. 54)
India, Uttar Pradesh, Mathura;
2nd–3rd century
Sikri sandstone; 30.5 cm high
No. 23233

Kubera, God of Wealth (fig. 56)
India, Uttar Pradesh; 6th century
Buff sandstone; 53.3 cm high
No. 23234

Shiva and Parvati (Uma-Maheshvara)
(fig. 8)
India, Madhya Pradesh; 6th century
Buff sandstone; 45.7 cm high
No. 23235

**Tile with Conversing Figures,
Ascetics, and Geese** (fig. 102)
India, Kashmir, Harwan; 5th century
Terracotta; 50.8 cm high
No. 23236

Male Head
India, Uttar Pradesh; 5th century
Terracotta; 16.5 cm high
No. 23237

Celestial Lady with Lotus Blossom
(fig. 57)
India, Uttar Pradesh; 6th century
Red sandstone; 55.9 cm high
No. 23238

Head of Vishnu (fig. 31, 55)
India, Madhya Pradesh; 5th century
Grey-buff sandstone; 22.9 cm high
No. 23239

**River Goddess Ganga with Retinue,
from a Temple Portal** (fig. 34)
India, Madhya Pradesh; 9th century
Reddish sandstone; 61 cm high
No. 23240

Architectural Fragment with Bhairava
(fig. 58)
India, Madhya Pradesh; 8th century
Reddish sandstone; 66 cm high
No. 23241

**River Goddess Yamuna on a Tortoise,
from a Temple Portal**
India, Madhya Pradesh; 8th century
Reddish sandstone; 66 cm high
No. 23242

Durga with Adorants
India, Uttar Pradesh; late 9th–10th century
Buff sandstone; 78.7 cm high
No. 23243

Dancing Ganesha (fig. 3)
India, Madhya Pradesh;
late 9th–10th century
Buff sandstone; 58.4 cm high
No. 23244

**Door Jamb with Yamuna, Attendants,
and Amorous Couples**
India, Madhya Pradesh or Rajasthan;
9th century
Reddish sandstone; 78.7 cm high
No. 23245

Head of Shiva Bhairava (fig. 12)
India, Madhya Pradesh; 9th century
Brown sandstone; 66 cm high
No. 23246

Jina Neminatha with Retinue
India, Madhya Pradesh; 9th–10th century
Brown sandstone; 58.5 cm high
No. 23247

**Jina Ajitanatha with Celestial
Attendants**
India, Madhya Pradesh; 10th century
Reddish sandstone; 81.3 cm high
No. 23248

Vishnu with Attendants
India, Madhya Pradesh; 10th century
Reddish sandstone; 81.3 cm high
No. 23249

Ram-headed(?) Yogini with Retinue
India, Madhya Pradesh; 10th century
Brown sandstone; 88.9 cm high
No. 23250

**Boar Incarnation of Vishnu with
Audience** (fig. 62)
India, Madhya Pradesh; 11th century
Buff sandstone; 69.9 cm high
No. 23251

Torso of a Celestial Woman
India, Madhya Pradesh; 10th century
Reddish sandstone; 61 cm high
No. 23252

**The Holy Family of Shiva and Parvati
(Uma-Maheshvara)**
India, Uttar or Madhya Pradesh;
c. 1000 A.D.
Buff sandstone; 88.9 cm high
No. 23253

**Shiva and Parvati Watch Ravana
Shaking Mount Kailash**
India, Madhya Pradesh; 11th century
Reddish sandstone; 96.5 cm high
No. 23254

Head of Vishnu
India; 9th century
Buff sandstone; 66 cm high
No. 23255

**Architectural Fragment with
Attendants of Vishnu** (fig. 61, 117)
India, Rajasthan(?); 10th century
Buff sandstone; 106.6 cm high
No. 23256

**Architectural Fragment with
Guardian Deities**
India; 10th century
Buff sandstone; 61 cm high
No. 23257

**Arch with Vishnu's Incarnations,
Planetary Deities, and Celestials**
(fig. 52)
India, Gujarat; 11th century
Buff sandstone; 43.2 cm high
No. 23258

Sun God Surya (fig. 59)
India, Bihar or Uttar Pradesh; 7th century
Grey sandstone; 81.3 cm high
No. 23259

Enlightenment of Buddha Shakyamuni
(fig. 20)
India, Bihar, Gaya district; 10th century
Grey sandstone; 71.2 cm high
No. 23260

Bodhisattva Avalokiteshvara
(fig. 22, 116)
India, Bihar, Gaya or Patna district;
c. 1000 A.D.
Black chlorite; 57.2 cm high
No. 23261

**Ganesha, the God of Beginnings
or Benevolence**
India, Karnataka; 13th century
Grey stone; 64.2 cm high
No. 23262

Indra, the King of the Gods
India; 9th–10th century
Red sandstone; 73.7 cm high
No. 23263

Durga in a Pacific Aspect
India; 9th–10th century
Red sandstone; 73.7 cm high
No. 23264

**Vasudhara, Buddhist Goddess
of Prosperity**
Nepal, Kathmandu Valley; 15th century
Wood, 50.8 cm high
No. 23265

Tara, Buddhist Saviour Goddess
Nepal, Kathmandu Valley; 16th century
Wood with traces of polychromy;
53.3 cm high
No. 23266

Arch for Doorway or Window
Nepal, Kathmandu Valley; c. 1600 A.D.
Wood; 66 cm high
No. 23267

BRONZE

Bodhisattva Maitreya (fig. 60)
India, Kashmir, or Pakistan, Swat;
7th century
Bronze with silver inlay; 19.7 cm high
No. 26649

Tara
India, Kashmir; 8th century
Bronze; 20.3 cm high
No. 26650

**Lakshmi and Vishnu
(Lakshmi-Narayana)** (fig. 4)
India, Uttar or Himachal Pradesh;
13th century
Brass; 25 cm high
No. 26651

Ganesha
India, Himachal Pradesh, Chamba area;
16th century
Brass; 13.5 cm high
No. 26652

Durga Destroying the Buffalo Titan
(fig. 14)
India, Himachal Pradesh, Kulu Valley;
before 15th century
Copper; 35.5 cm high
No. 26653

Buddhist Goddess
India or Bangladesh; 12th century
Copper; 7 cm high
No. 26654

**Krishna as the Flute-playing Cowherd
(Venugopala)**
India, Orissa; 15th century
Bronze; 20.3 cm high
No. 26655

Durga Destroying the Buffalo Titan
India, Orissa; 15th–16th century
Bronze or brass; 15.2 cm high
No. 26656

**Krishna as the Flute-playing Cowherd
(Venugopala)**
India, Orissa; 16th century
Brass; 19.5 cm high
No. 26657

Durga Destroying the Buffalo Titan
India, Bengal or Bangladesh; 15th century
Bronze; 15.3 cm high
No. 26658

**Altarpiece with Parshvanatha and
Four Jinas** (fig. 17)
India; 10th century
Bronze with silver inlay; 17.2 cm high
No. 26659

Jina Rishabhanatha
India, Gujarat; dated 1208 (=1151 A.D.)
Bronze, 24.1 cm high
No. 26660

**Altarpiece with Shitalanatha and
Twenty-three Jinas** (fig. 16)
India, Karnataka; dated 1531 V.S.
(= 1474 A.D.)
Bronze; 30.5 cm high
No. 26661

A Jina
India, Karnataka; 18th century
Brass; 16.5 cm high
No. 26662

Parvati (fig. 53A, B)
India, Tamil Nadu; 11th century
Bronze; 24.8 cm high
No. 26663

Shiva
India, Tamil Nadu; 14th century
Bronze; 38.1 cm high
No. 26664

Child Krishna Dancing
India, Tamil Nadu; 13th century
Bronze; 12.7 cm high
No. 26665

**Krishna as the Flute-playing Cowherd
(Venugopala)**
India, Tamil Nadu; 15th century
Bronze; 19.8 cm high
No. 26666

**Shiva as the Awesome Beggar
(Bhikshatanamurti)**
India, Tamil Nadu; 16th century
Bronze; 14 cm high
No. 26667

Vishnu
India, Tamil Nadu; 16th century
Bronze; 12 cm high
No. 26668

**Lamp Finial with Elephants Bathing
Lakshmi (Gajalakshmi)** (fig. 30)
India, Kerala; 16th century
Bronze; 13.3 cm high
No. 26669

**Ganesha as Mahaganapati with
Consort**
India, Kerala; 16th century
Bronze; 14.7 cm high
No. 26670

**Ganesha as Mahaganapati with
Consort**
India, Tamil Nadu; 16th century
Bronze; 12 cm high
No. 26671

Guardian Deity Aiyanar(?)
India, Tamil Nadu; 16th century
Bronze; 19.7 cm high
No. 26672

Shaiva Saint Sambandar (fig. 104)
India, Tamil Nadu; 17th century
Bronze; 16.5 cm high
No. 26673

Shiva as the Graceful Teacher
(Dakshinamurti) (fig. 10)
India, Tamil Nadu; 16th century
Bronze; 15.3 cm high
No. 26674

Shiva
India, Karnataka(?); 17th century
Bronze; 13.2 cm high
No. 26675

Aiynar
India, Tamil Nadu; 18th century
Bronze; 9.5 cm high
No. 26676

Vishnu with Consorts Shridevi and
Bhudevi
India, Kerala; 17th century
Bronze; 16.5 cm high
No. 26677

Ceremonial Dagger with Fluting Krishna
and Heraldic Eagles (fig. 7, 33)
India, Tamil Nadu; 16th century
Gilt copper; 26.7 cm high
No. 26678

Shiva as the Teacher
India, Karnataka(?); 17th century
Bronze; 12 cm high
No. 26679

Parvati
India, Tamil Nadu; 16th century
Bronze; 20.4 cm high
No. 26680

Kali with Musicians (fig. 15)
India, Tamil Nadu; 15th century
Bronze; 25.4 cm high
No. 26681

Shiva as Lord of the Dance (Nataraja)
(fig. 11)
India, Tamil Nadu; 17th century
Bronze; 23.2 cm high
No. 26682

Tara
Nepal; c. 1000 A.D.
Copper; 17.8 cm high
No. 26683

Tara
Nepal; 13th century
Gilt copper inlaid with stones; 17.8 cm high
No. 26684

Parvati from an Uma-Maheshvara
Group
Nepal; 11th century
Gilt copper; 15.5 cm high
No. 26685

Vishnu
Nepal; 14th century
Gilt copper; 14.9 cm high
No. 26686

Crowned Amitabha Buddha
(frontispiece)
Nepal; 15th century
Gilt copper; 11.4 cm high
No. 26687

Mahasahasrapramardani, Buddhist
Protective Goddess
Nepal; 16th century
Gilt copper inlaid with stones; 13.4 cm high
No. 26688

Cosmic Form of Vishnu (fig. 1)
Nepal; 16th century
Gilt copper; 20.3 cm high
No. 26689

Samvara Embracing Nairatmya (fig. 23)
Nepal; 17th century
Gilt copper; 21.7 cm high
No. 26690.1–2

Throne Back from an Altarpiece with
Buddha(?)
Nepal; 17th century
Gilt copper repoussé; 33 cm high
No. 26691

Buddha Vajradhara
Nepal or Tibet; 17th century
Copper; 14 cm high
No. 26692

Portrait of a Donor
Nepal, Kathmandu Valley; 18th century
Copper; 10.8 cm high
No. 26693

Bird-headed Form of Samvara
Embracing Consort
Nepal or Tibet; 20th century
Gilt copper; 15.2 cm high
No. 26694

Bodhisattva Avalokiteshvara
Western Tibet or Ladakh; 10th century
Copper; 10.2 cm high
No. 26695

Bodhisattva Avalokiteshvara
Western Tibet or Himachal Pradesh;
10th century
Bronze; 7 cm high
No. 26696

Tara
Southern Tibet; 13th century
Bronze with inlay; 12.7 cm high
No. 26697

Buddha Shakyamuni or Akshobhya
Buddha
Central Tibet; 13th–14th century
Bronze with inlay; 22.2 cm high
No. 26698

Jambhala, Buddhist God of Wealth
(fig. 64)
Central Tibet; 13th century
Bronze with inlay; 48.2 cm high
No. 26699

Bodhisattva Avalokiteshvara
Western Tibet or Northwest Nepal;
15th century
Bronze; 24.1 cm high
No. 26700

Ritual Dagger (Phurbu) (fig. 26)
Western Tibet; 15th century
Bronze, copper, iron, and paint;
24.1 cm long
No. 26701

Bodhisattva Avalokiteshvara
Central Tibet; 12th century
Gilt bronze with gold paint(?); 47 cm high
No. 26702

Tara
Central Tibet; 12th–13th century
Bronze; 9.2 cm high
No. 26703

Tara (fig. 63)
Central Tibet(?); 12–13th century
Bronze; 9.8 cm high
No. 26704

Bodhisattva Avalokiteshvara
Central Tibet; 13th century
Bronze; 10.2 cm high
No. 26705

Shrine with Bodhisattvas Avalokiteshvara, Vajrapani (right), **and Maitreya** (left)
Central Tibet; 14th century
Bronze; 35.5 cm high
No. 26706

Altarpiece with Buddha, Achala, Two Taras, and Two Lamas
Central Tibet; 14th–15th century
Bronze; 17.2 cm high
No. 26707

Monk-Teacher Namkha Landup
Central Tibet; late 17th century
Bronze; 18.6 cm high
No. 26708

Portrait of a Monk
Central Tibet; 16th century
Bronze; 16.5 cm high
No. 26709

The Great Attainer (Mahasiddha) Virupa (fig. 105)
Central Tibet; 16th century
Copper with silver inlay; 20.3 cm high
No. 26710

Vajrabhairava
Central Tibet; c. 1600 A.D.
Bronze; 21.6 cm high
No. 26711

Reliquary (Chöten) (fig. 21)
Central Tibet; 17th century
Gilt copper with inlay of stones;
24.7 cm high
No. 26712.1–2

Trailokyavijaya
Central Tibet; 17th century
Gilt copper; 14 cm high
No. 26713

Bodhisattva Avolokiteshvara
Central Tibet; 14th century
Bronze with silver inlay; 20.3 cm high
No. 26714

Jambhala
Central Tibet; 14th century
Bronze; 15.9 cm high
No. 26715

Buddha Shakyamuni
Central Tibet; 16th century
Bronze; 20.3 cm high
No. 26716

Sakyapa Teacher Kongton Chöje
(fig. 112, 113)
Central Tibet; 14th–15th century
Bronze; 21 cm high
No. 26717

Sakyapa Teacher Kunga Gyaltsan, known as Sakya Pandita
Central Tibet; 15th century
Bronze, copper, silver; 21 cm high
No. 26718

A Sakyapa Monk-Teacher
Central Tibet; 16th century
Bronze with inlay; 17.2 cm high
No. 26719

Rahula (fig. 32, back cover)
Central Tibet; 15th century
Gilt copper with inlay; 33 cm high
No. 26720

Sakyapa Monk Drogon Phakpa
Central Tibet, Tsang region; 17th century
Bronze with copper and silver; 22.9 cm high
No. 26721

Tara (fig. 24)
Central Tibet; 14th century
Gilt copper with inlay; 38.7 cm high
No. 26722

Moon God Chandra
Eastern Tibet; 18th century
Gilt bronze and copper; 15.3 cm high
No. 26723

Earth Spirit Daka
Eastern Tibet; 18th century
Bronze; 11.4 cm high
No. 26724

Samvara Embracing Nairatmya
Eastern Tibet; 19th century
Base silver with turquoise; 21 cm high
No. 26725

A Bodhisattva
Tibet; 15th century
Copper; 18.4 cm high
No. 26726

A Dakini
Tibet; 19th century
Bronze; 9.5 cm high
No. 26727

The Fifth Dalai Lama (fig. 111)
Eastern Tibet; late 17th century
Gilt bronze; 20.3 cm high
No. 26728

INDIAN PAINTING

Dying Ascetic with Attendants
Persia; 16th century
Opaque watercolour on paper with
decorated and ruled borders laid on gold
decorated board; 8.8 x 11.5 cm (image),
21 x 33.8 cm (mount)
No. 23268

Folio from an Album
RECTO: **Gathering of Women on a Terrace** (fig. 71)
India, Imperial Mughal; late 16th century
Opaque watercolour on light board bearing
seals, with added ruled paper borders;
20.5 x 10.8 cm (image), 40.5 x 26.3 cm (folio)
VERSO: page of calligraphy from an
unidentified story
India or Persia; 16th–17th century
Pen and brush with ink, opaque water-
colour and gold on light board bearing seal,
with added paper borders;
22.8 x 11.2 cm (page)
No. 23269

Folio from a *Baburnama* Manuscript
RECTO: **Mughal Ruler Babur Supervising the Creation of a Garden** (fig. 40)
India, Imperial Mughal, attributed to
Sur Gujarati; 1590–98
Opaque watercolour on paper with gold
and coloured ruled borders; 24.8 x 13.3 cm
(image), 26.5 x 15.9 cm (folio)
VERSO: Persian text of the *Baburnama* in
Nasta'liq script
India, Imperial Mughal, 1590–98
Brush and pen with ink and gold on paper;
17 x 7.8 cm (page)
No. 23551

Folio from an Album
RECTO: **The Lamentation of Shirin at Farhad's Grave** (fig. 41, 68)
India, Mughal; 17th century
Inscribed to Muhammad Fazil
Opaque watercolour on paper with gold
decorated and ruled borders laid on gold-
speckled board; 17.9 x 13.3 cm (image),
21.5 x 16.9 cm (folio)
VERSO: page of calligraphy of a Persian
poem (Wasli) by Shams al-Din Muhammad
Katibi (d. 1436 or 1438); calligrapher
Mahmud ibn Ishaq al-Shinabi (fig. 70)
Persia; 16th century
Brush and pen with opaque watercolour
and ink on paper with gold and coloured
ruled borders laid on gold-speckled board;
20 x 10.4 cm (page)
No. 23552

Folio from a *Ramayana* Manuscript
India, sub-imperial Mughal; c. 1595
RECTO: **The Gods Convince Rama of Sita's Purity** (fig. 38)
Opaque watercolour on light board;
28.6 x 18.6 cm (folio)
VERSO: text in Nagari script
Pen with ink and opaque watercolour on light board
No. 23553

A Mughal Courtier
India, Imperial Mughal, possibly by Rai Chitarman; c. 1650
Fine brush and ink on paper with coloured ruled borders laid on gold floral-decorated board; 15.8 x 9.8 cm (image),
29.5 x 18.0 cm (mount)
No. 23554

Falconer in a Yellow Garment (fig. 119)
India, Imperial Mughal; c. 1625
Opaque watercolour on paper with gold and coloured ruled borders laid on gold-speckled board; 15.4 x 9.5 cm (image),
36.6 x 23.3 cm (mount)
No. 23555

Folio from the *Late Shah Jahan Album*: Page of Calligraphy with Border Containing Animals, Birds, and Flowers (fig. 42)
India, Imperial Mughal border; Persian calligraphy, of an earlier but unknown date, by Ali; c. 1630
Brush and pen with opaque watercolour, ink, and gold on paper with ruled and decorated borders and margins; 19.3 x 10.5 cm (page), 36.6 x 25.1 cm (folio)
No. 23556

Folio from an Album: Prince Daniyal with Bow and Arrow (fig. 43)
India, Imperial Mughal; c. 1600, borders of later date
Opaque watercolour on paper with gold marbled border laid on blue stencilled board; 11.4 x 7.5 cm (image), 26 x 17.1 cm (folio)
No. 23557

Emperor Jahangir Examining a Gem (fig. 69)
India, Imperial Mughal; 1625–50, later mount
Opaque watercolour on paper laid on gold-speckled light board; 11.7 x 12 cm (image), 22.3 x 28.2 cm (sheet)
No. 23558

Iftikhar Khan
India, Imperial Mughal; 1650–75
Brush and black ink and opaque watercolour on paper with laid pink borders;
19.4 x 12 cm (image), 26.5 x 19 cm (mount)
VERSO: page of calligraphy over gold drawing
Opaque watercolour with decorative inserts on paper and coloured borders laid on board; 20.6 x 10.1 cm (page)
No. 23559

Nursing Woman with Attendants on a Palace Terrace (fig. 72)
India, Imperial Mughal; 1625 or earlier
Opaque watercolour on paper with border laid on gold-speckled board;
19.7 x 12.9 cm (sheet)
No. 23560

King Humayun (fig. 67)
India, Imperial Mughal; c. 1650
Opaque watercolour on paper with gold and coloured ruled borders laid on light board; 16.3 x 7.8 cm (image),
20.0 x 11.7 cm (mount)
No. 23561

Woman Visiting a Pierced-ear (Kanphata) Yogi at Night (fig. 44)
India, Imperial Mughal, style of Payag; c. 1650
Opaque watercolour on paper laid on board; 18.7 x 14.0 cm (sheet)
No. 23562

Folio from an Album
RECTO: **Ali Mardan Khan** (fig. 120)
India, sub-imperial Mughal; c. 1650
Opaque watercolour on paper with ruled and decorated border embossed with gold and hand colouring; 19.6 x 11.5 cm (image), 44.1 x 28.7 cm (folio)
VERSO: page of calligraphy with verses (Wasli) from Sa'di's *Gulistan*
Persia or India, calligrapher unknown; c. 1600
Pen and brush with opaque watercolour, ink and gold on paper with ruled borders laid on coloured embossed board;
20 x 14.1 cm (page)
No. 23563

Portrait Head of a Noble (fig. 118)
India, Deccan, Golconda(?); 1650–75
Opaque watercolour on paper with gold floral-decorated borders; 5.5 x 4.6 cm (image), 32.4 x 25.4 cm (sheet)
No. 23564

Asaf Khan(?) (fig. 121)
India, Imperial Mughal; c. 1650
Inscribed (on belt) to Nadir al-Zaman (Abu'l Hasan)
Opaque watercolour on laminated paper;
21.7 x 10.5 cm (sheet)
No. 23565

Prince with Two Ladies and a Female Musician (fig. 78)
India, later Mughal; c. 1725
Opaque watercolour on paper with gold decorated and ruled borders laid on gold-speckled board; 15 x 9 cm (image),
29 x 23 cm (sheet)
VERSO: page of calligraphy over gold drawing
Pen and brush with opaque watercolour, black ink, and gold on paper with ruled borders laid on gold-speckled board;
15.7 x 7.7 cm (page)
No. 23566

Two Women Embracing
India, later Mughal or Deccan; 18th century
Brush and black ink with traces of colour on paper; 8.8 x 6.5 cm (sheet)
No. 23567

Portrait of a Lady (fig. 124)
India, later Mughal; 18th century
Opaque watercolour on paper with gold decorated borders laid on gold-speckled blue board; 24.5 x 15.8 cm (image),
37.6 x 26.7 cm (sheet)
No. 23568

A Mughal Prince, possibly Muhammad Muazzam, later Shah Alam Bahadur I
India, later Mughal; 18th century
VERSO: inscriptions in Nagari and Arabic scripts
Opaque watercolour on paper with gold ruled and coloured borders laid on board;
17.1 x 9 cm (image), 23.4 x 14.8 cm (sheet)
No. 23569

A Hindu Bridal Scene (fig. 73)
India, later Mughal; c. 1725
Opaque watercolour on paper with gold decorated and ruled borders laid on gold-speckled board; 22 x 14 cm (image),
35.8 x 24.6 cm (sheet)
No. 23570

Elephants with Mahouts
India, later Mughal; 18th century or earlier
Brush and black ink with grey washes on
paper, images cut out and laid on paper;
23.5 x 32.8 cm (sheet)
No. 23571

Two Textile Designs with Flowers
India, later Mughal; 18th–19th century
Opaque watercolour on sized silk
1. calligraphy in Thuluth and Naskh
scripts; 21.6 x 32 cm
2. 20.8 x 32 cm
No. 23572.1–2

**Kesri Singh of Bikaner and a Guest
on a Terrace** (fig. 126)
India, Rajasthan, Bikaner; c. 1675
Opaque watercolour on paper laid on
paper; 17.4 x 11.8 cm (image),
21.5 x 12.5 cm (sheet)
No. 23573

**Nadir Shah of Persia with His Chief
Minister** (fig. 122)
India, Deccan, Golconda; 1675–1700
Opaque watercolour on paper with gold
and coloured ruled borders laid on board;
24.0 x 16.9 cm (sheet)
No. 23574

**Two Ladies Chit-chat while a Maid
Chases Flies**
India, Andhra Pradesh, Hyderabad;
18th century
Pounced drawing, pen and ink, and
graphite on paper with traces of colour
on verso; 16.3 x 11.1 cm (sheet)
No. 23575

Ladies Being Entertained on a Terrace
(fig. 77)
India, Deccan, Shorapur(?); 18th century
Opaque watercolour on light board;
25.4 x 20.1 cm (sheet)
No. 23576

Royal Procession (fig. 28, 123)
India, Andhra Pradesh, Hyderabad;
early 18th century
Opaque watercolour on three joined pieces
of paper, at one stage mounted on canvas,
later mounted on wood, now laid on
modern paper; unfinished, cut at left;
36.4 x 131.7 cm (sheet)
No. 23577

**Folio from a *Kalakacharyakatha*
Manuscript**
India, Gujarat; late 15th century
RECTO: **Kalaka with Indra Disguised**
(upper register); **Kalaka with Indra
Revealed** (lower register)
Opaque watercolour on paper;
11 x 6 cm (image), 11.0 x 23.5 cm (folio)
VERSO: text, colophon page naming scribe
Mahanshiva
Black and red ink, with red lettering
forming designs: a swastika (at left) and
an elephant (at right)
No. 23578

**Folio from a *Kalpasutra* and
Kalakacharyakatha Manuscript:
Kalaka and the Shahi King in
Conversation**
India, Gujarat; early 15th century
Opaque watercolour on paper laid on
modern sheet; 11.1 x 9.7 cm (folio)
No. 23579

**Folio from a *Kalpasutra* Manuscript:
Enshrined Jina and a Preaching Monk**
India, Gujarat; late 15th century
Opaque watercolour on paper laid on
modern sheet; 12.5 x 25.5 cm (folio)
No. 23580

**Two Folios from a *Kalpasutra*
Manuscript**
India, Gujarat; 16th century
1. RECTO: **Siddhartha Hears the
Recitation of Queen Trisala's Dreams**
VERSO: text
Opaque watercolour on paper;
10.7 x 21.4 cm (folio)
2. RECTO: **Mahavira in the Initiation
Palanquin**
VERSO: text
Opaque watercolour on paper;
10.7 x 21.4 cm (folio)
No. 23581.1–2

**Three Folios from a *Kalpasutra* and
Kalakacharyakatha Manuscript**
India, Gujarat; 16th century
1. RECTO: **Indra Instructing
Harinaigamesha** (fig. 18)
VERSO: text
Opaque watercolour on paper;
12.6 x 32.5 cm (folio)
2. RECTO: **Kalaka and the Shahi King**
(upper register); **Kalaka Converts Bricks
to Gold** (lower register) (fig. 65)
VERSO: text
Opaque watercolour on paper;
12.6 x 32.1 cm (folio)

3. RECTO: **Kosha Dances before the
Royal Archer** (fig. 35)
VERSO: text
Opaque watercolour on paper;
12.0 x 32.1 cm (folio)
No. 23582.1–3

**Shvetambara Pilgrims Performing
Prostrations in front of Jain Temple**
(fig. 19)
India, Rajasthan, Marwar(?);
late 18th century
Opaque watercolour on paper;
11.5 x 25.5 cm (sheet)
No. 23583

Folio from a *Bhagavatapurana* Series
Northern India, Mewar(?); 1540–50
RECTO: **Yasoda Sees the Universe in
Krishna's Mouth** (fig. 39)
Opaque watercolour on laminated paper;
17.9 x 23.5 cm (folio)
VERSO: text
Brush with opaque watercolour and ink
on laminated paper
No. 23584

**Folio from a *Panchakhyana*
Manuscript: Tales with Animals**
India, Rajasthan, Mewar; c. 1725
Opaque watercolour on light board;
24.7 x 40.2 cm (folio)
No. 23585

**Folio from a *Sursagar* Manuscript of
Surdas: Radha and Krishna
Exchanging Clothes and Reversing
Roles** (fig. 86)
India, Rajasthan, Mewar; 1700–25
Opaque watercolour on light board with
added board borders in colour;
39.5 x 28.6 cm (folio)
No. 23586

Two Folios from an Unidentified Album
Nepal; c. 1700
God Ganesha
Opaque watercolour on laminated paper;
17.0 x 21.0 cm (folio)
No. 23587
A Raja on an Elephant, with Attendant
Opaque watercolour on paper;
20.4 x 16.0 cm (folio)
No. 23603

Three Folios from an Unidentified Manuscript Describing Hells
India, Rajasthan or Gujarat; c. 1800
1. **Two Scenes on the Theme of Justice**
RECTO AND VERSO: opaque watercolour on laminated paper; 16.5 x 21.5 cm (folio)
2. **Two Scenes on the Theme of Justice**
RECTO AND VERSO: opaque watercolour on laminated paper; 16.5 x 21.5 cm (folio)
3. **Two Scenes on the Theme of Justice**
RECTO AND VERSO: opaque watercolour on laminated paper; 16.5 x 21.5 cm (folio)
No. 23588.1–3

Two Folios from a *Ragamala* Series
India, Rajasthan, Bundi-Kota; 18th century
Madhumadhavi Ragini (fig. 90)
Opaque watercolour on laminated paper; 26.5 x 19.0 cm (folio)
No. 23589
Kamodini Ragini (fig. 37)
Opaque watercolour on laminated paper; 27.1 x 19.6 cm (folio)
No. 23590

Ladies on a Terrace with Two Male Musicians (fig. 75)
India, Rajasthan, Bundi-Kota; 1725–50
Opaque watercolour on laminated paper; 30.4 x 23.8 cm (sheet)
No. 23591

Entertainment with Pigeons (fig. 74)
India, Rajasthan, Bundi-Kota; 1725–50
Opaque watercolour on laminated paper; 23.0 x 18.7 cm (sheet)
No. 23592

Folio from a *Ragamala* Series: Nata Ragini (fig. 45)
India, Rajasthan, Kota, workshop of Sheikh Taju; c. 1750
Opaque watercolour on light board with gold decorated ruled borders; 13.3 x 23.0 cm (folio)
No. 23593

A Raja Hunting Boars (fig. 79)
India, Rajasthan, Kota; 18th century
Opaque watercolour on laminated paper; 22.5 x 28.4 cm (sheet)
No. 23594

Portrait of a Horse and Groom (fig. 129)
India, Rajasthan, Kishangarh; 18th century
VERSO: **Flower Painting**
Opaque watercolour on board with gold decorated and ruled borders; 25.8 x 34.8 cm (sheet)
No. 23595

Radha Seated against a Bolster
India, Rajasthan, Kishangarh; early 20th century
Opaque watercolour on light board; 19.3 x 16.2 cm (sheet)
VERSO: **Female Profile**
Brush and black ink on light board; 19.3 x 16.2 cm (sheet)
No. 23596

Maharaja Bakhat Singh of Jodhpur (fig. 125)
India, Rajasthan, Jodhpur, c. 1750
Opaque watercolour on board; 43.1 x 30.4 cm (sheet)
VERSO: **Sketches of Elephants** (fig. 29)
Brush with opaque watercolour and ink on board; 43.1 x 30.4 cm (sheet)
No. 23597

A Raja on a Carpet, Smoking a Hookah
India, Rajasthan, Raghugarh(?); 18th century
Opaque watercolour on light board; 29.7 x 20.5 cm (sheet)
No. 23598

Scene from an Unidentified Myth
India, Rajasthan, Jodhpur(?); c. 1800
Opaque watercolour on laminated paper; 30.0 x 22.9 cm (sheet)
No. 23599

Krishna and Cowherdesses
India, Rajasthan, Nathadvara; 19th century
Opaque watercolour on cotton, with border; 313.5 x 263.5 cm (sheet)
No. 23600

Krishna and Cowherdesses
India, Rajasthan, Nathadvara; 19th century
Opaque watercolour on cotton lined with paper; 187 x 154.7 cm (sheet)
No. 23601

Ladies Celebrating in a Courtyard (fig. 76)
India, Rajasthan, Jodhpur; 18th century
Opaque watercolour on board; 34.9 x 23.9 cm (sheet)
No. 23602

Lady with a Crane beside a Pool and a Man Hunting Antelope (fig. 80)
India, Rajasthan, Ajmer(?); c. 1750
Opaque watercolour on light board; 19.7 x 13.3 cm (sheet)
No. 23604

Four Folios from a *Rasikapriya* Manuscript
India, Malwa; dated 1634
RECTO: **Krishna and His Lover in a Landscape**
VERSO: **A Man and a Woman outside a Pavilion with Bed (Lilahava)**
Opaque watercolour on laminated paper; 20.0 x 16.2 cm (folio)
No. 23605
RECTO: **Two Women outside a Pavilion with Bed (Krishna's Hidden Frenzy)** (fig. 36)
VERSO: **Women Converse in a Pavilion with Bed as Krishna Waits outside (Krishna's Overt Frenzy)** (fig. 85)
Opaque watercolour on laminated paper; 21.2 x 16.7 cm (folio)
No. 23606
RECTO: **Woman Holding the Child Krishna**
VERSO: **Lady Climbing the Steps to a Pavilion (Lalitahava)**
Opaque watercolour on laminated paper; 21.6 x 17.0 cm (folio)
No. 23607
RECTO: **Lovers Embracing in a Pavilion (Meeting in the Nurse's House)**
VERSO: **Lovers Conversing in a Pavilion (Meeting in the Friend's House)**
Opaque watercolour on laminated paper; 21.3 x 17.2 cm (folio)
No. 23608

Folio from a *Bhagavatapurana* Series
India, Bundelkhand(?); c. 1650
Couple Adoring Krishna (Birth of Krishna)
Opaque watercolour on paper; 14.0 x 21.1 cm (folio)
No. 23609

Two Folios from an *Amarusataka* (Amaru's Centum of Verses) Manuscript
India, Malwa; c. 1660
Two Females Converse within a Blue-walled Pavilion
Opaque watercolour on laminated paper; 21.8 x 14.7 cm (folio)
No. 23610
A Man and a Woman Converse inside a Pavilion, with Two Attendants outside (fig. 83)
Opaque watercolour on laminated paper; 21.7 x 14.3 cm (folio)
No. 23612

Folio from a *Ragamala* Series:
Vasanta Raga (fig. 46)
India, Malwa; c. 1660
Opaque watercolour on laminated paper;
20.5 x 14.5 cm (folio)
No. 23611

Folio from a *Ragamala* Series:
Todi Ragini (fig. 89)
India, Malwa; c. 1650
Opaque watercolour on laminated paper;
21.7 x 16.4 cm (folio)
No. 23613

Folio from a *Ragamala* Series:
Shri Raga Chandra (fig. 92)
India, Himachal Pradesh, Bilaspur;
late 17th century
Opaque watercolour on paper laid on
laminated paper; 25.6 x 19.5 cm (folio)
No. 23614

A Prince Meeting a Lady in a
Landscape
India, Madhya Pradesh, Datia; c. 1700
Opaque watercolour on paper;
22.2. x 15.0 cm (sheet)
No. 23615

Radha and Krishna (fig. 87)
India, Rajasthan; c. 1700
Opaque watercolour on laminated paper
laid on narrow mount;
23.3 x 16.0 cm (sheet)
No. 23616

Illustration from a *Mahabharata*
Series: Warrior Killing a Tiger (fig. 81)
India, Andhra Pradesh or Maharashtra;
19th century
Opaque watercolour on light board;
31.1 x 42.2 cm (sheet)
No. 23617

Illustration from a *Mahabharata* Series
India, Andhra Pradesh or Maharashtra;
19th century
RECTO: **Babhruvahana with the**
Sacrificial Horse
VERSO: **Babhruvahana with the**
Sacrificial Horse
Opaque watercolour on paper;
29.5 x 43.0 cm (sheet)
No. 23618

Illustration from a *Mahabharata*
Series: Battle Scene
India, Andhra Pradesh or Maharashtra;
19th–20th century
Opaque watercolour on paper laid on
modern sheet; 28.0 x 40.5 cm (sheet)
No. 23619

Krishna, Radha, and Balarama(?)
India, Orissa; 19th century
Opaque watercolour on palm leaf mounted
on modern board; 22.0 x 21.5 cm (sheet)
No. 23620

Maharaja Abhai Singh of Jodhpur
India, Rajasthan, Bikaner; late 18th century
Brush with black ink, grey washes, and
traces of colour on paper;
24.5 x 14.5 cm (sheet)
No. 23621

Portrait of a Prince Holding a Stick
and a Rose
India, Rajasthan, Bikaner; late 18th century
Brush with black ink and touches of
colour on paper;
15 x 10.9 cm (sheet, irregularly shaped)
VERSO: **Portrait of a Prince Holding a**
Bow and Arrow
Brush and black ink on paper
No. 23622

Portrait of the Artist Sahibdin of Umran
India, Rajasthan, Bikaner; 1750–75
VERSO: inscriptions in Nagari and
Arabic scripts
Brush and black ink with light brown
washes on laminated paper; 22.4 x 16.4 cm
No. 23623

Maharaja Gaj Singh of Bikaner
India, Rajasthan, Jodhpur; c. 1800
Opaque watercolour on light board;
22 x 13.2 cm (image), 24.9 x 17.0 cm
(sheet)
No. 23624

Folio from a *Rasamanjari* Series
India, Himachal Pradesh, Nurpur, attributed
to Golu; c. 1710
RECTO: **Uttama Nayaka (Excellent Hero)**
(fig. 84)
VERSO: text unrelated to image on recto
Opaque watercolour on laminated paper;
18.2 x 29.0 cm (folio)
No. 23625

Folio from a *Bhagavatapurana* Series:
Vishnu Orders the Uprooting of Mount
Mandara
India, Rajasthan, Mewar; c. 1675
Opaque watercolour on light board;
22.6 x 34.3 cm (folio)
No. 23626

Raja Sidh Sen of Mandi Smoking
a Hookah (fig. 127)
India, Himachal Pradesh, Mandi; c. 1700
Opaque watercolour on paper;
22.3 x 16.0 cm (sheet, irregularly shaped)
No. 23627

Folio from an *Usha-Aniruddha*
Romance Series: Banasura Dispatches
His Demon Armies (fig. 82)
India, Himachal Pradesh, Guler;
late 18th century
Unfinished, opaque watercolour on
laminated paper; 20.4 x 29.7 cm (folio)
No. 23628

Two Portraits Mounted Together
Northern India, Mughal style of early
17th century; 18th century or later
Opaque watercolour on paper with inserts
laid on board; 3 x 2.2 cm (each portrait),
9.8 x 4.4 cm (mount)
No. 23629

Trysting Heroine (Abhisarika Nayika)
India, Himachal Pradesh, Chamba; c. 1800
Opaque watercolour on board;
25.3 x 19.0 cm (sheet)
No. 23630

Radha and Krishna in a Landscape
(fig. 6)
India, Himachal Pradesh, Mandi, ascribed
to Sajnu; c. 1810
Opaque watercolour on paper with gold
ruled borders laid on gold-speckled blue
board with traces of colour;
23.0 x 15.0 cm (sheet)
No. 23631

Shiva and Parvati on Mount Kailash
(fig. 9)
India, Uttar Pradesh, Garhwal; c. 1825
Opaque watercolour on light board;
22.2 x 16 cm (image), 27.7 x 22.2 cm
(sheet)
No. 23632

Folio from a *Ragamala* Series:
A Prince on a Terrace with Two
Female Attendants (fig. 91)
India, Andhra Pradesh, Hyderabad;
19th century
Opaque watercolour; 25.0 x 16.0 cm (folio)
No. 23633

A Raja Smoking a Hookah (fig. 128)
India, Rajasthan, Bundi; 19th century
Opaque watercolour on board;
34.1 x 30.4 cm (sheet)
VERSO: **Male Figure**
Brush and blue watercolour on board
No. 23634

Dervishes Dancing
India, Punjab(?); 19th century
VERSO: inscription in Arabic
Brush and black ink on paper;
23.6 x 28.5 cm (sheet)
No. 23635

Lady with Attendants on a Terrace
in an Approaching Storm
India, Himachal Pradesh;
late 19th century or later
VERSO: inscription in Gurmukhi regarding
the effect of the monsoon on women's
moods
Opaque watercolour on light board with
overleaf bearing calligraphy;
27.5 x 20.8 cm (sheet)
No. 23636

Radha and Krishna (fig. 88, cover)
India, Himachal Pradesh, Kangra; c. 1875
Opaque watercolour on light board;
35.7 x 25.6 cm (sheet)
No. 23637

Two Sheets from a Krishna Lore
Manuscript
India, Rajasthan; late 19th century
RECTO: **Three Armed Men**
VERSO: **Four Archers on Horseback**
Opaque watercolour on paper;
15 x 10.1 cm (sheet)
No. 23638.1
RECTO: **A Row of Devotees Seeing**
Divine Visions
VERSO: **Krishna Receiving Heroes**
Opaque watercolour on paper;
14.4 x 10.4 cm (sheet)
No. 23638.2

Muralidharji, a Vaishnava Holy Man
India, Rajasthan, Kishangarh(?);
19th century
Opaque watercolour on board;
22.8 x 18.0 cm (sheet)
No. 23639

Fragment of a Folio from a *Kalpasutra*
Manuscript
India, Gujarat; later copy of 16th-century
illustration
RECTO: **Jina Neminatha and Krishna**
VERSO: text
Opaque watercolour on paper;
11 x 7.6 cm (image), 11 x 11.5 cm
(sheet, irregularly cut)
No. 23640

Manuscript: Avatars of Vishnu and
Vaishnava Text (fig. 5A, B, 66)
India, Orissa; 19th century
Roundels, hinged at the centre, open to
form another set of 6 avatars or 6 texts
Opaque watercolour on 12 palm-leaf
panels with incised pen line and cut-out
laid decorative border; 15.8 x 3.7 cm (each
panel), 15.8 x 45.9 cm (overall)
No. 23641

HIMALAYAN PAINTING

Buddha Shakyamuni with Disciples
and Donors (fig. 103, 115)
Western Tibet, Guge; c. 1500
Opaque watercolour on cotton;
83.5 x 74.3 cm
No. 26826

Sakyapa Hierarch Kunga Nyingpo
(fig. 110)
Central Tibet, Tsang region; c. 1500
Opaque watercolour on cotton;
66.5 x 57.6 cm
No. 26827

Mandalas of the Ngör Cycle according
to Sakyapa Teachings (fig. 93)
Central Tibet, Tsang region; 1475–1500
Opaque watercolour on cotton;
83.5 x 74.3 cm
No. 26828

Vajrabhairava
Central Tibet, Ü region; 18th century
Opaque watercolour on cotton;
48.6 x 39.8 cm
No. 26829

Buddha Shakyamuni with Four Arhats
Central Tibet; 18th century
Opaque watercolour on cotton;
74 x 53.7 cm
No. 26830

Angry and Pacific Deities of Bardo
Tibet or Northern Nepal; 19th century
Opaque watercolour on cotton;
63.7 x 43.3 cm
No. 26831

Visions of Mahasiddha Virupa (fig. 106)
Tibet; 17th century
Verso: invocation mantras in Lantsa script
Opaque watercolour on cotton;
67.3 x 47 cm
No. 26832

Padmasambhava with Four of His
Incarnations, Consorts, and Other
Deities
Central Tibet; 18th century
Opaque watercolour on cotton;
71.3 x 48 cm
No. 26833

Dakini Simhavaktra (Lion-faced)
with Acolytes and Teachers
Central Tibet; 18th century
Opaque watercolour on cotton;
47.6 x 35.9 cm
No. 26834

Buddha Shakyamuni with Two
Disciples, Sixteen Arhats, Two Monks,
and Four Lokapalas (fig. 48)
Central Tibet; 17th century
Opaque watercolour on cotton;
68.5 x 45.7 cm
No. 26835

Naro Dakini and Retinue with Monks
and Dancing Skeletons (fig. 97)
Central Tibet, Ü region; 17th century
Opaque watercolour on cotton;
58.4 x 37.5 cm
No. 26836

Ushnishavijaya
Central Tibet; 18th century
Opaque watercolour on cotton;
74.4 x 54.3 cm
No. 26837

Vajrabhairava (fig. 98)
Central Tibet; 18th century
Opaque watercolour on cotton;
50.7 x 34.2 cm
No. 26838

Mahakala
Central Tibet; 18th century
Opaque watercolour on cotton;
75 x 51 cm
No. 26839

**Padmasambhava with Scenes from
the Life of an Unknown Monk** (fig. 108)
Central Tibet; 18th century
Opaque watercolour on cotton;
89.4 x 59.4 cm
No. 26840

**The Fifth Dalai Lama with Scenes
from His Life** (fig. 49)
Central Tibet; 18th century
Opaque watercolour on cotton;
67.6 x 46.2 cm
No. 26841

**Paradise of Amitabha
(Sukhavati, the Land of Bliss)**
Central Tibet; 18th century
Opaque watercolour on cotton;
73.5 x 51 cm
No. 26842

**Ushnishasitatapatra, the Cosmic
Goddess** (fig. 2)
Central Tibet; 18th century
Opaque watercolour on cotton;
63.9 x 43 cm
No. 26843

**Bodhisattva Vajrasattva Embracing
Consort**
Tibet; 18th century
Opaque watercolour on cotton;
66 x 48 cm
No. 26844

Mahakala (fig. 13)
Central Tibet; 18th century
Opaque watercolour on cotton;
100.5 x 74.3 cm
No. 26845

Lha-mo (fig. 25)
Central Tibet; 18th century
Opaque watercolour on cotton with silk
mounting; 76.3 x 52 cm
No. 26846

Tsongkhapa with Scenes from His Life
Central Tibet, 18th century
Opaque watercolour on cotton with silk
mounting; 67.5 x 46.2 cm
No. 26847

**Yontan Gyila, a Tutelary Deity of the
Nyingma Order** (fig. 100)
Central Tibet; 18th century
Opaque watercolour on cotton;
71.4 x 49.4 cm
No. 26848

Vajrabhairava
Central Tibet; 18th century
Opaque watercolour on cotton;
61.9 x 43.2 cm
No. 26849

**Five Dakinis with Nyingmapa
Teachers**
Central Tibet; late 18th–19th century
Opaque watercolour on cotton with silk
mounting; 36.7 x 27cm
No. 26850

**Buddha (Akshobhya?) with
Bodhisattvas**
Central Tibet; late 18th–early 19th century
Opaque watercolour on cotton;
80.6 x 50.3 cm
No. 26851

Heruka Mandala from Bardo
Central Tibet; early 19th century
Opaque watercolour on cotton;
84.2 x 56.5 cm
No. 26852

Tsongkhapa with Scenes from His Life
(fig. 109)
Central Tibet; late 18th century
Opaque watercolour on cotton;
68.7 x 48.2 cm
No. 26853

**Kalachakra with Retinue and
Sakyapa Monks** (fig. 95, 114)
Eastern Tibet; 19th century
Opaque watercolour on cotton with silk
mounting; 75.2 x 58.2 cm
No. 26854

**Eleven-headed (Ekadasamukha)
Avalokiteshvara**
Eastern Tibet; 19th century
Opaque watercolour on cotton with silk
mounting; 54.3 x 38.3 cm
No. 26855

**Vajrabhairava Mandala with
Vajradhara, Two Gelukpa Teachers,
and Four Angry Deities**
Central Tibet; 19th century
Opaque watercolour on cotton;
68 x 49.5 cm
No. 26856

**The Great Attainer (Mahasiddha)
Kampalipada**
Southern Tibet or Northern Nepal;
late 19th century
Opaque watercolour on cotton;
26.6 x 19.6 cm
No. 26857

**Buddha Shakyamuni and Previous
Birth (Jataka) Stories**
Central Tibet, Tashilunpo Monastery;
c. 1700
Opaque watercolour on cotton;
80 x 51 cm
No. 26858

**Buddha Shakyamuni with Sariputra,
Mahamaudgyalayana, and Two Arhats**
Central Tibet, Tashilunpo Monastery;
18th century
Opaque watercolour on cotton;
57.6 x 41.4 cm
No. 26859

**Paradise of Avalokiteshvara (as
Shadakshari) on Mount Potalaka**
Central Tibet, Tashilunpo Monastery;
18th century
Opaque watercolour on cotton;
78 x 60 cm
No. 26860

**Four Arhats with Attendants, Deities,
and Tibetan Teachers** (fig. 107)
Central Tibet, Tashilunpo Monastery;
18th century
Opaque watercolour on cotton;
62.2 x 41 cm
No. 26861

**Bodhisattva Avalokiteshvara with
Mahakala and Two Buddhas** (fig. 50)
Central Tibet, Tashilunpo Monastery;
18th century
Opaque watercolour on cotton;
67.5 x 41.9 cm
No. 26862

Abhayakaragupta with Mahakala, Samvara, and Nagarjuna
Central Tibet, Tashilunpo Monastery;
18th century
Opaque watercolour on cotton;
64.2 x 35.9 cm
No. 26863

Sakya Pandita, from a Panchen Lama Lineage Series
Central Tibet, Tashilunpo Monastery;
18th century
Opaque watercolour on cotton;
70.0 x 41.5 cm
No. 26864

Bhavaviveka, the Indian Teacher (fig. 51)
Central Tibet, Tashilunpo Monastery;
18th century
Opaque watercolour on cotton;
68.2 x 41.2 cm
No. 26865

Monks and Buddhas
Central Tibet, Tashilunpo Monastery;
18th century
Opaque watercolour on cotton;
91 x 64.2 cm
No. 26866

A Monk-Teacher Surrounded by Nine Arhats and Two Lokapalas
Eastern Tibet, Amdo region(?);
19th century
Opaque watercolour on cotton;
74.3 x 49.3 cm
No. 26867

Ushnishavijaya Attended by Sixteen Arhats, Two Monks, and Two Religious Supporters
China; 18th century
Embroidery and dyes on paper stitched to cotton support with silk mounting;
262.9 x 190.5 cm
No. 26868

Four Mandalas of Four Manifestations of Heruka (fig. 27, 94)
Tibet; 19th century
Opaque watercolour on cotton with separate brocaded silk mounting;
85 x 63.6 cm
No. 26869

Arhat Vanavasin
Eastern Tibet, Kham region; 16th century
Opaque watercolour on cotton;
78.3 x 46.7 cm
No. 26870

A King (Gyalpo)
Eastern Tibet, Kham region;
early 16th century
Opaque watercolour on cotton;
55.3 x 35.1 cm
No. 26871

Padmasambhava Embracing His Consort in a Cremation Ground
Eastern Tibet, Kham region; 18th century
Opaque watercolour on cotton;
71.9 x 53.1 cm
No. 26872

Naro Dakini with Retinue and Spiritual Leaders (fig. 96)
Eastern Tibet; 17th century
Opaque watercolour on cotton;
110.5 x 85.8 cm
No. 26873

Kurukulla with Buddha and Other Deities
Eastern Tibet; 18th century
Opaque watercolour on cotton;
82.5 x 55 cm
No. 26874

An Angry Vajrapani with Other Deities
Nepal, Kathmandu Valley;
early 18th century
Opaque watercolour on cotton;
88 x 58.5 cm
No. 26875

Chakrasamvara and Nairatmya
Nepal; 19th century
Opaque watercolour on cotton;
91 x 67.5 cm
No. 26876

Preaching of the Avalokiteshvara Sutra(?)
Nepal; 19th century
Opaque watercolour on cotton;
37.5 x 2 534.9 cm
No. 26877

Padmasambhava and Attendants
Nepal; 1850–1900
Opaque watercolour on cotton;
80.6 x 54.8 cm
No. 26878

Five Forms of Manjushri on Mount Wutai Shan (fig. 47)
China; dated 1707
Opaque watercolour on cotton;
108.5 x 60.5 cm
No. 26879

Red Hayagriva in the Nyingmapa Tradition
Tibet; 18th century
Opaque watercolour on cotton;
65.3 x 47.5 cm
No. 26880

Hayagriva, a Protector Deity (fig. 99)
Tibet, Tsang region; 18th century
Opaque watercolour on cotton;
67.7 x 45 cm
No. 26881

Thanka Mount
Tibet; 19th century
Chinese silk; 138.5 x 68.5 cm
No. 26882

Begtse, a Defender of the Faith
Central Tibet; c. 1800
Opaque watercolour on cotton with silk mounting; 58 x 38.1 cm
No. 26883

A Protective Deity (fig. 101)
Tibet; c. 1800
Opaque watercolour on cotton;
68.6 x 47.5 cm
No. 26884

Garuda (Khyung)
Tibet; 19th century
Opaque watercolour on cotton;
26.6 x 19.7 cm
No. 26885

Seated Lohan
Bhutan; 17th–18th century
Opaque watercolour on cotton;
50.2 x 73.6 cm
No. 26886

Twelve Small Cut-outs from a Manuscript
Tibet or Nepal; 18th or 19th century
Opaque watercolour on light board;
11.1 x 9.4 cm
No. 26887.1–12